THE ART OF

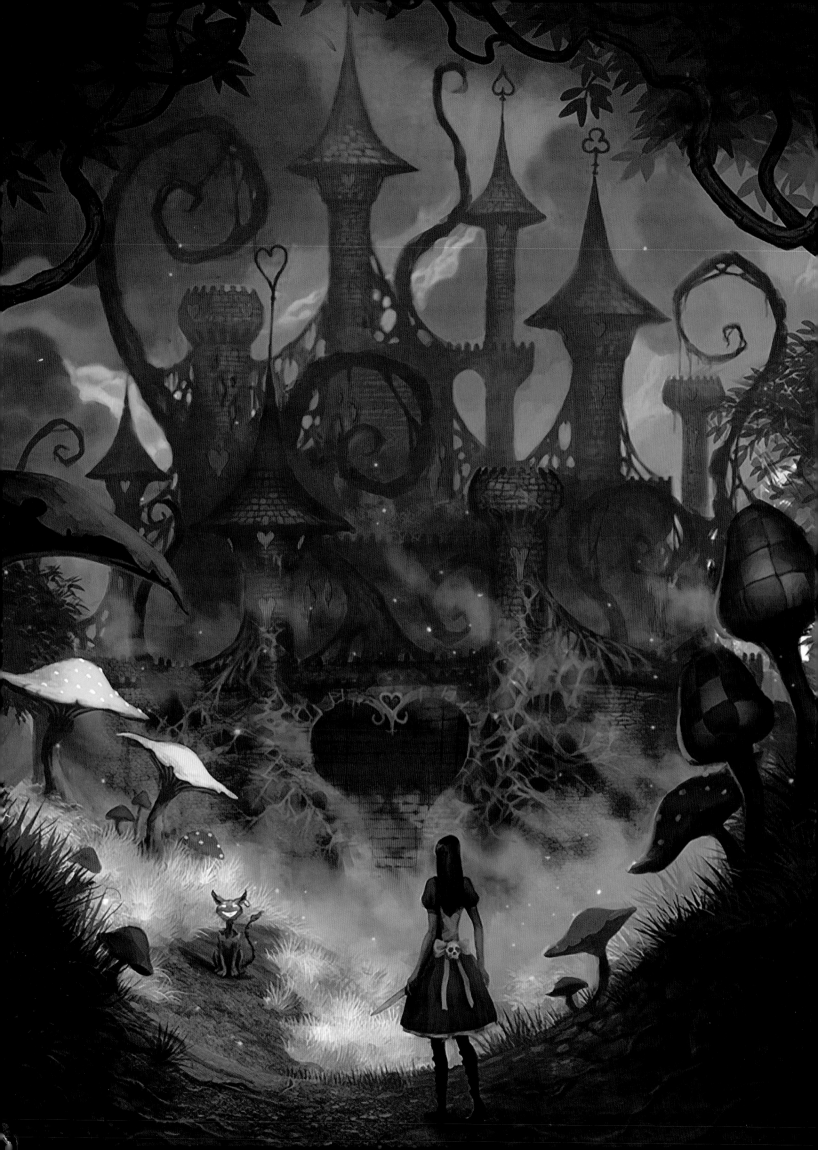

THE ART OF

ALICE
MADNESS RETURNS ™

Art and Captions by

BEN KERSLAKE	LUIS MELO	TYLER LOCKETT
FELLIPE MARTINS	NAKO	WANG SHENGHUA
HONG LEI	PU JINSONG	WU YUEHAN
JIN LEI	SUN GUOLIANG	YUAN SHAOFENG

and
Alice: Madness Returns Art Director
KEN WONG

Introduction by
AMERICAN MCGEE

Dark Horse Books®

Publisher
Mike Richardson

Designer
Tina Alessi

Digital Production
Matt Dryer

Assistant Editor
Brendan Wright

Editor
Dave Marshall

Special thanks to R. J. Berg, Peter McCullagh, LiJia, and American McGee

THE ART OF ALICE: MADNESS RETURNS

Published by Dark Horse Books
A division of Dark Horse Comics, Inc.
10956 SE Main Street
Milwaukie, OR 97222

DarkHorse.com

Library of Congress Cataloging-in-Publication Data

The art of Alice : madness returns / Art and Captions by Ben Kerslake ... [et al.] ; and Alice :
Madness Returns art director Ken Wong ; introduction by American McGee. -- 1st ed.
p. cm.
1. Computer games. 2. Carroll, Lewis, 1832-1898. Alice's adventures in Wonderland.
GV1469.27.A78 2011
794.8--dc22
2010052818

First edition: May 2011
ISBN: 978-1-59582-697-8

5 7 9 10 8 6
Printed by 1010 Printing International, Ltd., Guangdong Province, China.

CONTENTS

tracks on my playlist at the time, like Rob Zombie's "Living Dead Girl," helped to further inject tone into the story and characters as the idea formed.

Back at EA's Redwood Shores campus, my creative partner, R. J. Berg, and I sketched a narrative and design—material that drove concept-art creation around characters, weapons, world, and items. Writing and art worked hand in hand to form a more complete concept of the world.

The idea was to present something classic and dark—not necessarily my own vision of what a "dark" *Alice's Adventures in Wonderland* might be, but a vision that felt like it could be a natural extension of the world and characters in

would define the game. Two years of game development passed in a blur. The result was a thing of beauty.

Alice was released to great critical acclaim and went on to sell over 1.5 million copies worldwide. It was the little game that no one at EA had much expectation for—they even allowed it to grab an M rating, a first for any EA title, probably thinking it wouldn't make much noise. But noise it made—and lots of it. And for a moment we basked in the warmth of a job well done. Might we make a sequel or another twisted fairy tale? No.

R. J. was let go, Rogue went out of business, and I left EA in frustration. It seemed our *Alice* would have only one chapter.

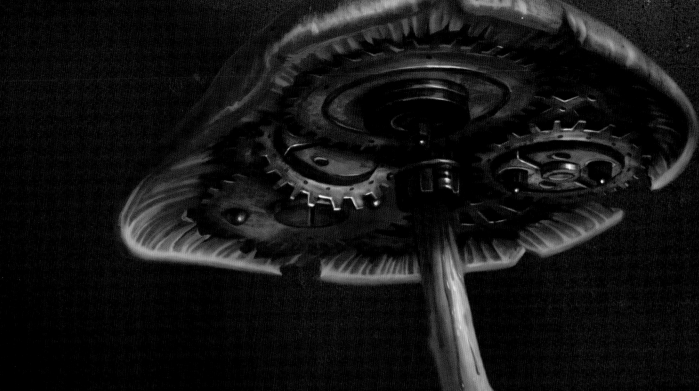

I moved to Los Angeles, where I started work on *Oz*. It was at this point that I met Ken Wong. I was first made aware of him through an excellent piece of *Alice* fan art he'd posted online. He was still living at home, going to college, and resided several thousand miles from LA in Adelaide, Australia. When I first asked him to work with me, he was headstrong and resistant to the proposal—this was a trait I would come to know well during our working relationship. But his art was fantastic, and I wouldn't take "no" for an answer. We worked on *Oz* until it was canceled. Tired of LA and all it implied, I took a chance on a game production in Hong Kong. Ken joined me at the studio and we made our first game together. It sucked, but we learned a lot of valuable lessons, which we then applied to a new studio in Shanghai.

Spicy Horse was founded around artists and surrounded by artists. Our first office was in a space shared with an art-outsourcing company called Vykarian. Art was everywhere—on the walls, on the computers, and in our heads. Our first game project, *Grimm*, was very "artful," an episodic retelling of all the classic *Grimm's Fairy Tales* rendered in a very clean and cute cartoony style. As a game production it honed our ability to design, produce, and deliver high-quality game content very quickly and efficiently. It showed our team they could do something no one had done before—nor has done since—in terms of rapid development of episodic content.

On a whim I reached out to EA and inquired about an *Alice* sequel. We were less than a year from delivering the final episode of *Grimm* and looking for our next project. That EA might take the idea of a sequel seriously—one produced by our unproven team in Shanghai—was far from my mind. It was a fanciful inquiry that I doubted would go anywhere. Luckily for us (and *Alice!*), the ever-supportive crew at Electronic Arts Partners made the deal a reality and has supported us greatly throughout development.

Ten years after that drive along the California coast, I'm sitting in our Shanghai studio, looking out over a team of eighty-five people who are producing one of the most beautiful video games I've ever seen. *Alice: Madness Returns* has been in production for nearly two years now, and we can tell we're about to deliver something awesome, scary, and artistically meaningful.

Contained within the pages of this book you'll find the explorations, concepts, sketches, and final renders that chronicle the development of *Alice*'s next chapter. At Spicy Horse a fresh group of artists under the direction of Ken have managed their own "getting out of the way" to let *Alice* flow through them and into their art. But as with the first, this new adventure has picked up little bits of each artist along the way. This is Alice's world, but it is also theirs. And now it is yours. Enjoy.

AMERICAN MCGEE
Senior Creative Director, Spicy Horse Games
Shanghai, December 2010

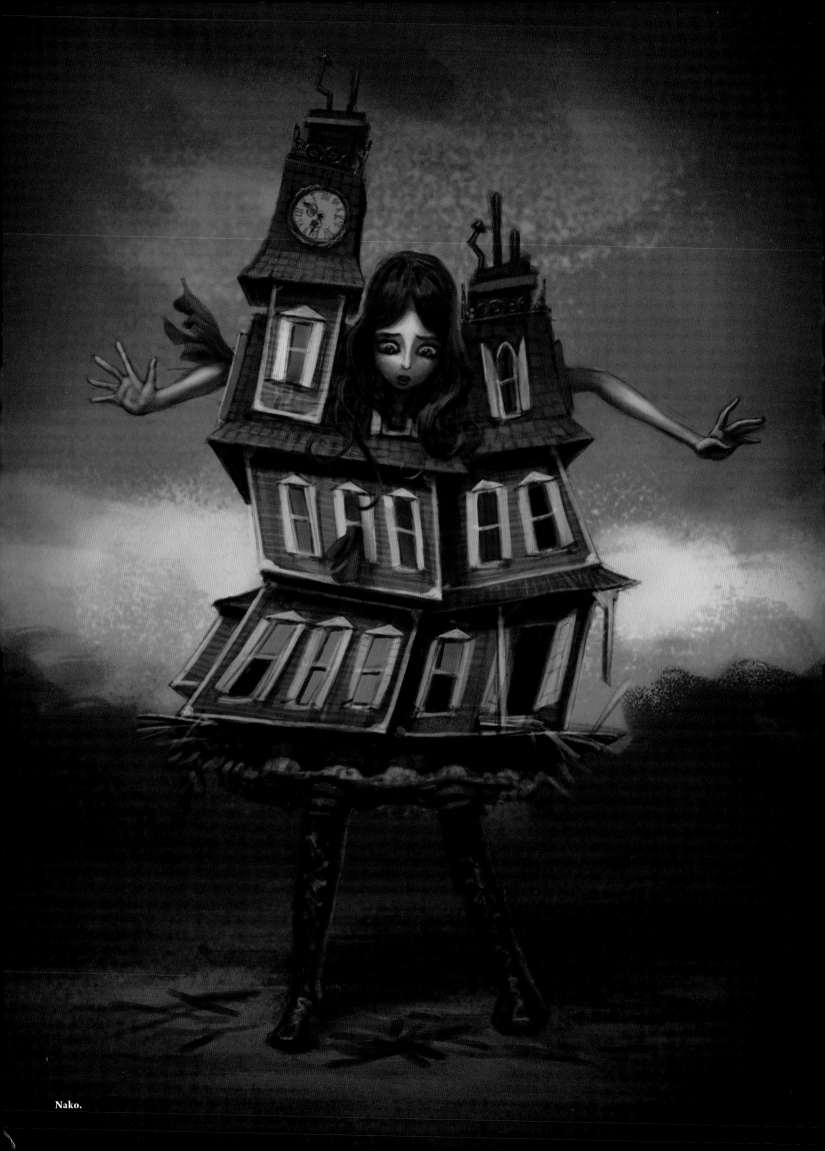

Nako.

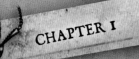

PREPRODUCTION

PREPRODUCTION began on *Alice: Madness Returns* in mid-2008.

The Spicy Horse art team of Nako, Hong Lei, Wang ShengHua, Yuan ShaoFeng, Sun GuoLiang, and Tyler Lockett had spent the past two years working on *American McGee's Grimm*, an episodic PC game with a clean, cartoony look inspired by 1950s illustration and animation. The multiplatform, as-yet-untitled *Alice* sequel couldn't be more different in style, with its focus on surrealism, psychosis-bending imagery, and heavily Victorian-gothic influence. We expanded our team, adding Pu JinSong and Jin Lei, and contracting some freelance artists for outsider perspective.

An initial challenge for us was to arm the Chinese artists of our team with an understanding of what "surreal" meant and what the Victorian sensibility was—two concepts at the very core of *Alice in Wonderland*. We studied the books by Carroll and its many illustrations, including the classic series by John Tenniel. We explored other *Alice* incarnations by other artists and filmmakers, including the original *American McGee's Alice* and art by its fans. We sought out paintings, photography, sculptures, engravings, films both new and old—anything that could inspire creepy, nightmarish, disturbed imagery in our imaginations.

Artists we found particularly inspiring included Dave McKean, Mark Ryden, and Zdzisław Beksiński—but we drew from a wide variety of sources including cosplay, custom jewelry, collector's doll props, Burning Man art, and taxidermy. We also owe a lot to fantasy films like *The NeverEnding Story*, *The Dark Crystal*, *Return to Oz*, *The City of Lost Children*, and *Pan's Labyrinth*, as well as the work of the Creature Shop and the Brothers Quay.

During preproduction we like to create as much art as possible. Some of it is requested to support the early game design documents, but a lot of it comes from very open design briefs. Much of this art ends up inspiring the story, gameplay, and world. Therefore our artists were given a lot of freedom to imagine what Alice's return to Wonderland might look like.

As the art flowed and the schedule crept towards production, I began to work on a style guide, to start drawing all these talented artists in the same direction. American's early guidance was that we should keep the palette colorful, and keep our designs simple and bold.

In the following pages you'll see an incredible gallery of mostly unused ideas. Each would have its place in an alternate Alice story, but may not have fit into our gradually evolving vision for this game. Here you can see other directions for what this game could have become.

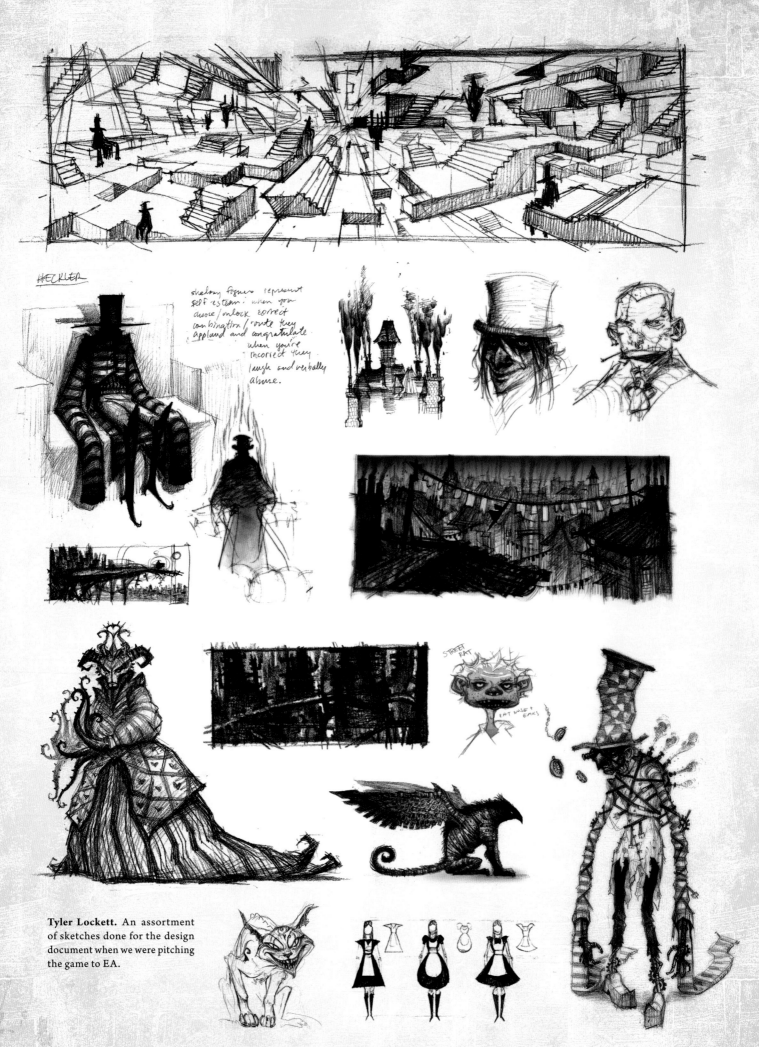

HECKLER

shadowy figures represent
self esteem : when you
choose/unlock correct
combination/route they
applaud and congratulate
when you're
incorrect they
laugh and verbally
abuse.

STREET
RAT

RAT NOSE +
EARS

Tyler Lockett. An assortment
of sketches done for the design
document when we were pitching
the game to EA.

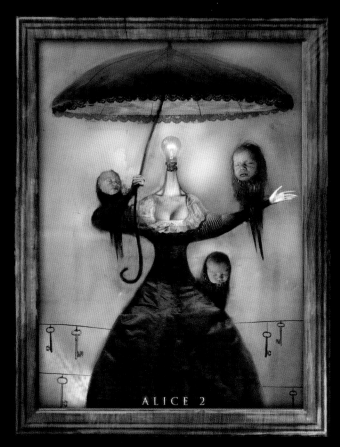

ALICE 2

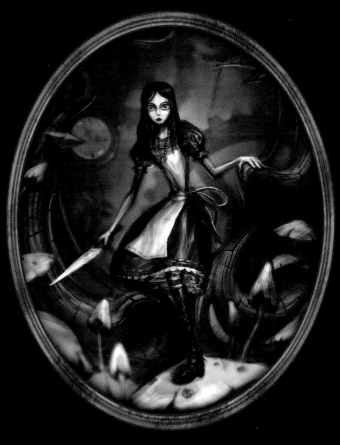

LEFT: Sun GuoLiang. This weird scene is intended to be a prophet trying to tell Alice something. Ken commented it was too "conventional fantasy," so we decided not to use it. **TOP RIGHT: Ken Wong.** This was the very first image I did for the game—I was pushing for a style closer to photomontage. Babies are creepy. I remember even at this date we were talking about whether there should be light bulbs in Wonderland. **BOTTOM RIGHT: Luis Melo.** Nothing is what it seems in Wonderland . . . The trees are hollow, and clockwork is ticking inside them. In fact, whole worlds of clockwork are ticking while Alice tries to find her way around. This is a study for a game poster, based on the forest and clockwork settings, which we think are emblematic to the game series.

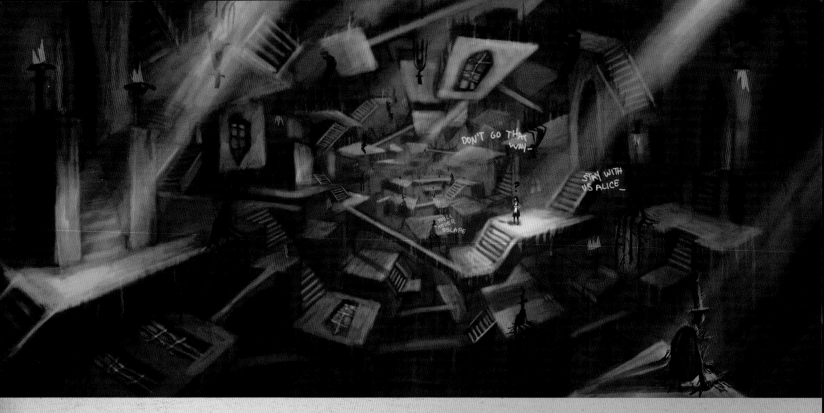

Tyler Lockett. This idea came from a desire to see Alice running on the walls and ceiling. *KW: An M. C. Escher–inspired environment, which we tried to get into the game, but which ultimately posed too many technical problems.*

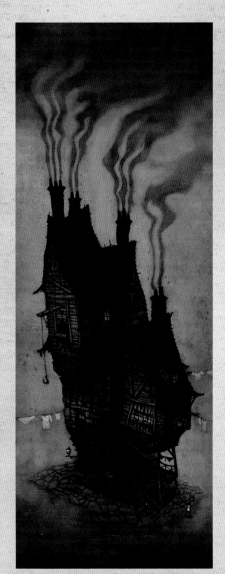

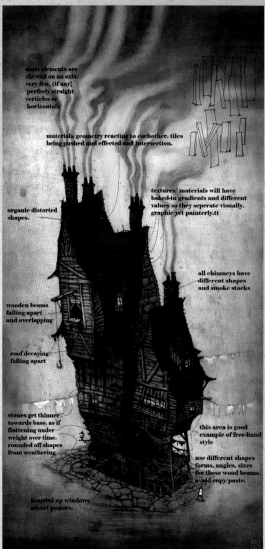

most elements are skewed on an axis. very few, (if any) perfectly straight verticles or horizontals

materials/geometry reacting to eachother. tiles being pushed and effected and intersection.

organic distorted shapes.

textures/ materials will have baked-in gradients and different values so they seperate visnally. graphic yet painterly.tt

all chimneys have different shapes and smoke stacks

wooden beams falling apart and overlapping

roof decaying falling apart

stones get thinner towards base. as if flattening under weight over time. rounded off shapes from weathering

this area is good example of free-hand style

use different shapes forms, angles, sizes for these wood beams. avoid copy/paste.

boarded up windows advert posters.

defensive block

Tyler Lockett. A sagging and warped Victorian slum house. I was looking closely at the brilliant set designs in Carol Reed's *Oliver! KW: One of our first test assets. When you outsource 3-D art, you need to add as many notes and instructions as possible for the artist.*

Tyler Lockett. *KW: In our initial designs, Alice was armed with an umbrella in London, which she could use as a tool or weapon.*

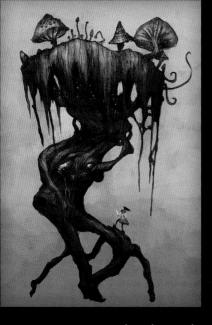

Sun GuoLiang. *KW: An early exploration for a forest environment.*

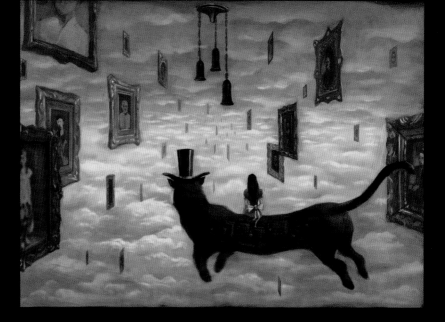

Nako. This was my first design for *Alice*. The brief was quite simple: put a Victorian animal into a scene and show some gameplay. At that time I knew little about Victorian style, so I collected a lot of reference, then I made this. It is the Alice world in my mind. *KW: One of the challenges of working with Chinese artists is that they're not as familiar with surrealism as Westerners are. However, I think Nako showed a good understanding in this picture. It also has quite a Victorian sensibility to it, which was another challenge for them.*

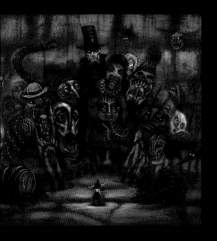

Tyler Lockett. Alice warns a group about the dangers of drug use.

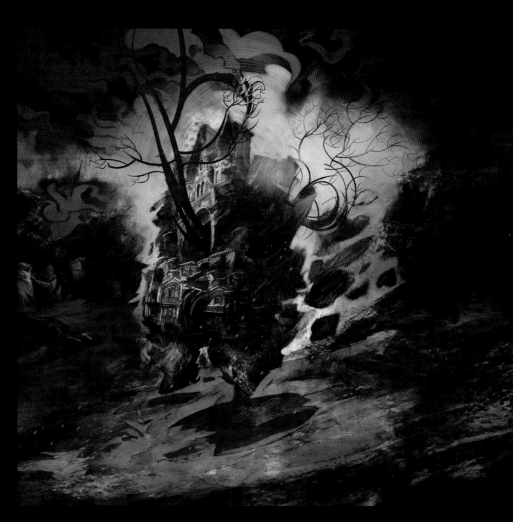

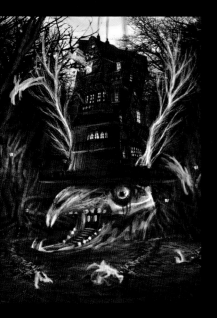

Tyler Lockett. The March Hare's house. I wanted the top hat on the skull to read as his house, and the white trees to read as skeletal ears.

Emmanuel Malin. This was the initial idea, a giant Alice wearing the Rabbit's house. Unfortunately, it doesn't give her much room for destructive mobility.

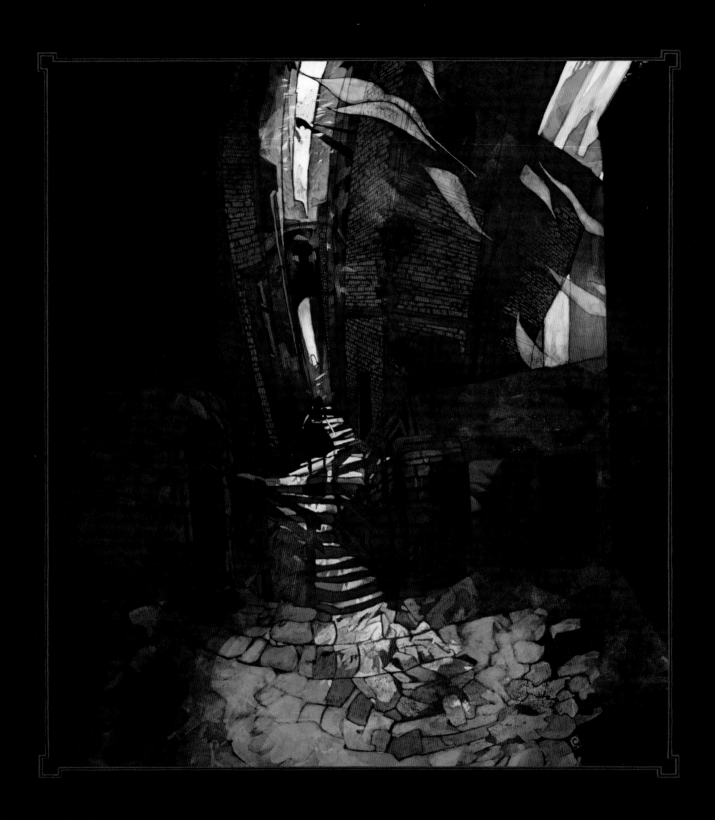

THIS PAGE AND FACING: Emmanuel Malin. *KW: Some early mood shots. These are incredibly beautiful paintings, but ultimately we wanted to root Alice in a more recognizable, less abstract world.*

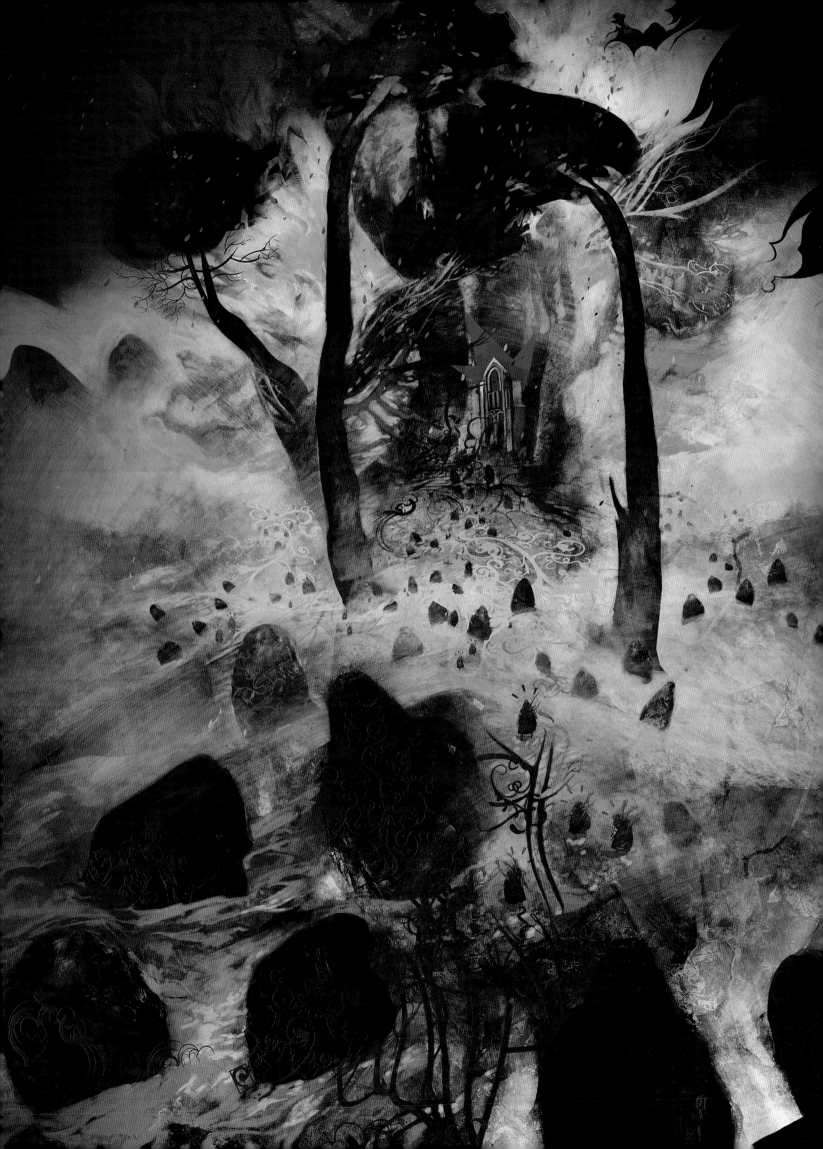

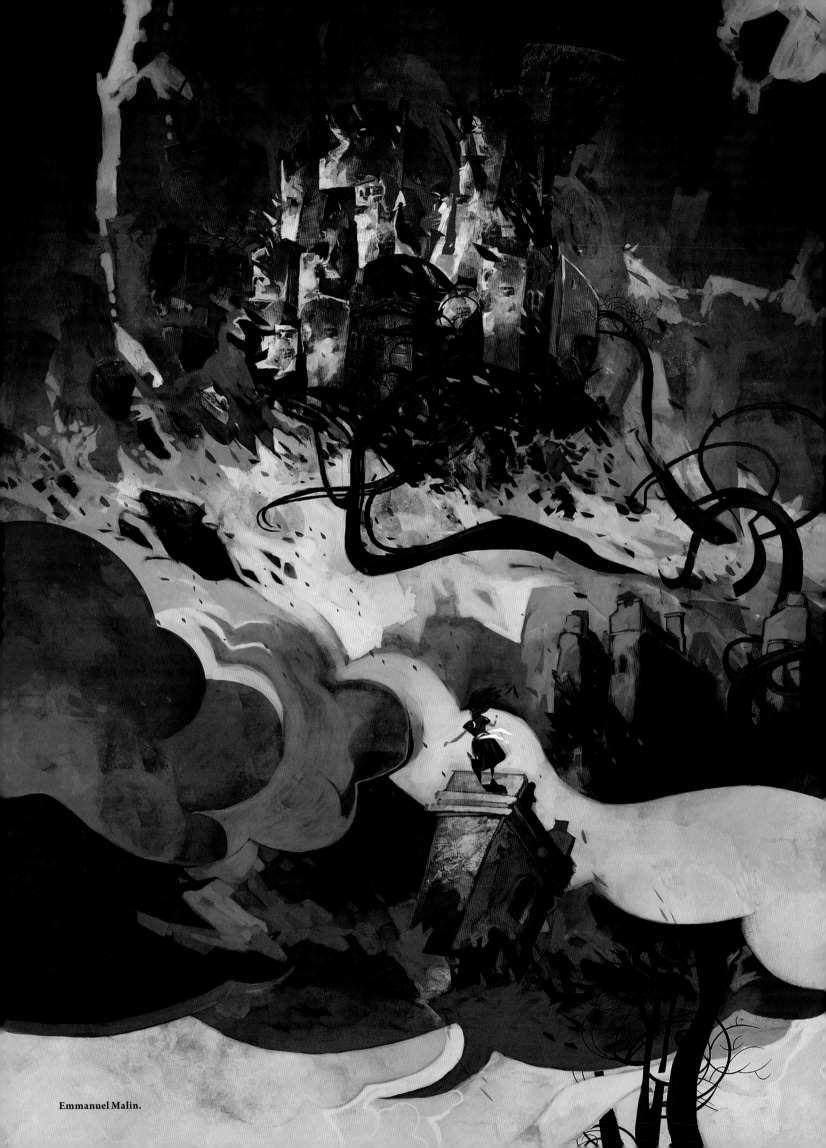

Emmanuel Malin.

ABOVE: **Tyler Lockett.** Wonderland merges into London. Jack the Ripper meets H. P. Lovecraft. BELOW LEFT: **Ben Kerslake.** *KW: Ben is a great concept artist, but on Alice he served as creative director. It was a rare treat to get this bit of early art from him, capturing a nice, strange moment.* BELOW RIGHT: **Julie Dillon.** *KW: An idea for the Red King, bound in a forest/asylum.*

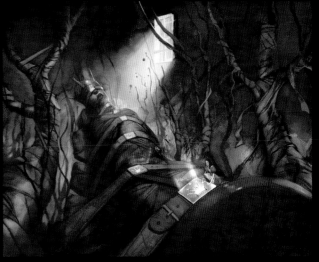

FOLLOWING PAGES: **Sun GuoLiang.** This is a giant princess who gives birth to a lot of monster babies. Alice ends her suffering—by killing her. We didn't really use it in the game; perhaps it was too bloody? *KW: Our artists are all nice, pleasant people, so we really had to push them to explore their dark sides for this game. This image is the result of me telling Sonny to go darker, darker, darker. Maybe we went too far.*

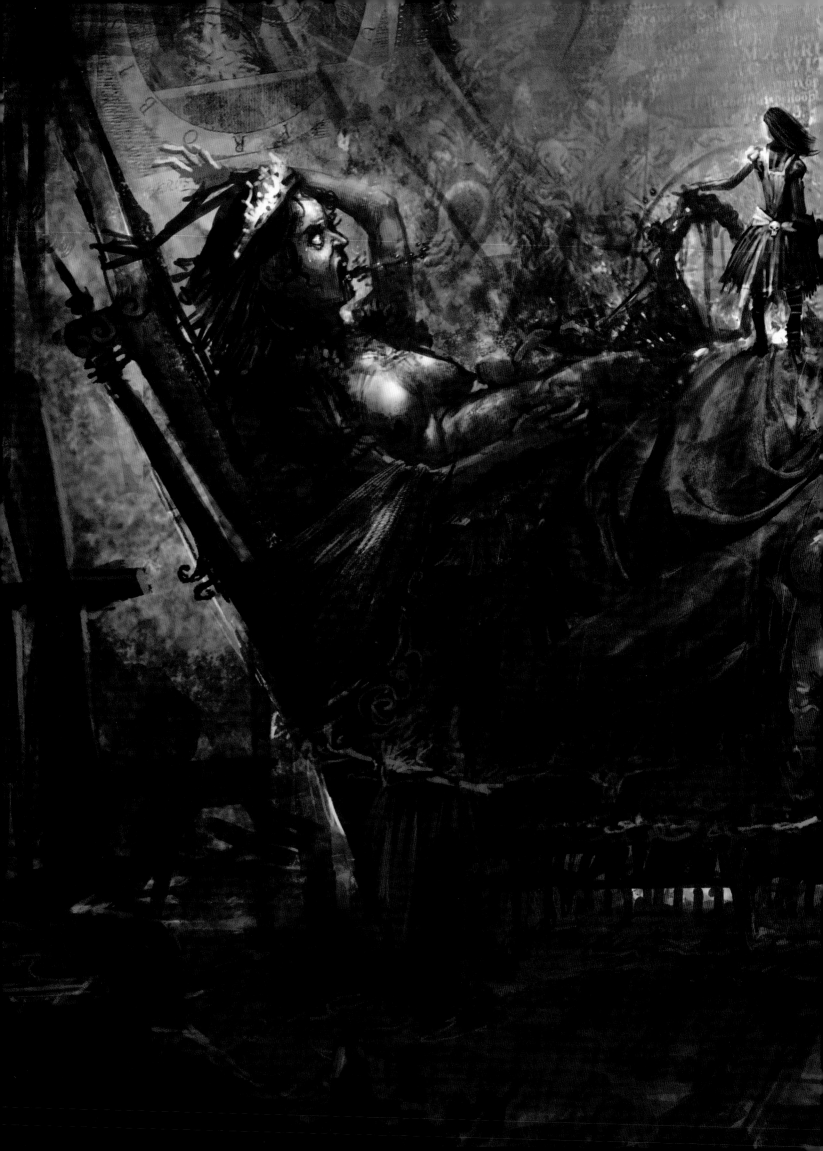

Tyler Lockett. A sketch for a rickety-stilt world, supported by thin planks of wood, reflective of Alice's fragile state of mind.

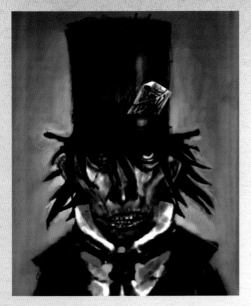

Tyler Lockett. The Mad Hatter as an East End ruffian.

Wang ShengHua. *KW: Some early ideas for a broken-down Mad Hatter for Wonderland.*

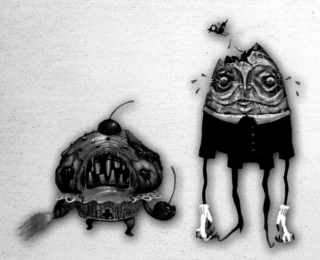

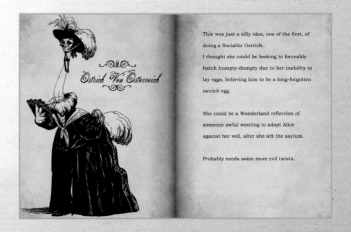

This was just a silly idea, one of the first, of doing a Socialite Ostrich.

I thought she could be looking to forceably hatch humpty-dumpty due to her inability to lay eggs, believing him to be a long-forgotten ostrich egg.

She could be a Wonderland reflection of someone awful wanting to adopt Alice against her will, after she left the asylum.

Probably needs some more evil twists.

Ostrich Von Österreich

LEFT: Luis Melo. RIGHT: Tyler Lockett. LM: The tea party turned into a nightmare . . . This one was a concept for a living muffin creature, who was not too happy to have his face bitten and his blueberry brains oozing out.

Luis Melo. This is another character from the initial brainstorming for new characters, based on eccentric animals and Victorian references. An Austrian ostrich aristocrat, obsessed with snatching up Humpty Dumpty so she can hatch a monster out of him . . . maybe. *KW: Luis had no problem capturing the ridiculous, Victorian roots of Wonderland.*

 THE ART OF *ALICE: MADNESS RETURNS*

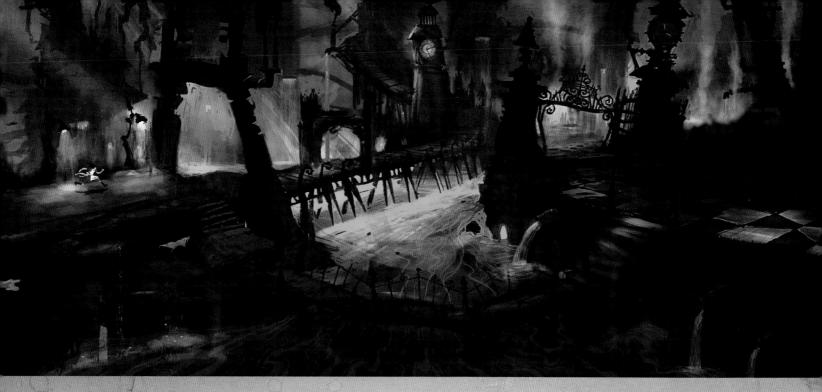

Tyler Lockett.

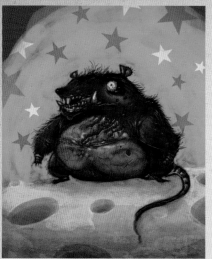

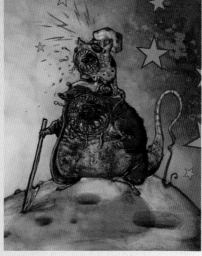

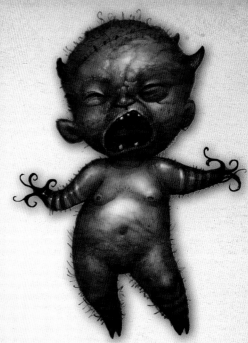

Wan KokLeung. Some ideas for a level on the moon, made of cheese. *KW: I absolutely love Wan KokLeung's unique rendering style and outrageous monster designs.*

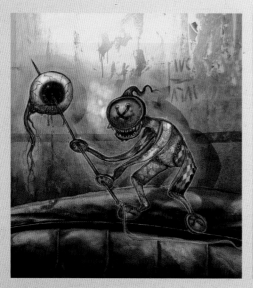

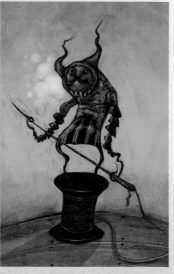

Wan KokLeung. *KW: Some really wonderful designs for the Dollhouse that we never had time to use.*

Sun GuoLiang. A weird baby. We decided not to use it in the end. American loved it very much. *KW: This baby was our first test-character model after Alice. It was about four meters tall. It was also featured on Spicy Horse's Christmas card that year.*

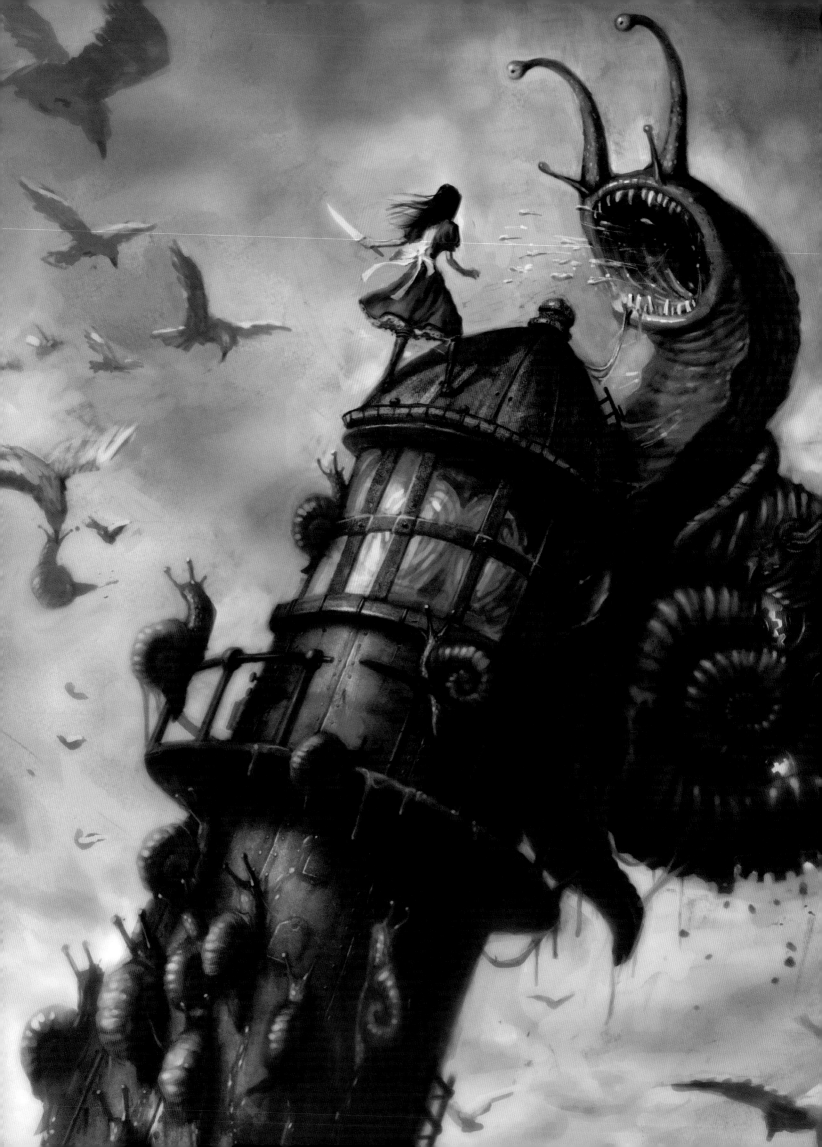

FACING PAGE: Ken Wong. I wanted to create a "key illustration" for the game to help define its direction early on. In this picture I wanted to capture the uniqueness of our heroine and the ridiculous, surreal situations she finds herself in. This image eventually accompanied the announcement of the game, and was the only piece of art released publicly for some time.

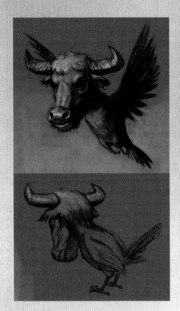
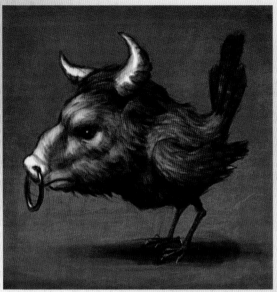

Nako. The brief was to design a creature that lives in the Wonderland forest, with a bull's head and a bird's body. We tried a lot of combinations. Some look gentler, others more violent.

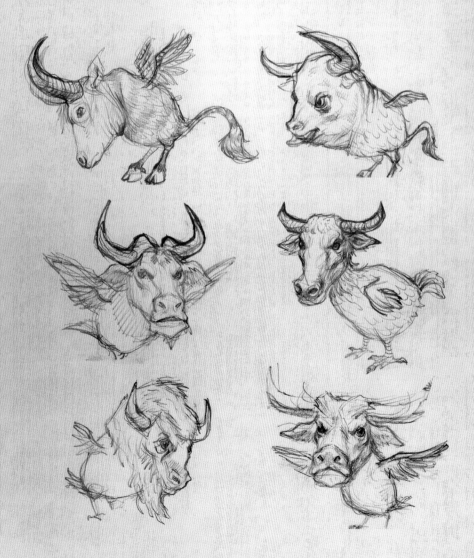

Nako. *KW: The Cowbird, also known as the Mock Sparrow, always made us laugh. We eventually did both male and female versions.*

23

ABOVE: **Tyler Lockett.** A colorful, rat-pack street gang. I was shooting for a balance between menacing and humorous. BELOW: **Tyler Lockett.**
An early map of Victorian London, showing different 'hoods. *KW: Actual nineteenth-century London provided a lot of inspiration. The deeper we dug, the more filth we uncovered. London was not a pleasant place in those days, especially for a crazy young woman like Alice.*

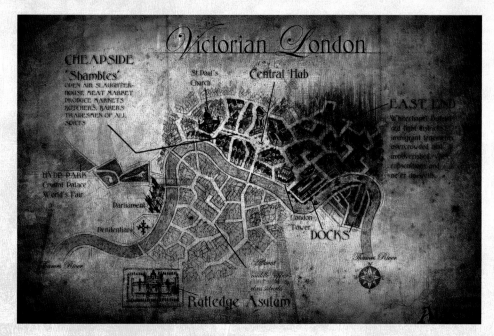

FACING PAGE: **Tyler Lockett.**
A festively plump Victorian gentle-
man. Early on we were trying
to decide how far to push the
characters' proportions.

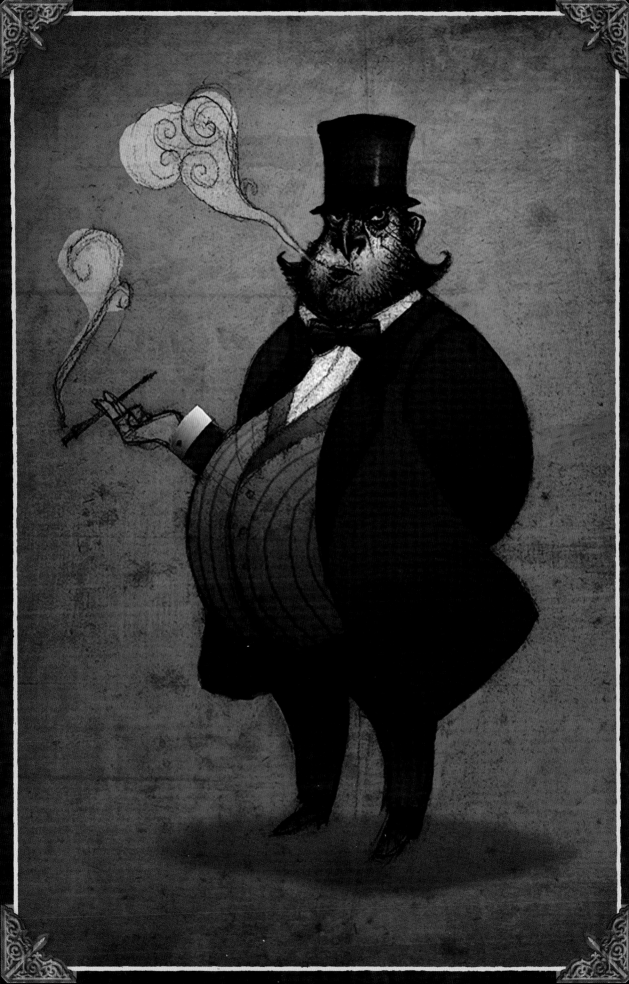

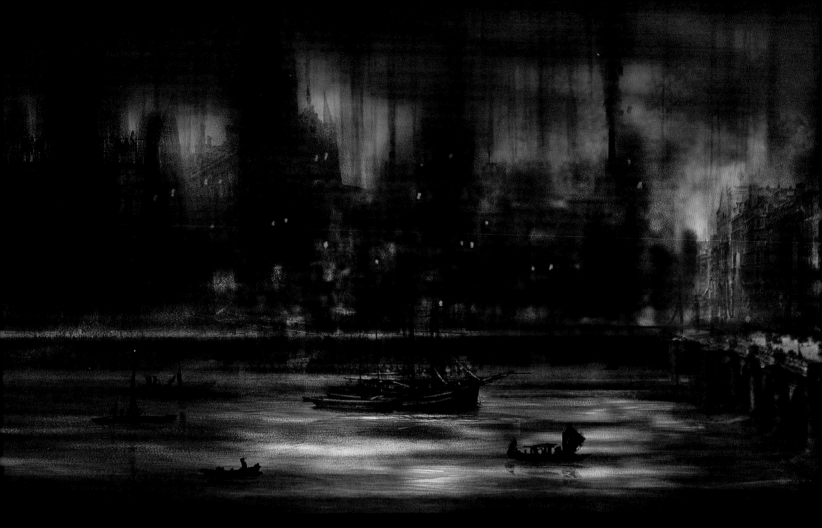

Tyler Lockett. An extremely sooty London, compiled from old Victorian photos.

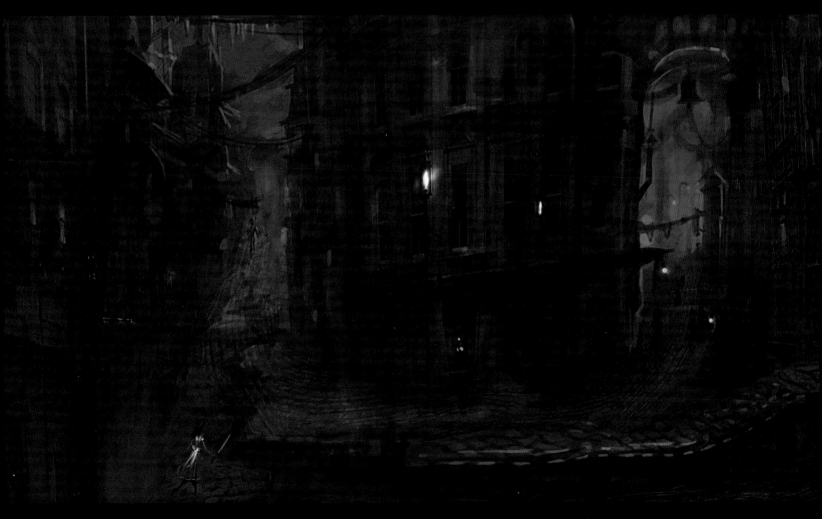

Sun GuoLiang. The transition between London and Wonderland, one of my favorite pieces. *KW: A study of the visual difference between London and Wonderland. London is gray, gritty, and low contrast. Wonderland is full of color, with dark shadows and bright lights. This is also the only real environment art we created for the Vale of Tears.*

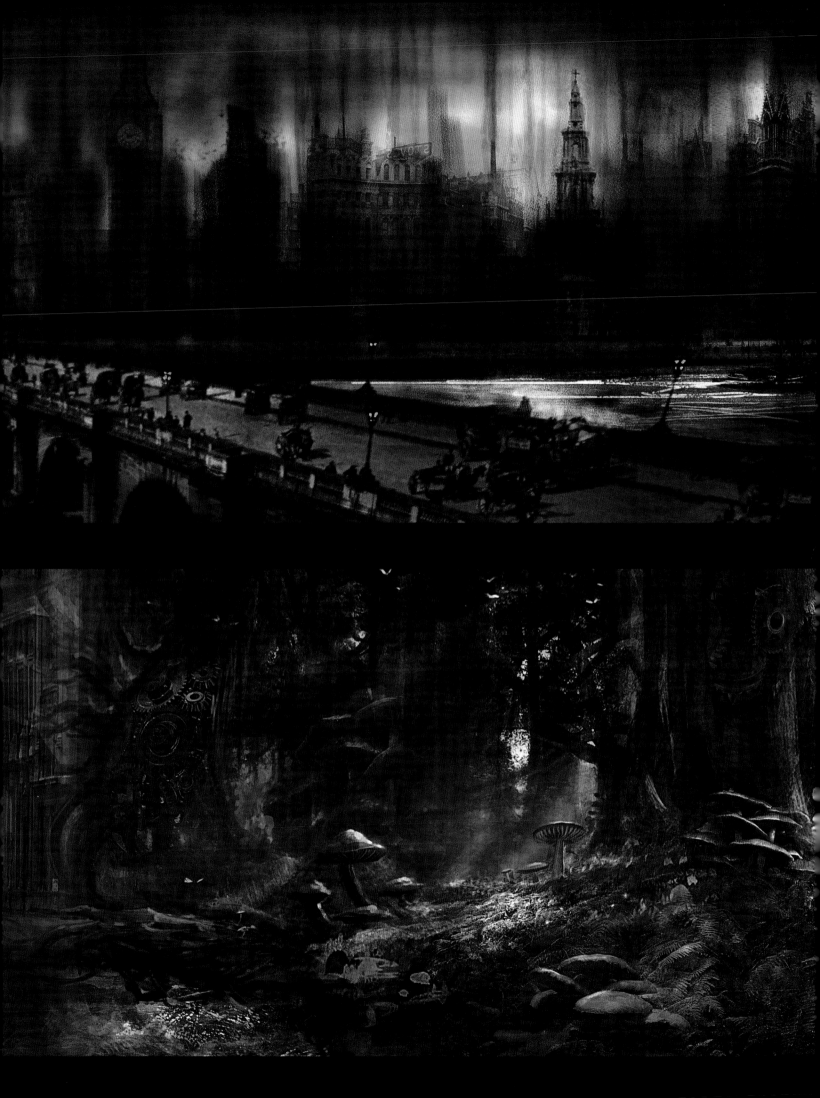

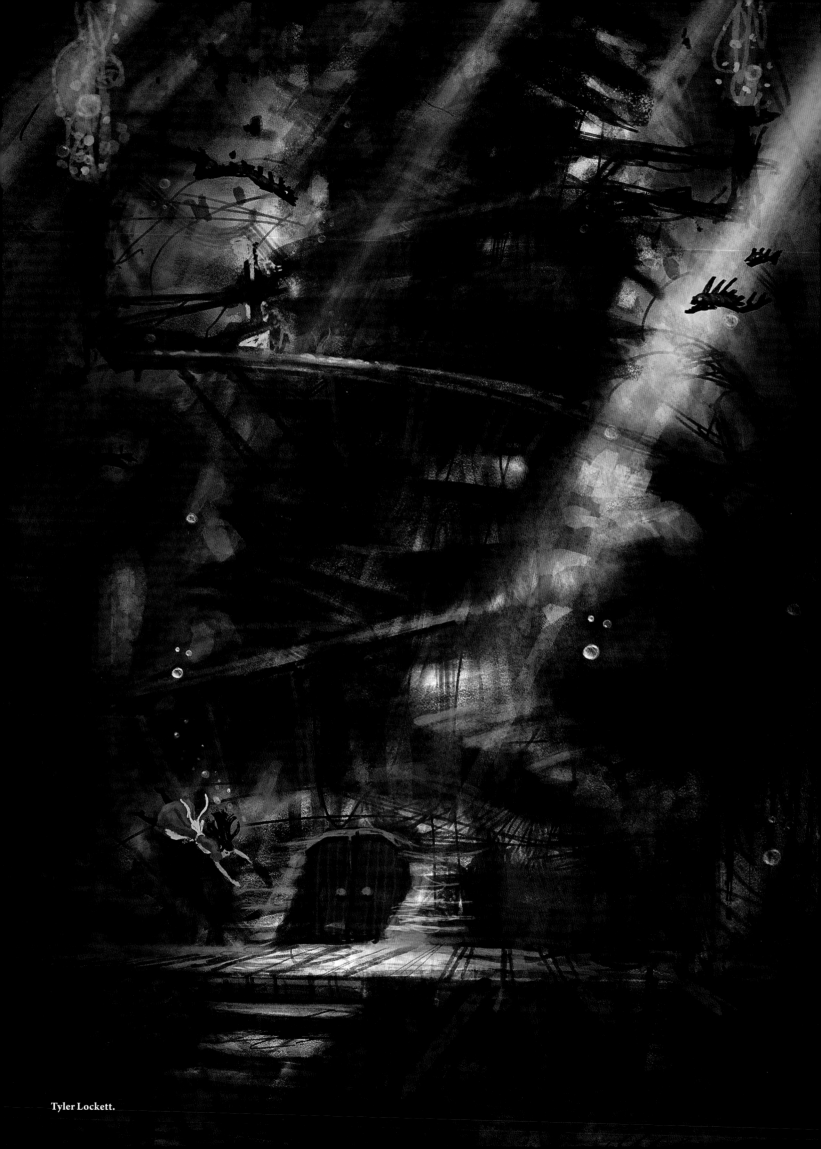

Tyler Lockett.

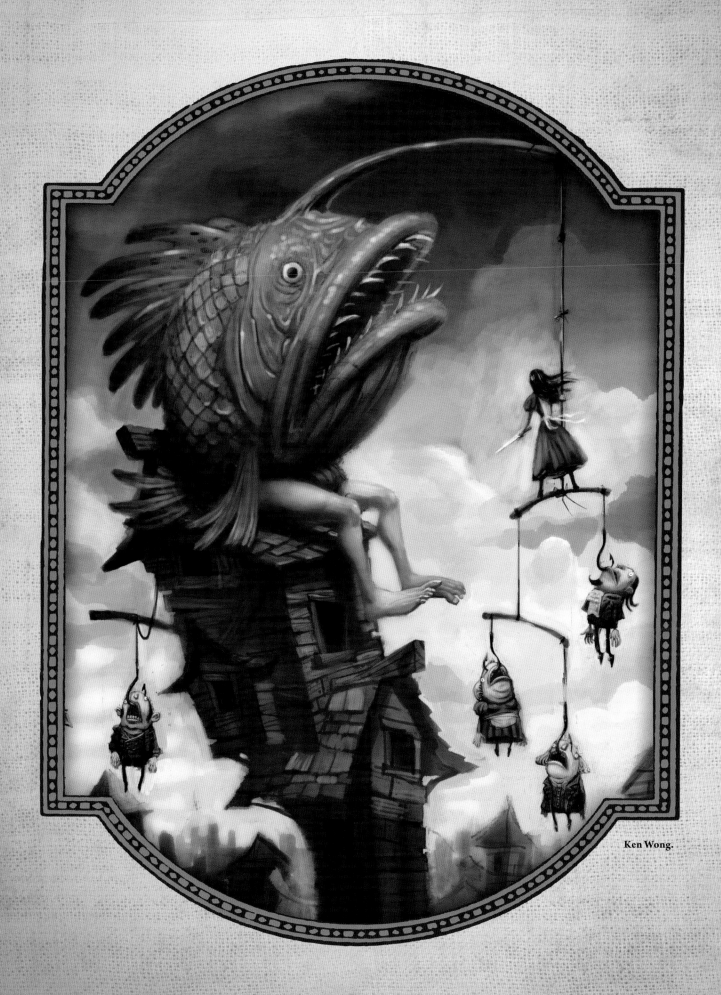

Ken Wong.

Luis Melo. The goal for creating an encounter with the Duchess's cook was to turn the mayhem of that part of the book into pure horror. We went the disgusting way, trying to come up with the most foul-looking and pig-innards-obsessed "woman" we could.

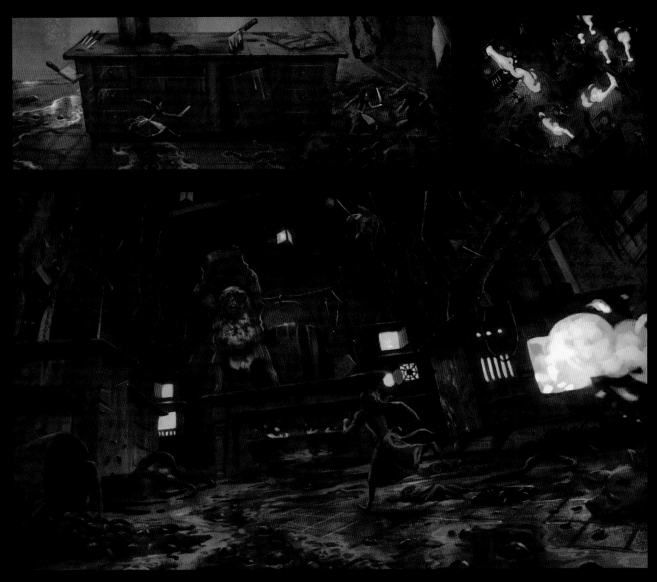

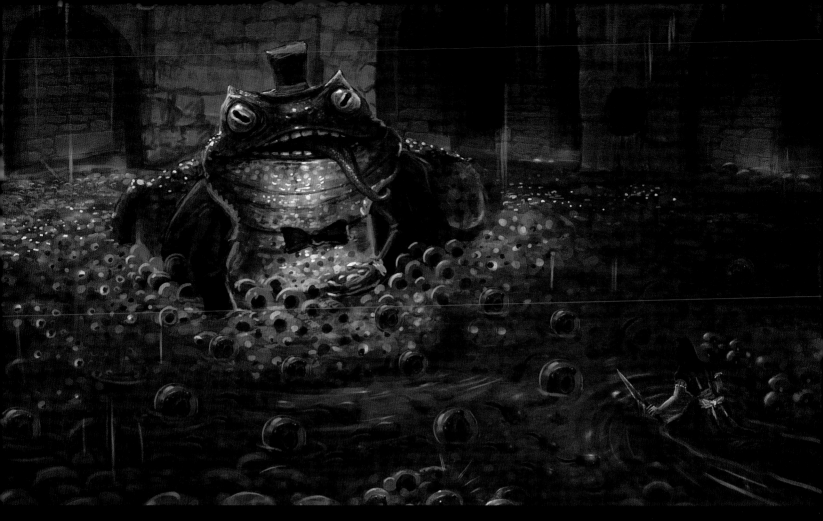

Sun GuoLiang. This was a paintover for Mr. Toad, living in the sewer. Ken and I tried a lot of interesting and disgusting ideas, like Alice destroying the eggs.

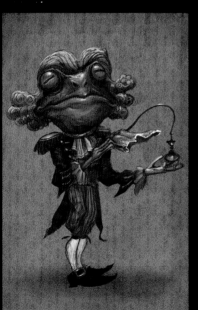 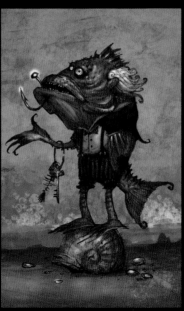

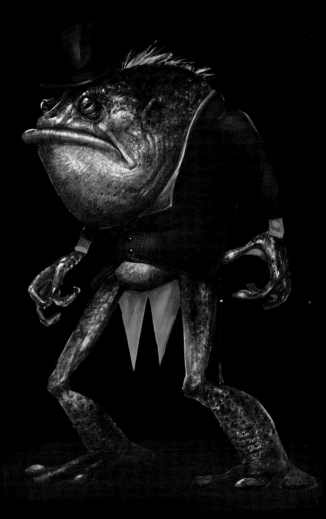

ABOVE LEFT: Sun GuoLiang. The Frog Footman. I collected many Victorian servant photos when designing this. **ABOVE RIGHT: Sun GuoLiang.** Abused fish servant. I like the hook on his mouth, though it is removed in the final version.

RIGHT: Sun GuoLiang.

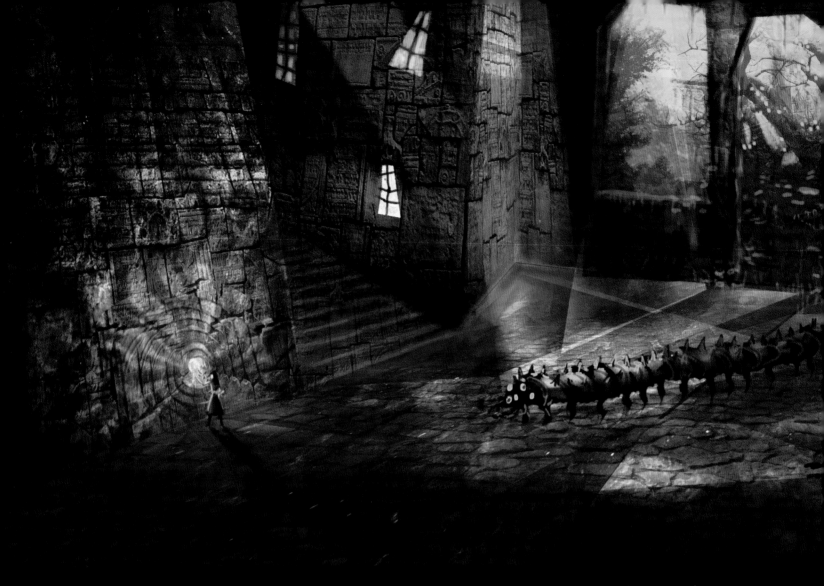

Tyler Lockett. Alice opening a doorway in a wall, as huge centipedes descend behind her. The environment has a surreal, stage-set quality to it.

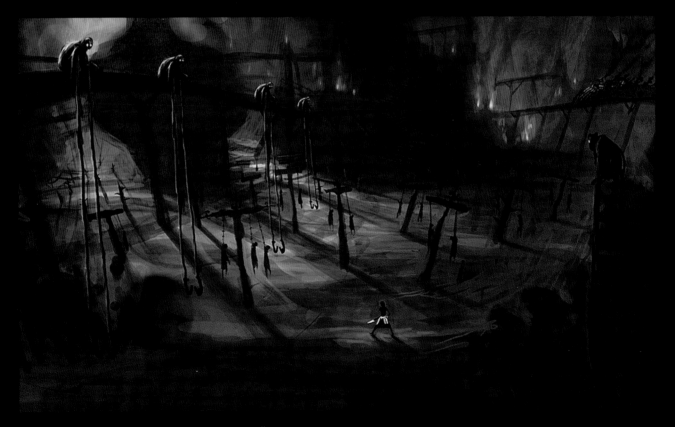

Tyler Lockett. A nightmarish, industrial-graveyard environment. We were looking at a lot of Beksiński early on.

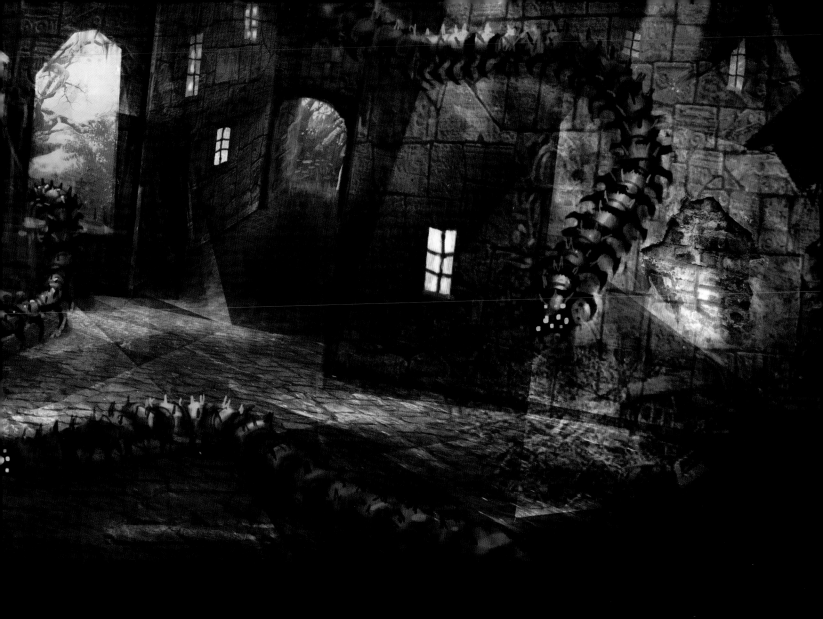

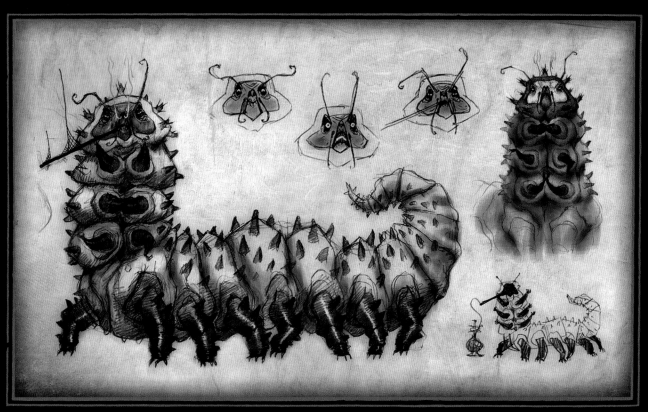

Tyler Lockett.

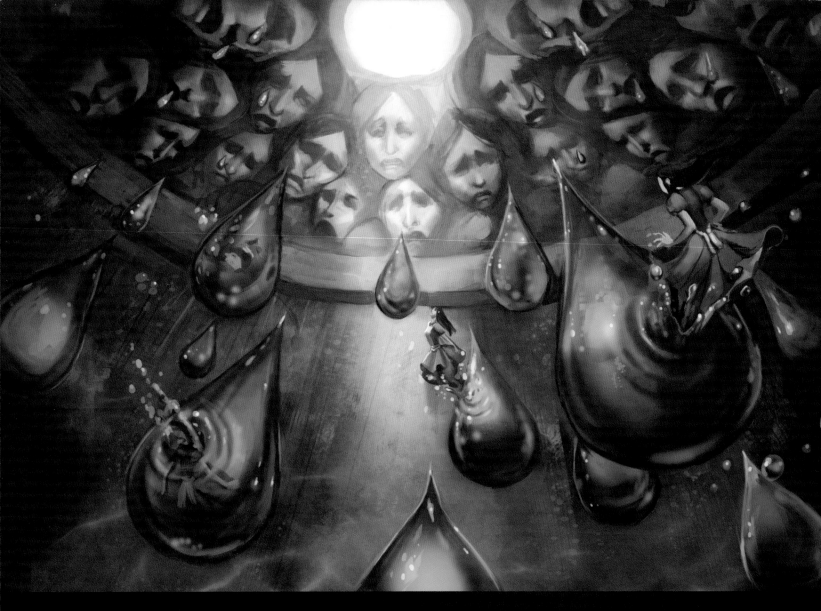

Julie Dillon. *KW: We always liked this idea inspired by Alice's pool of tears, but it would have been a huge technical challenge for just one scene.*

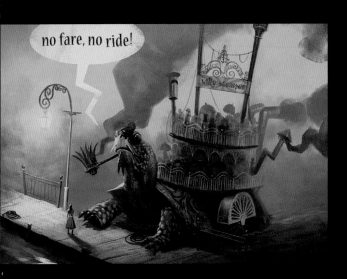

Luis Melo. A steamboat tortoise . . . the only way to get around in this soggy and murky part of Wonderland. If you can figure out how to pay the fare, that is. This came up when we were brainstorming about possible new characters for Wonderland, and what their role and interaction with Alice would be.

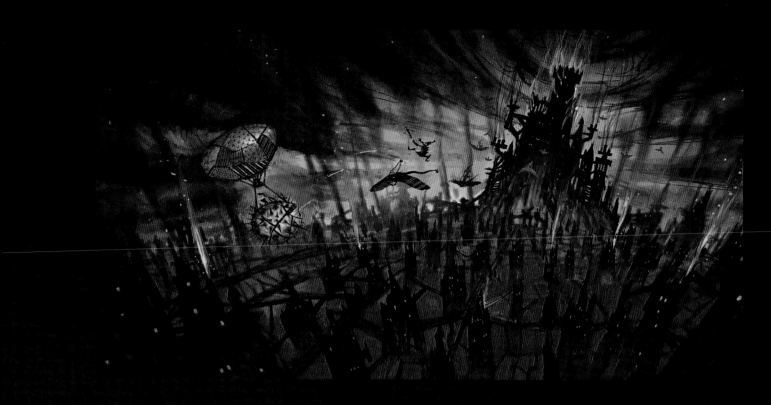

TOP AND BOTTOM: **Tyler Lockett.** Wonderland with a twisted, floating Victorian London and abstracted brain/synapse surroundings.

LEFT: **Luis Melo.** This creature sketch was directly derived (and amplified in wickedness) from a part in *Through the Looking-Glass, and What Alice Found There* in which table objects and cutlery come to life in the form of bizarre flying creatures.

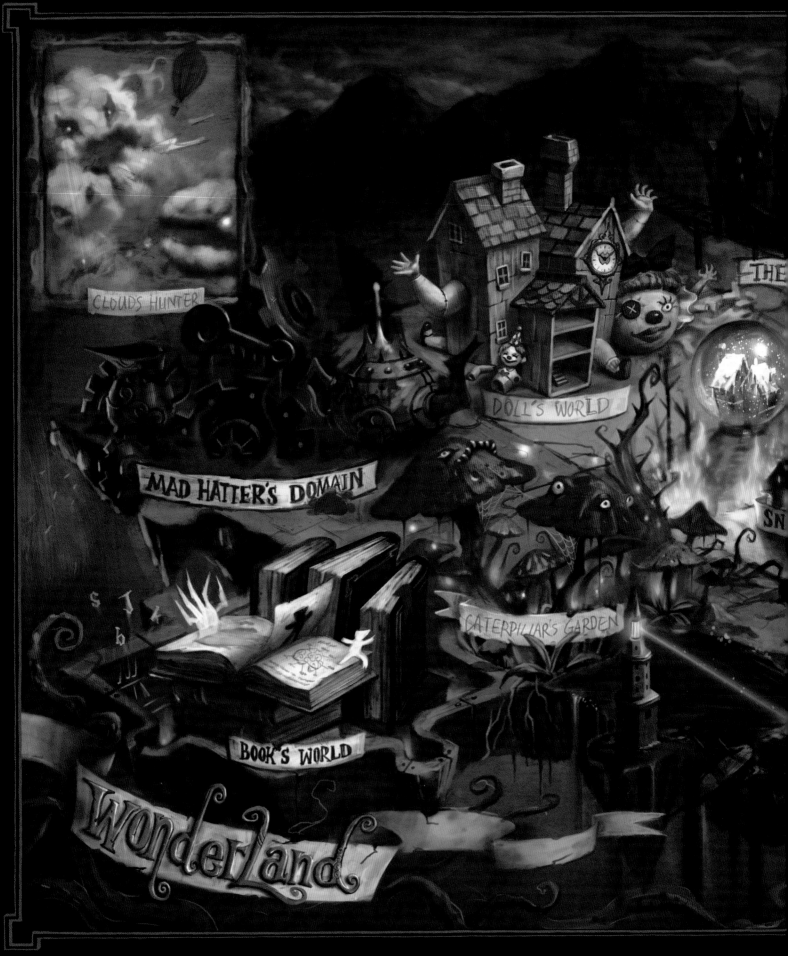

CLOUDS HUNTER

DOLL'S WORLD

THE

MAD HATTER'S DOMAIN

SN

CATERPILLAR'S GARDEN

BOOK'S WORLD

WonderLand

Nako. This is an old map of the whole game. The level design changed a lot after that, and some parts were removed. You can see we had planned a level on the moon! But it was removed, as was the M. C. Escher level.

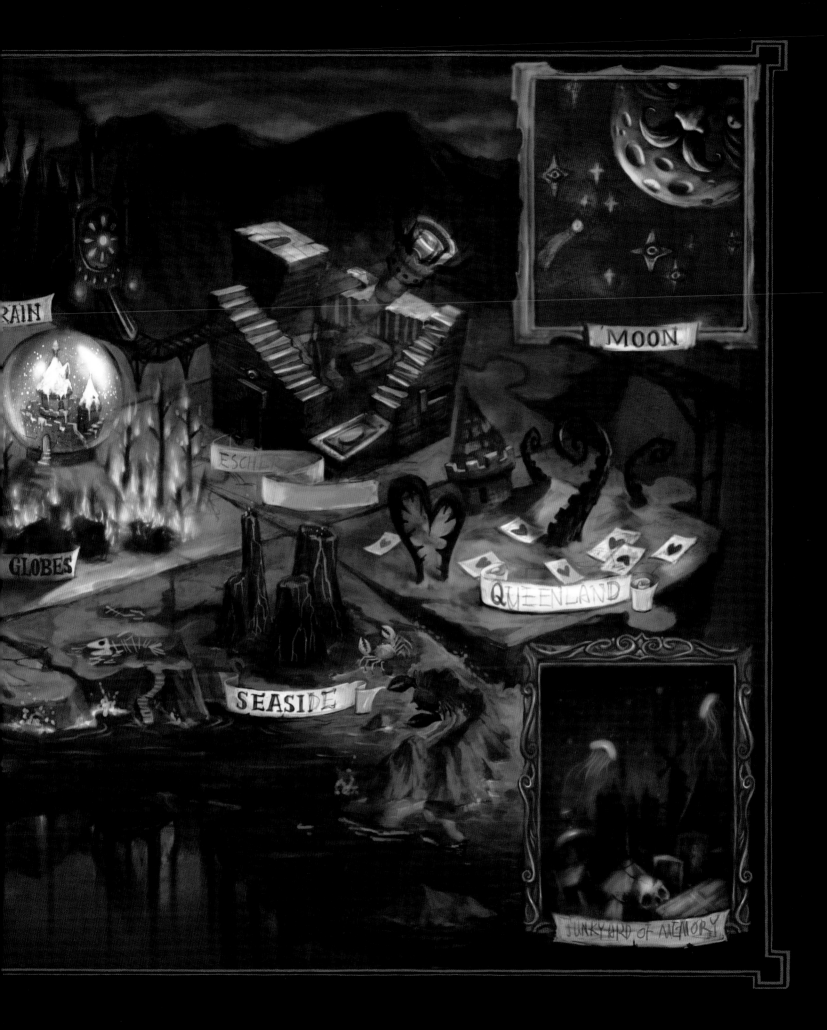

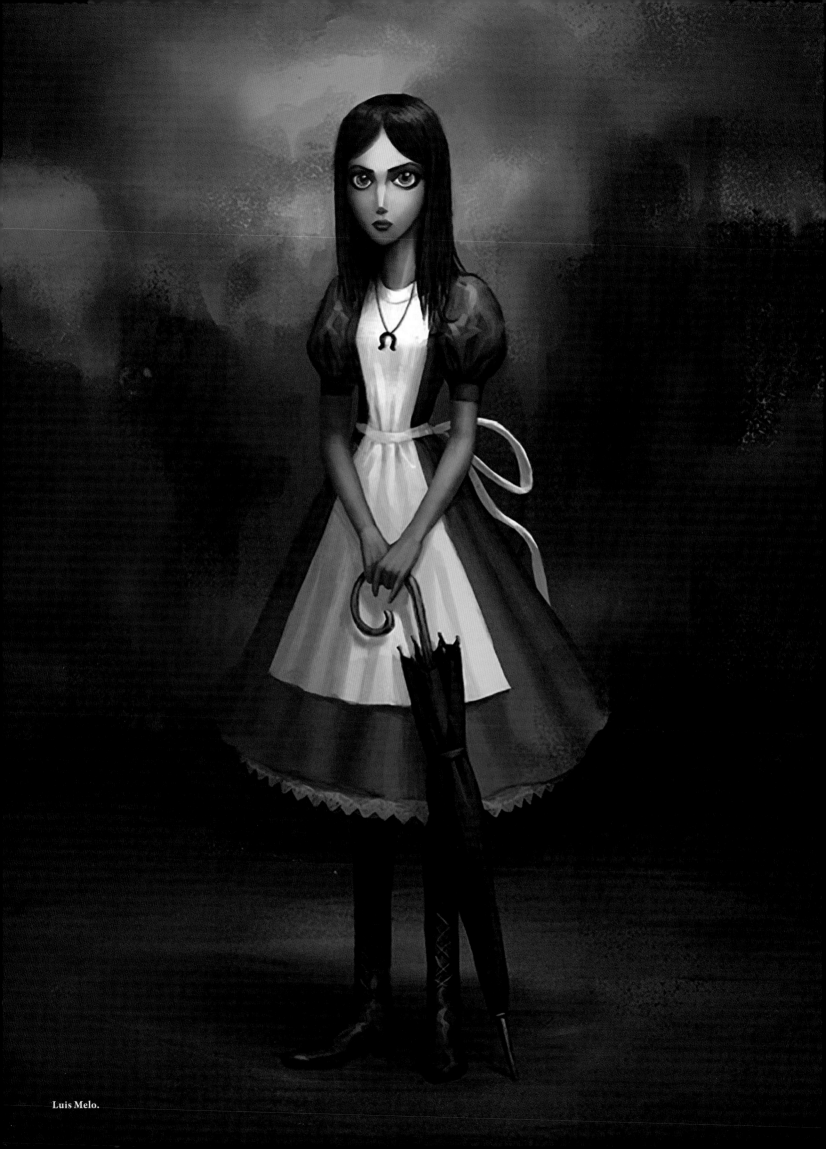

Luis Melo.

ALICE AND HER DRESSES

FINDING our Alice was perhaps the biggest struggle for the art team. The heroine of *American McGee's Alice* is very well designed, visually. She has a great silhouette from every angle and she's recognizable as being the Alice of Carroll and Tenniel's creation, while having her own distinct "American McGee" style.

However, the art team quickly found that bringing Alice into high resolution for the modern age was not easy. The 3-D Alice model in the original game looks quite different from her form in marketing materials, like the box cover. She looks different again in the concept art, and as a toy. We even looked through piles of art contributed by fans over the years in the search for how people saw and remembered our main character.

Each of our artists did their own take on this "blue dress" Alice, but none really stuck. Part of the problem was that her anatomic style needed to be tied with the art style of the whole game, which was also being debated. The months ticked by, and patience wore thin as we argued over style and anorexia and Angelina Jolie. Tempers wore thin; frustration ran high. I think the only aspect we agreed on easily was that we didn't want Alice to have oversized breasts.

After three major revisions, we developed a model that was in a direction that everyone could at least partially agree on, and after months of tweaking, our Alice came through . . . somehow looking like everyone always expected her to.

Besides the classic blue dress, Alice appears in a variety of dresses. A design that made it into our early prototypes had Alice changing dresses every time she switched to one of her four weapons. It looked really great, but became impractical when our weapons system changed. We decided to give Alice a unique costume for each of the Wonderland domains she would visit, a little inspired by *The Cell*. These were later expanded to include downloadable dresses and the Hysteria dress, replacing the Rage Box power-up from the first game.

From the beginning, we knew we wanted to show a meeker, more downtrodden Alice in London, the girl who had been locked up for years in an insane asylum. In contrast to the blue dress and domain dresses, this design evolved very little and without much fuss throughout the duration of the project.

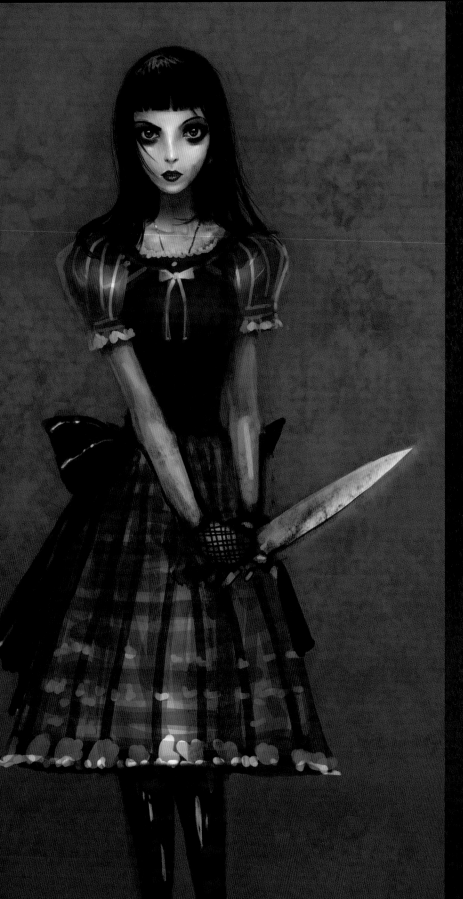

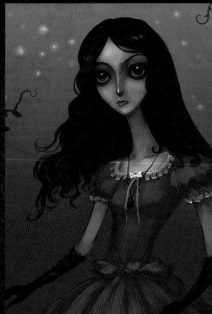

Sun GuoLiang. We were pursuing the stop-motion style, so I adapted some *Corpse Bride* inspiration in this design. I know she looks too weak, but I think the personality is good.

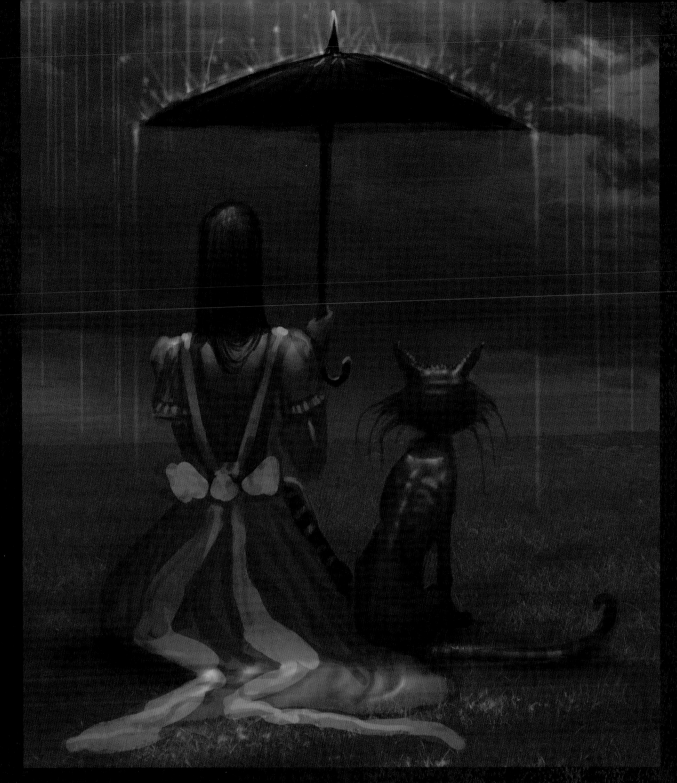

Sun GuoLiang. KW: Our team actually started working on Alice months before we had a deal in place. Just as the deal was being signed, the 2008 financial crisis caught up with our publisher, and the deal was cancelled, along with many other projects. Sonny painted this picture on that sad day. Several months later, after a lot of hard work and negotiating, the deal was resurrected, and we resumed our art.

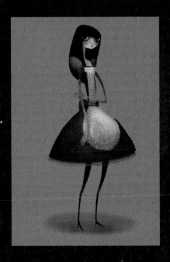

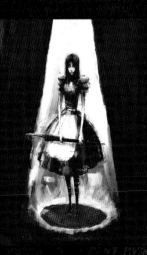

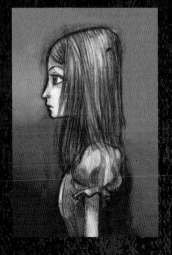

Ben Kerslake. These images represent very different directions that both the Alice character and the entire game may have taken. It was important to us that Alice remained a character players could relate to. We cycled through countless variants of proportion and shape.

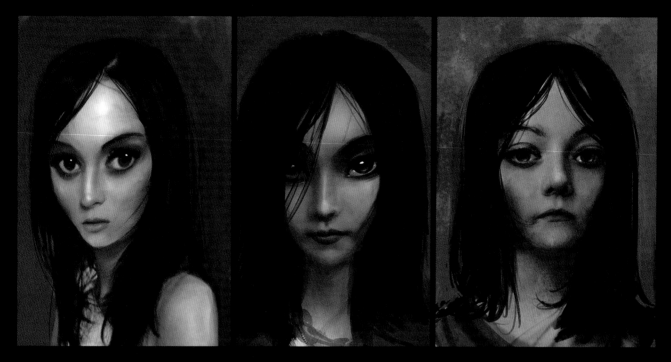

Sun GuoLiang. I tried a lot of styles during the designing of Alice's face, to make her look more haggard.

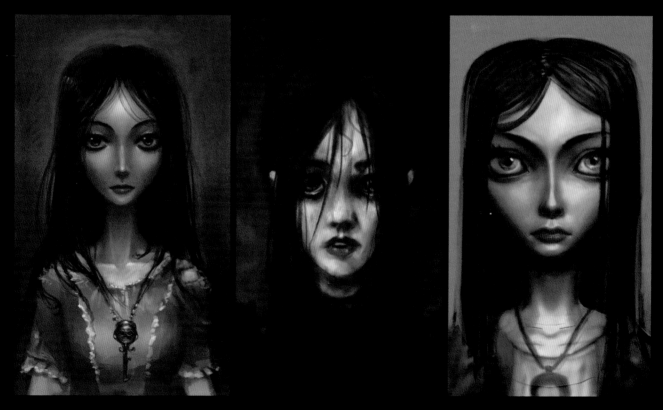

LEFT TO RIGHT: Sun GuoLiang, Ben Kerslake, Ken Wong. SGL: We really tried a lot of styles for Alice's face.

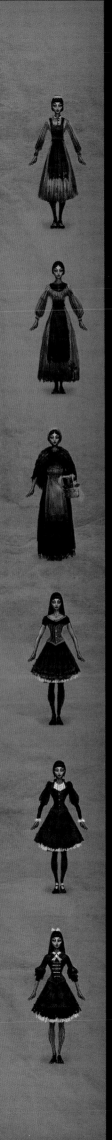

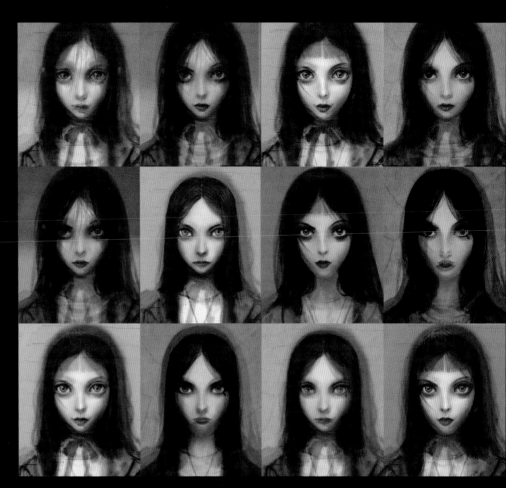

KW: Each of these images is a composite of different Alices by different artists, created to examine the different proportions and styles we were trying.

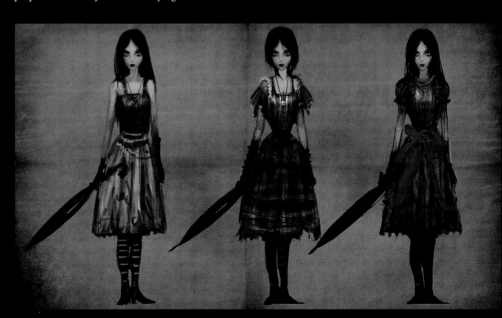

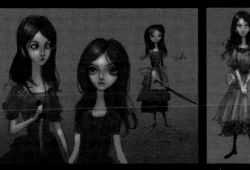 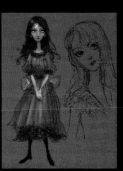

ABOVE: Sun GuoLiang. Alice's London costume. I realized later that these designs are too adult.

LEFT: Sun GuoLiang. Two Alice designs. You can see I tried many very different styles.

 ALICE AND HER DRESSES

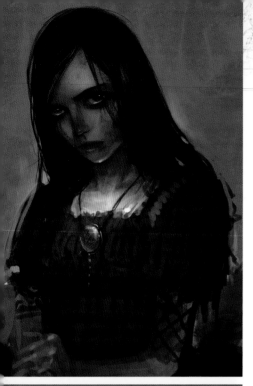

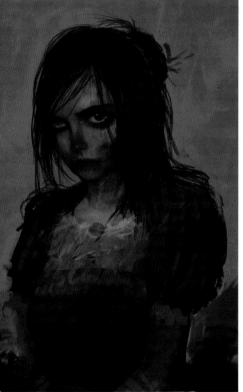

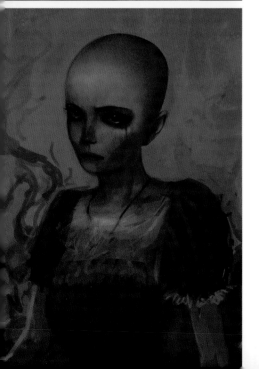

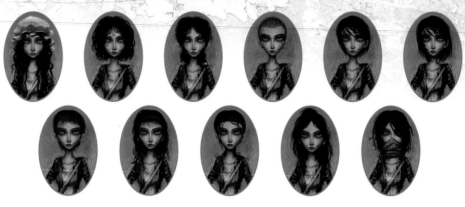

Sun GuoLiang. Alice's hairstyles. I felt like a professional stylist.

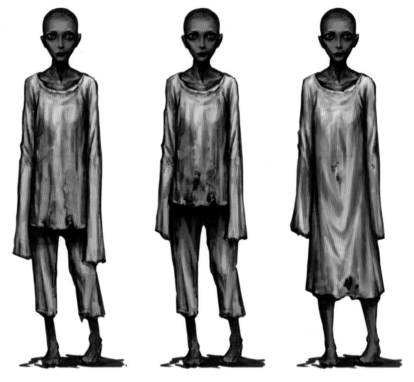

Nako. Alice in the asylum. I spent a lot of time on the details of her clothes.

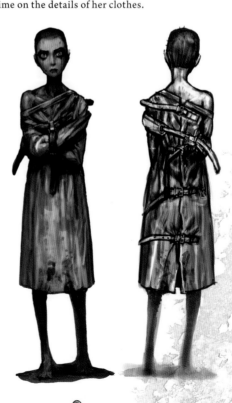

LEFT: **Sun GuoLiang.** Alice, more and more crazy. At last she cut off all her hair.

RIGHT: **Hong Lei.** *KW: The final design for "Asylum Alice."*

FACING PAGE: **Ben Kerslake.** An impressionistic take on Victorian London at night.

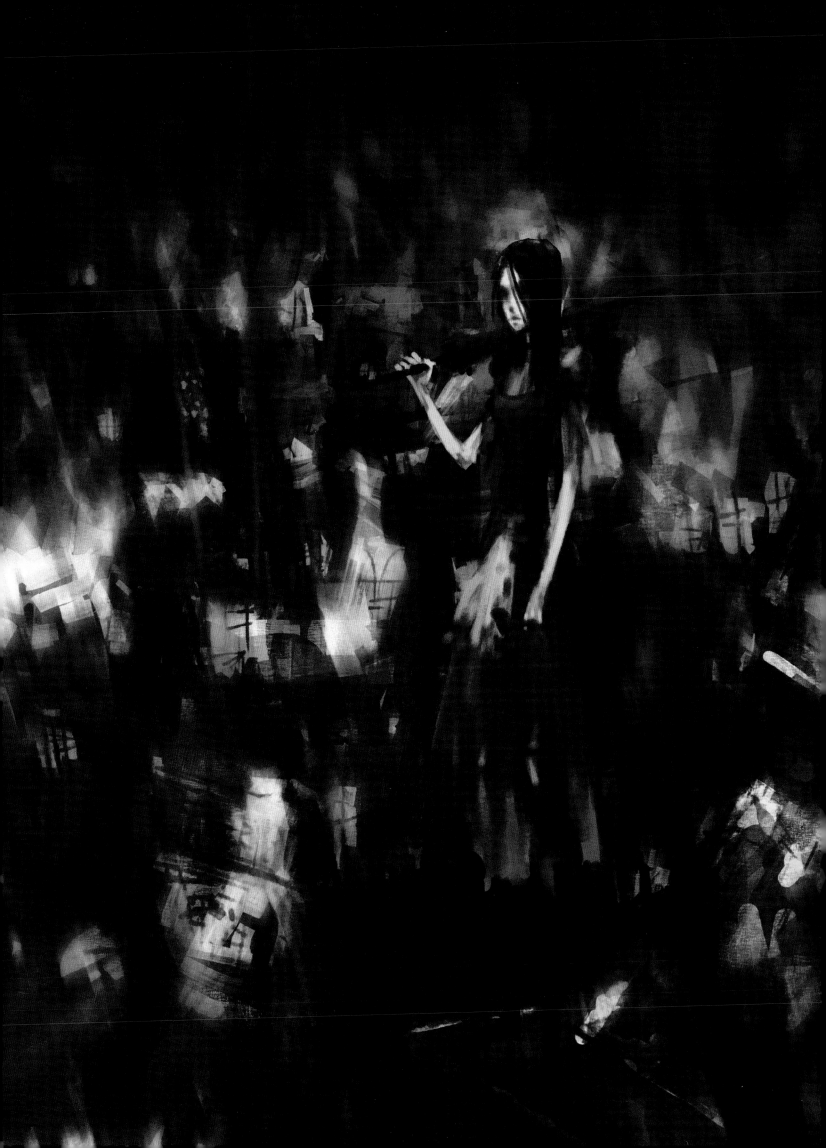

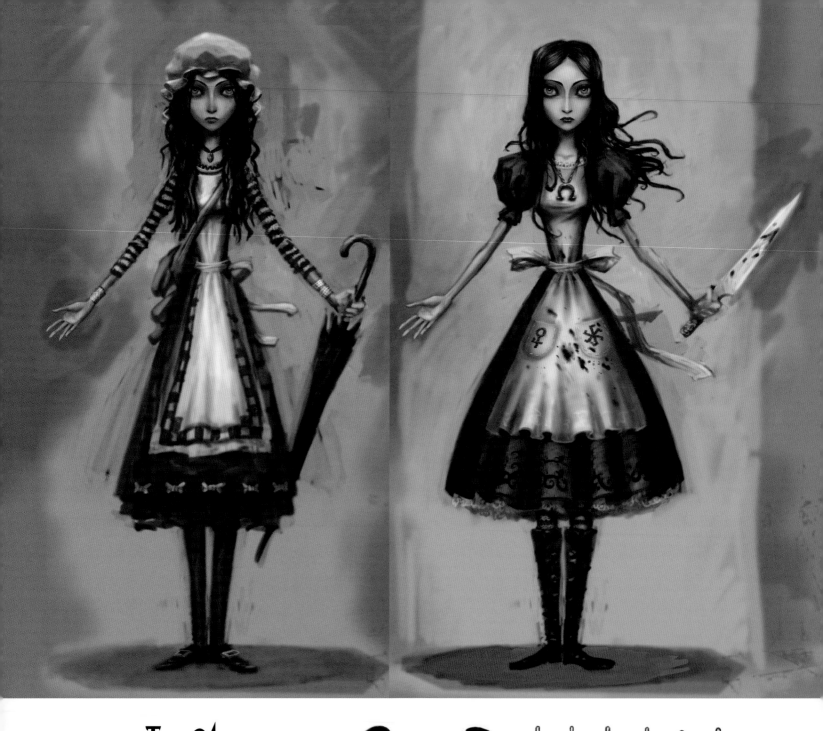

ERIS
*Is ruler of Strife
and Discord*

JUPITER
*Mind rising above the
Horizon of Matter*

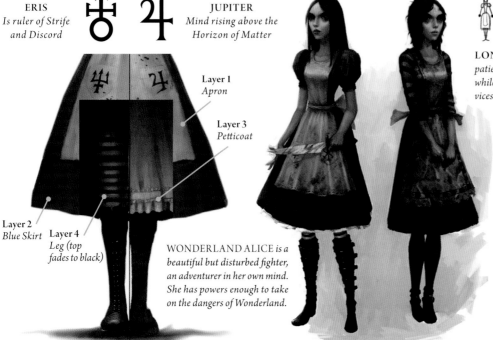

Layer 1
Apron

Layer 3
Petticoat

Layer 2
Blue Skirt

Layer 4
*Leg (top
fades to black)*

WONDERLAND ALICE *is a
beautiful but disturbed fighter,
an adventurer in her own mind.
She has powers enough to take
on the dangers of Wonderland.*

LONDON ALICE *is a fragile, recovering mental
patient. She struggles to maintain her grasp of reality
while dealing with the horrible daily life of London's
vices and industrial upheaval.*

ABOVE: Ken Wong. For quite a
while, this was the hero image of
Alice, even though nobody was
really happy with it. Her thinness
(or stylization) was particularly
contentious. Her London costume
remained mostly unchanged.

LEFT: Ken Wong and Jin Lei. *KW:
Alice's pocket symbols didn't mean
anything in the first game, so we
revised them for this one. The image
on the right was the final concept
art we argued about before we
started arguing full time about the
3-D model.*

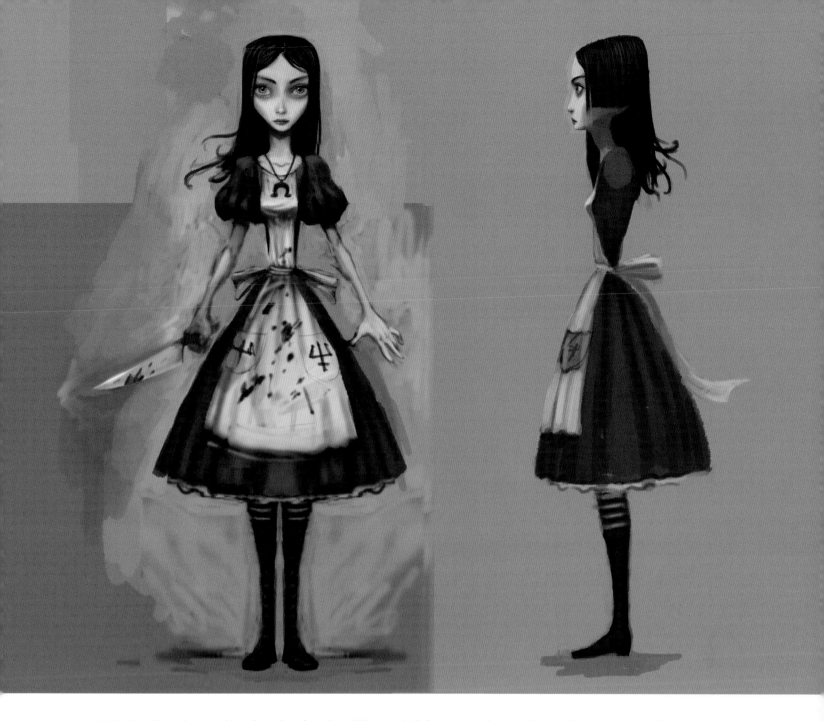

ABOVE: **Ken Wong.** I was pushing the style as far as I could here—which for some people meant I was pushing as far as possible in the wrong direction. BELOW: **Hong Lei and Jin Lei.**

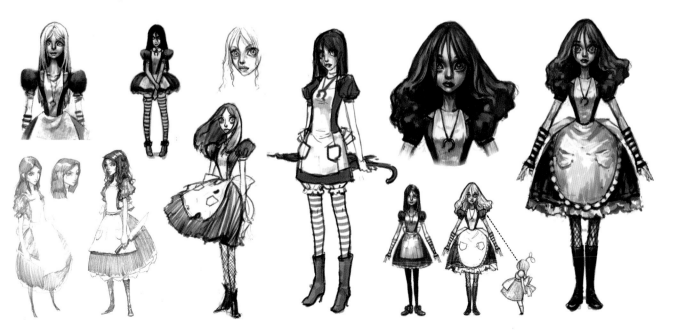

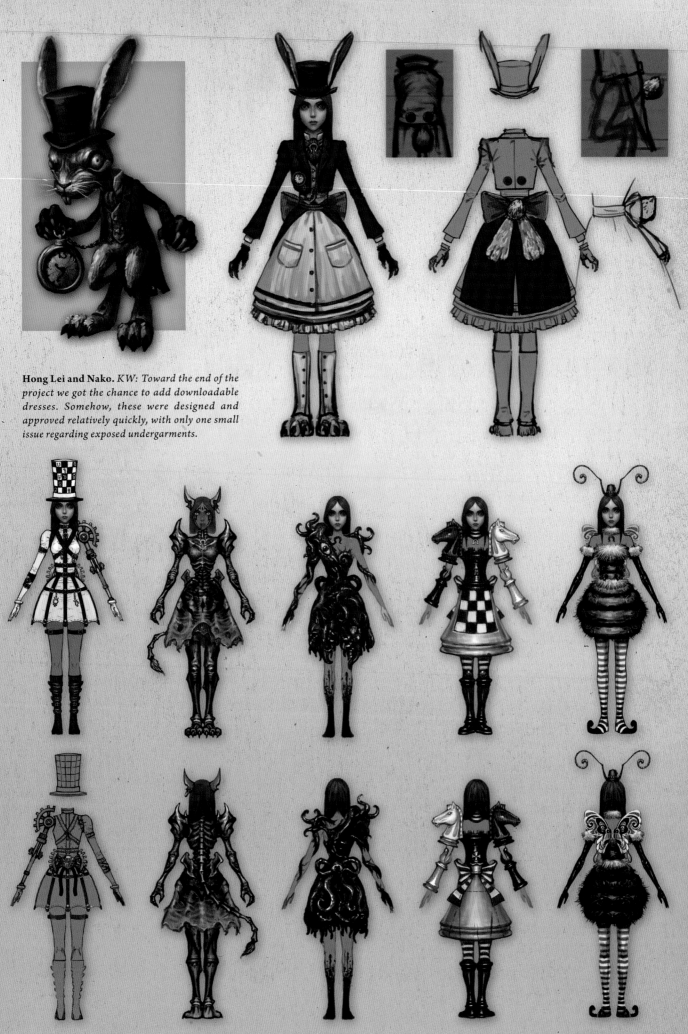

Hong Lei and Nako. *KW: Toward the end of the project we got the chance to add downloadable dresses. Somehow, these were designed and approved relatively quickly, with only one small issue regarding exposed undergarments.*

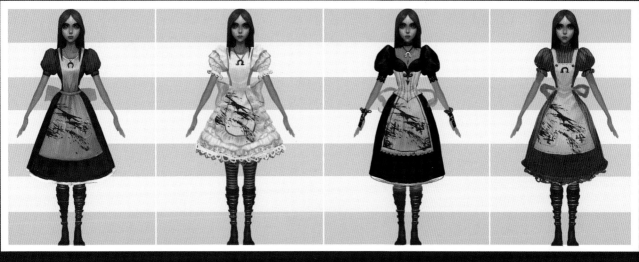

Hong Lei. *KW: These four dresses were the original lineup. Alice had four weapons, and when she switched weapons her dress also switched. It was a really cool thing to play with.*

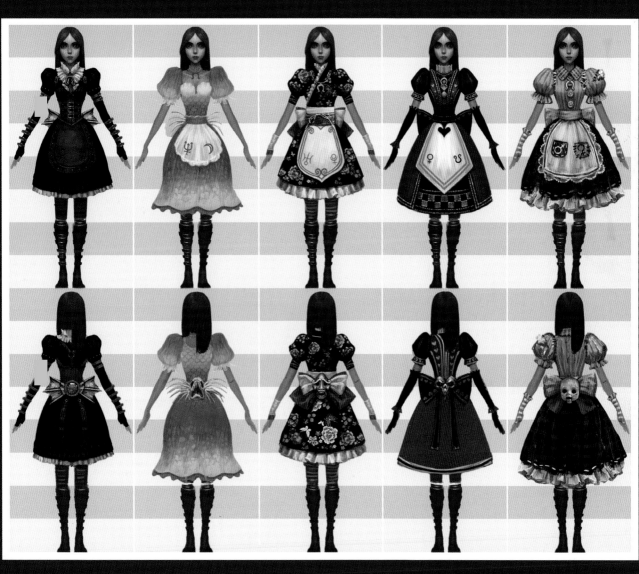

Hong Lei. *KW: Eventually we decided each Wonderland domain would have its own dress. The arguments over the design of these dresses were just as heated as over the original blue dress.*

KW: This was our first Alice model, created by Epic Games China.

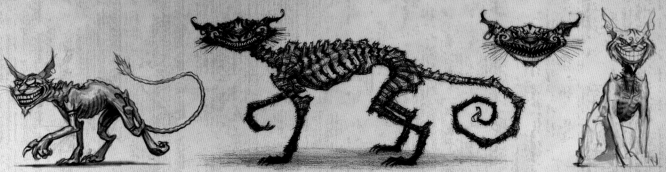

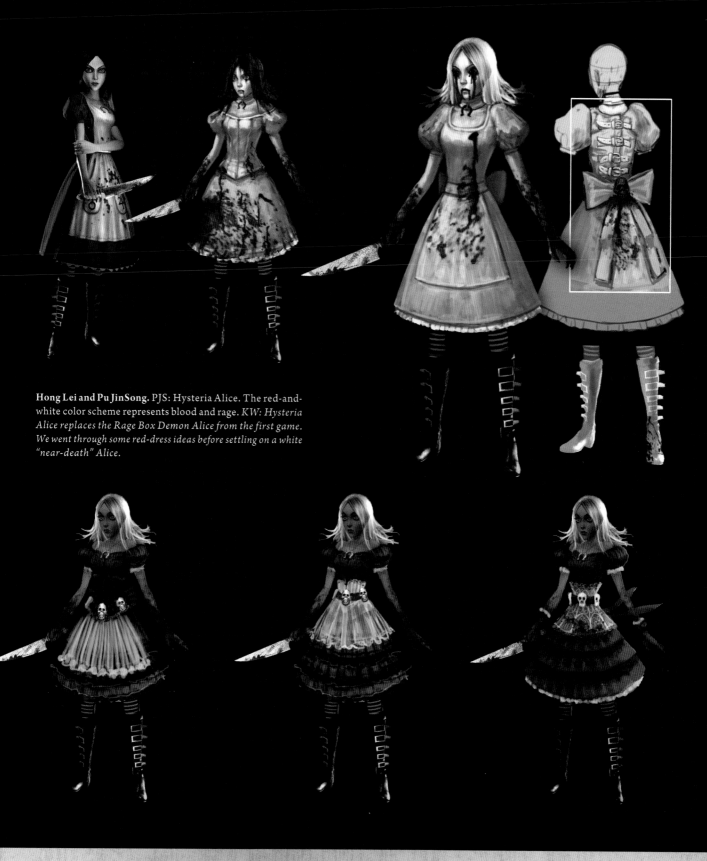

Hong Lei and Pu JinSong. PJS: Hysteria Alice. The red-and-white color scheme represents blood and rage. *KW: Hysteria Alice replaces the Rage Box Demon Alice from the first game. We went through some red-dress ideas before settling on a white "near-death" Alice.*

LEFT: Luis Melo. Paragliding with Alice's dress over steam vents is fun! We wanted to use that platforming element on several levels, coming from different sources. Here are a couple of aesthetic variations. *KW: Studies of what updrafts could look like in different Wonderland locations.*

BELOW: Luis Melo. What would Alice do if she grew to ten times her usual size? Get revenge, of course! These are some studies for the kind of irate actions Alice might take in this stage, not only against the common enemies, but also against big, otherwise-indestructible obstacles and even scenery. *KW: An exploration of the different ways Giant Alice could attack.*

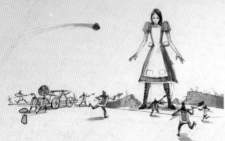
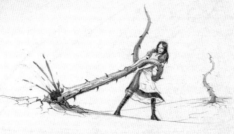
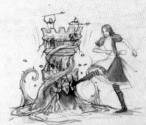

Alice eats the cake at the center of the Queen's maze and breaks out of it, onto some rolling hills outside the castle. Everything which before was threatening is now small and at her mercy.

She can pick up/pull things. The huge tentacles everywhere, which used to be deadly, can now be ripped from the root.

She also has a melee attack, a kick, since the world is now at her feet.

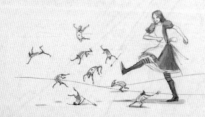
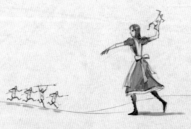

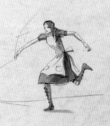

The Card Guards, however puny, are now swarming in large numbers, though. She has to keep fighting back, either by kicking . . .

. . . or by throwing them around and at each other.

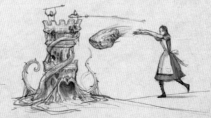

Heavy objects such as stones can also be picked up (same action button as to grab the tentacles and to pick up Card Guards) and thrown at enemies . . .

. . . or thrown at enemy outposts, as they deal a lot more damage than if she kicks them down.

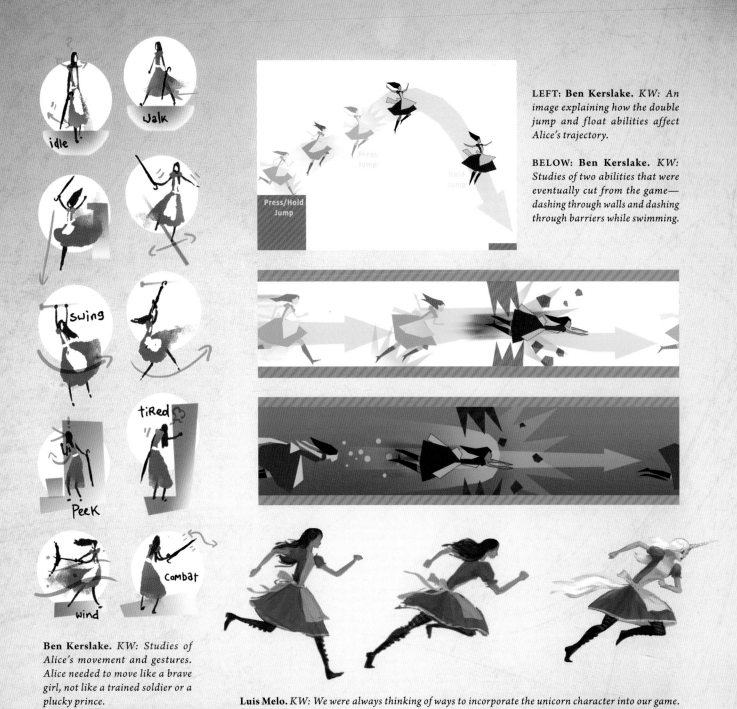

idle

walk

swing

tiRed

Peek

wind

combat

LEFT: **Ben Kerslake.** *KW: An image explaining how the double jump and float abilities affect Alice's trajectory.*

BELOW: **Ben Kerslake.** *KW: Studies of two abilities that were eventually cut from the game— dashing through walls and dashing through barriers while swimming.*

Press Jump

Hold Jump

Press/Hold Jump

Ben Kerslake. *KW: Studies of Alice's movement and gestures. Alice needed to move like a brave girl, not like a trained soldier or a plucky prince.*

Luis Melo. *KW: We were always thinking of ways to incorporate the unicorn character into our game.*

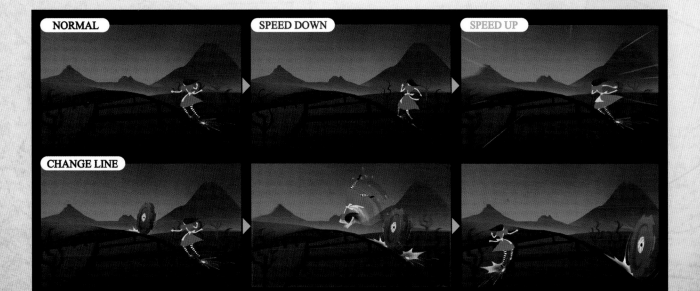

NORMAL

SPEED DOWN

SPEED UP

CHANGE LINE

Pu JinSong. Interaction with the rails, a speed-based minigame.

ALICE AND HER DRESSES

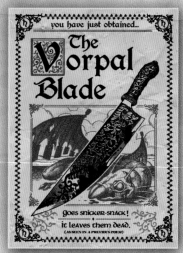

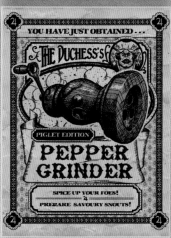

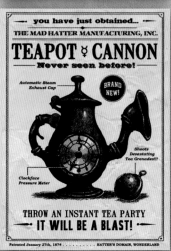

WEAPONS

ALICE'S SET OF WEAPONS underwent considerable change during the course of the project. Initially, she had four sets of weapons that corresponded to the suits of the Tarot. This turned out to be too limiting, so we left the Tarot behind and evolved the designs we have now. Each weapon can be upgraded three times into more powerful versions. One guiding principle is that we wanted the weapons to be bizarre and surreal, not anything you might find in a conventional fantasy world.

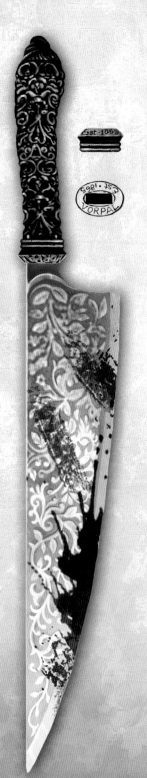

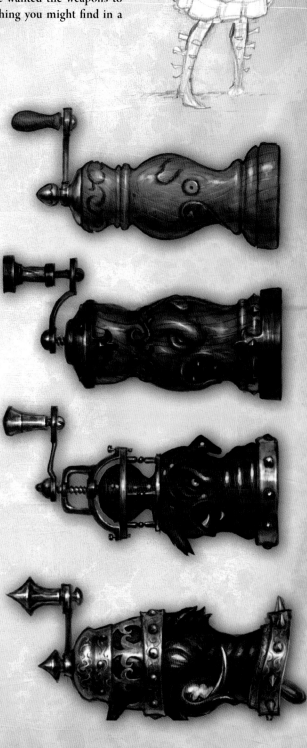

POSTERS: **Luis Melo.** Whether products of London, Wonderland, or both, we chose to introduce the weapons as fabulous devices of Victorian technology. These are the ads for them, and as you may experience in the game, the gadgets live up to the hype. VORPAL BLADE: **Pu JinSong.** PEPPER GRINDER: **Nako.**

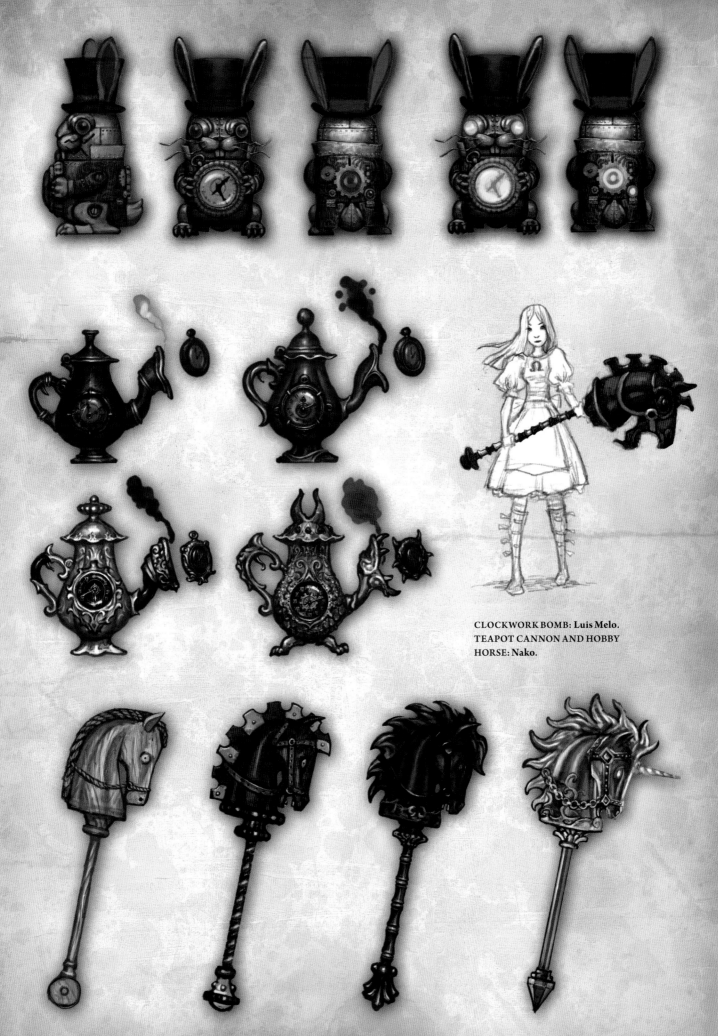

CLOCKWORK BOMB: Luis Melo.
TEAPOT CANNON AND HOBBY
HORSE: Nako.

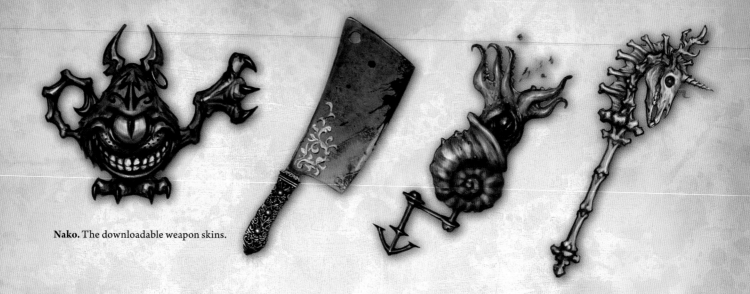

Nako. The downloadable weapon skins.

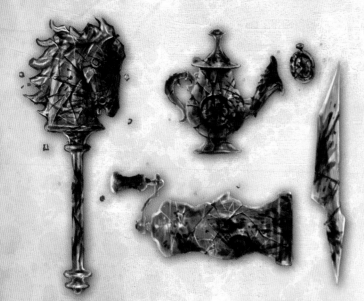

Nako. *KW: Unused designs for Hysteria weapons.*

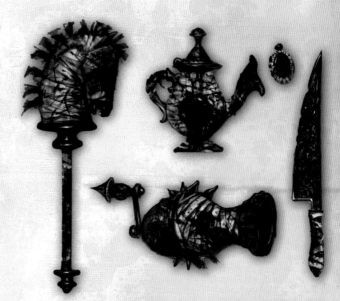

Nako. *KW: The weapons Alice uses as Hysteria Alice.*

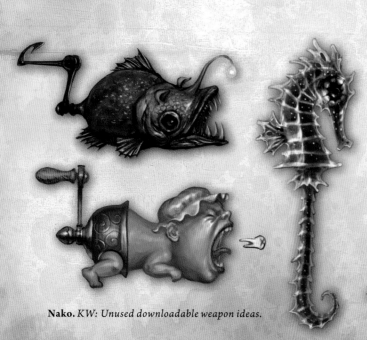

Nako. *KW: Unused downloadable weapon ideas.*

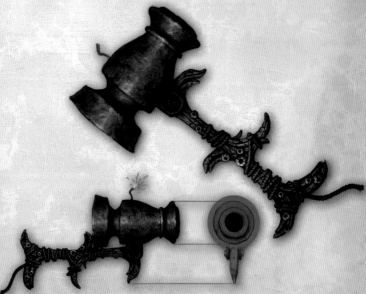

Luis Melo. A weapon devised by the Carpenter, combining a sunken ship's cannon with a hammer's handle. It doubles as a heavy-range weapon and a powerful hammer for close range.

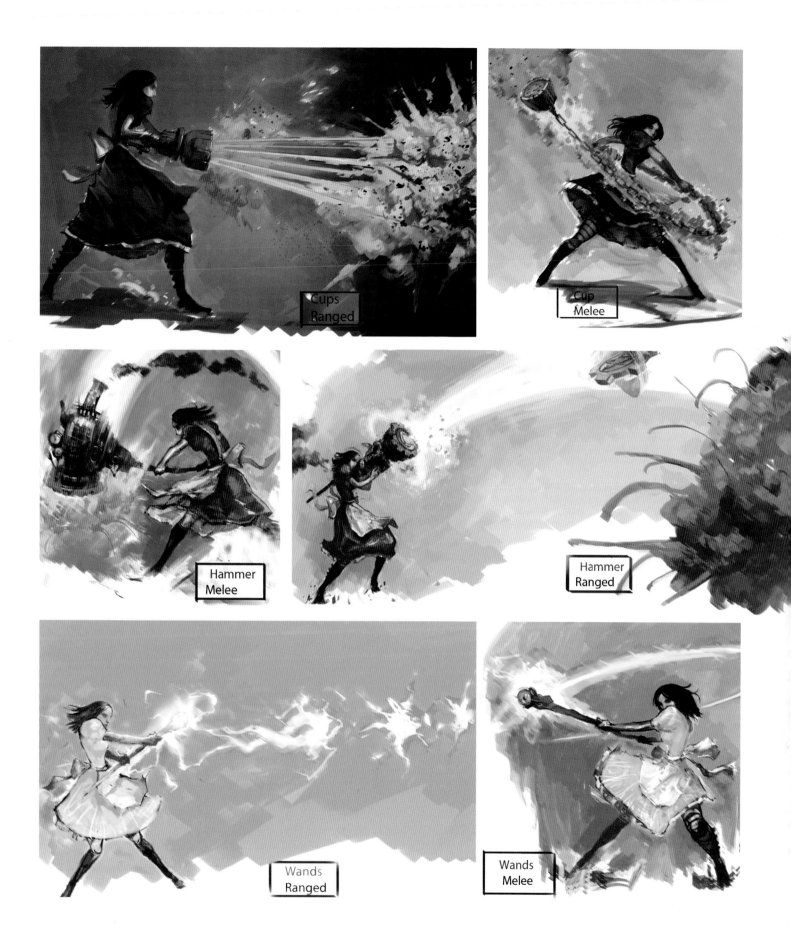

Jin Lei. *KW: Action shots of the old Tarot-based weapons.*

Sun GuoLiang.

LONDON

FROM the very beginning of the project, American wanted to explore Alice's world outside of Wonderland—the Victorian London of her waking life. London in 1875 was not a pleasant place. The Industrial Revolution tore up the streets, put children to work in factories, and soiled the sky with acrid clouds of black smoke; poverty, crime, and disease marched through the streets. The more we found out about the real Victorian London, the more we found we didn't need to fictionalize it.

We wanted players to be able to see, breathe, and smell this seething city. For visual reference, we were particularly inspired by the muck-filled, textural Paris of Perfume, and by the stunning set design and lighting of Oliver! (1986). We also drew from Roman Polanski's 2005 Oliver Twist, David Lynch's The Elephant Man, and the recent Sherlock Holmes. We also collected reference files of architecture, fashion, and graphic design from the period and studied maps for areas that could make compelling environments.

Compared to Wonderland, Victorian London is a gray, desaturated place—low contrast and smoggy. All the wood is half-rotten, every brick wall is caked in soot, and all of the streets are covered in unspeakable filth. Our approach to London's environmental art focused on bringing out these qualities in the materials, through concept art, texture, shading, and geometry. We attempted to break and sag every straight line, and fill every empty space with a little debris or refuse. At the same time, we had to be cautious not to make scenes overly noisy or crowded with objects. Splashes of color were necessary to stop scenes from dissolving into a brown-and-gray mess.

Like The Wizard of Oz, we wanted Alice's experiences in Wonderland to be hinted at or foreshadowed in the "real world." Observant players can find lots of subtle (and not so subtle) links between the two worlds.

The people of London were just as important as the streets and buildings they inhabited. Criminals, street urchins, and other unsavory elements prowl the shadows. Shop owners clamor for customers. Bar patrons brawl and chat up whores. We did many sketches to try to find our anatomic style, eventually gravitating toward an exaggerated, caricatured look. Just like with the environment, we wanted to play up the textural elements—frayed, stained clothes, wrinkled and aged skin, tousled hair. We drew inspiration from collector toys, Victorian caricatures, and prosthetics work like that used for Hoggle in Labyrinth.

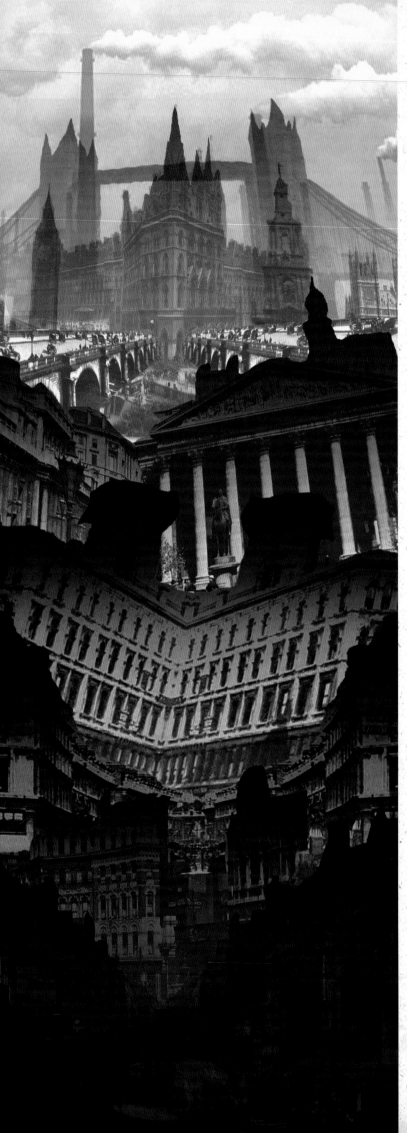

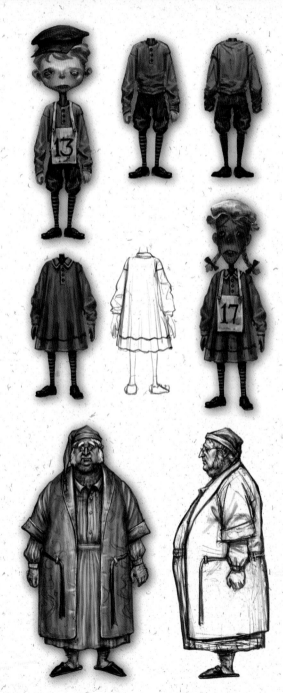

CLOCKWISE FROM LEFT: Tyler Lockett, Tyler Lockett, Hong Lei, Nako. N: Designing the lawyer was pretty easy. I understood the idea from the director quickly. The main points were that he was fat, kind, and wore pajamas.

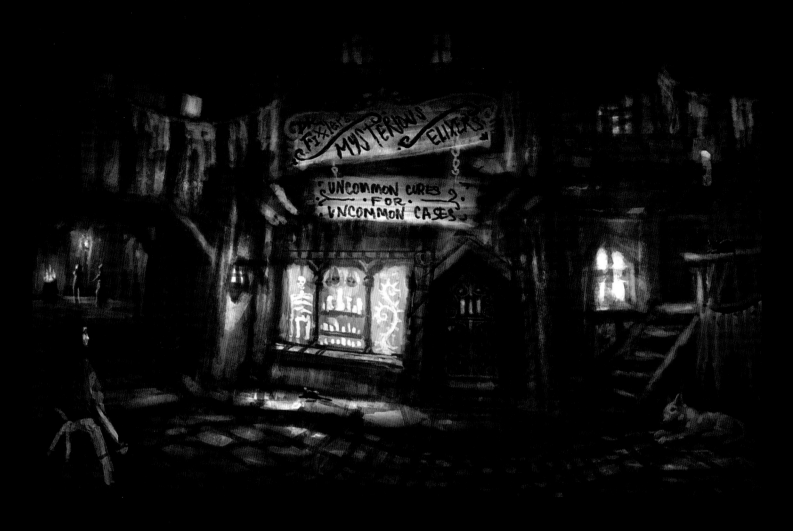

ABOVE: **Tyler Lockett.** Alice visits a mysterious hidden shop for alternative medicine. BELOW: **Tyler Lockett.** An interior sketch of Dr. Fixxler's.

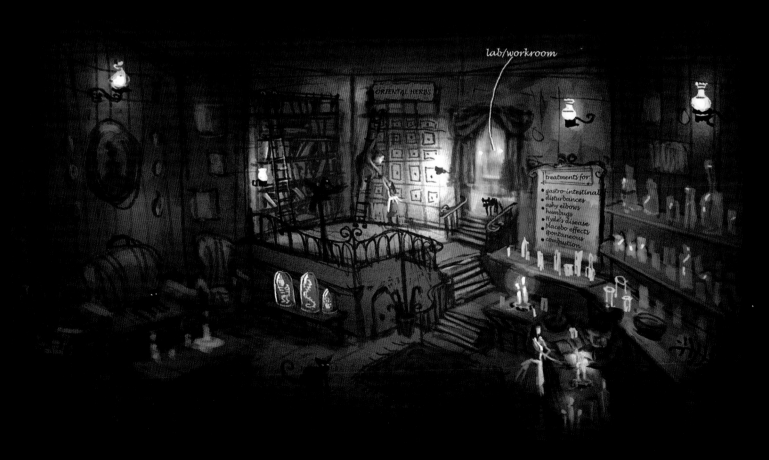

Nako. The jail has two parts: the upper one is the "real" London jail, and the other one is a chaos version when Alice becomes mad.

THE ART OF *ALICE: MADNESS RETURNS*

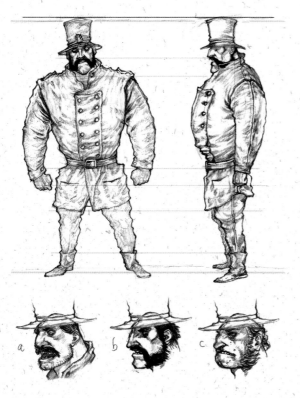

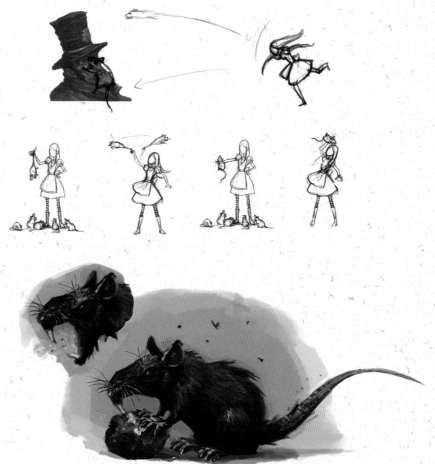

TOP LEFT: Jin Lei. TOP RIGHT: Hong Lei.

BELOW: Jin Lei. *KW: These are studies for the interior of Bumby's house.*

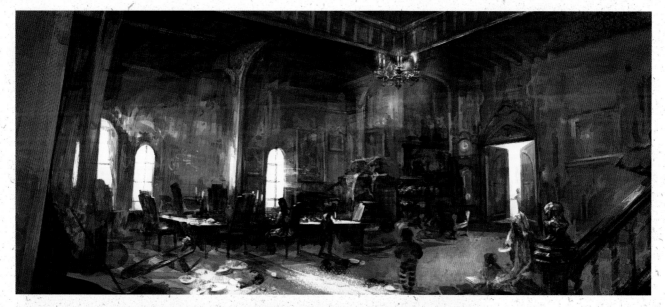

FOLLOWING PAGES: Jin Lei. *KW: Character designs. The bottom image served as a sort of style guide for the London humans. We wanted to make them exaggerated, like caricatures.*

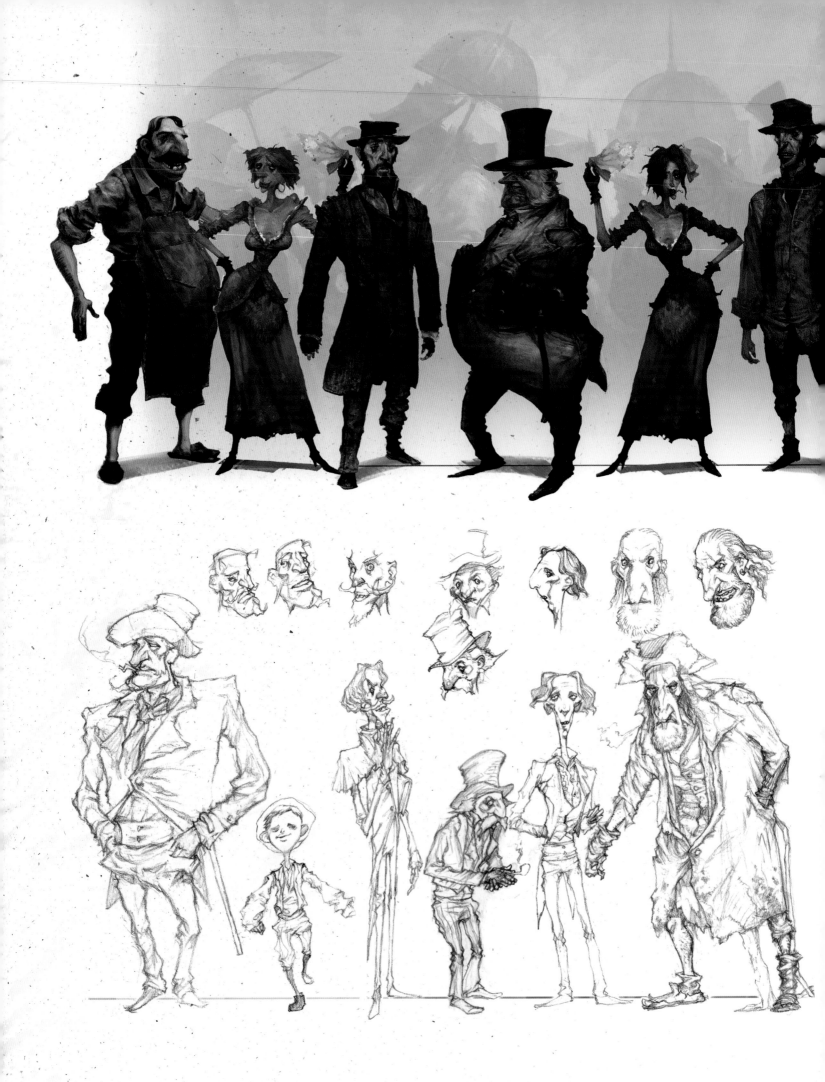

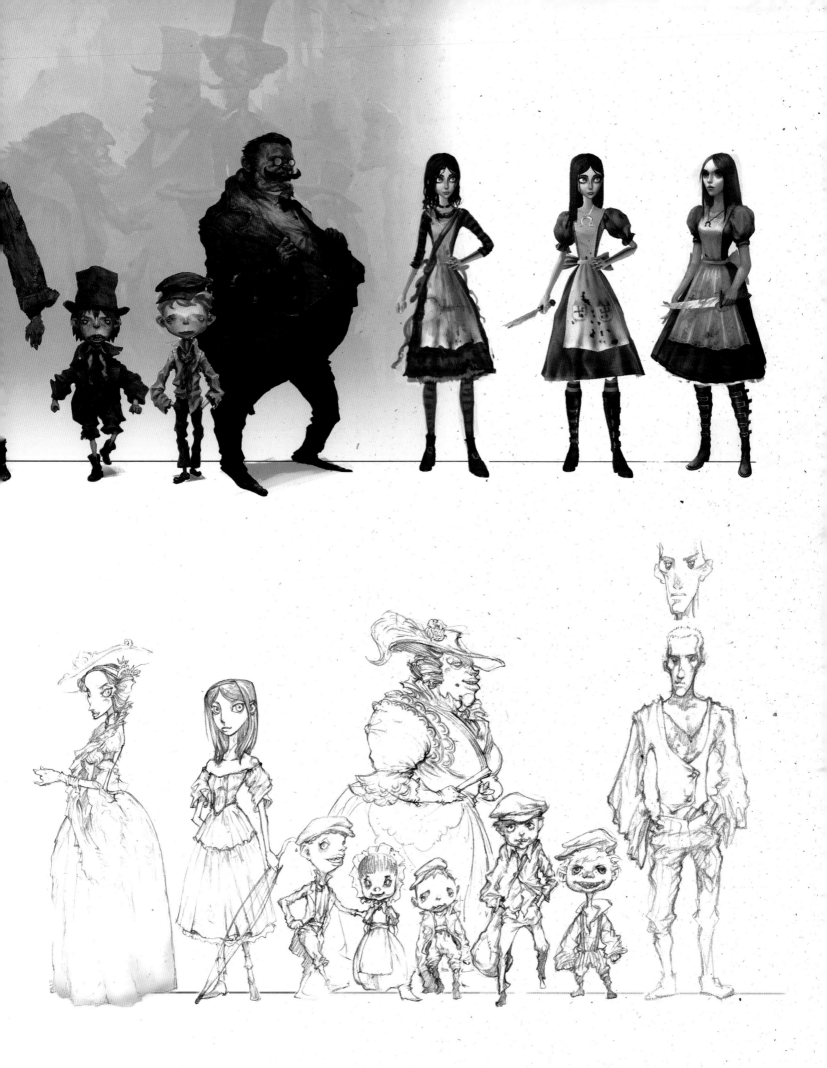

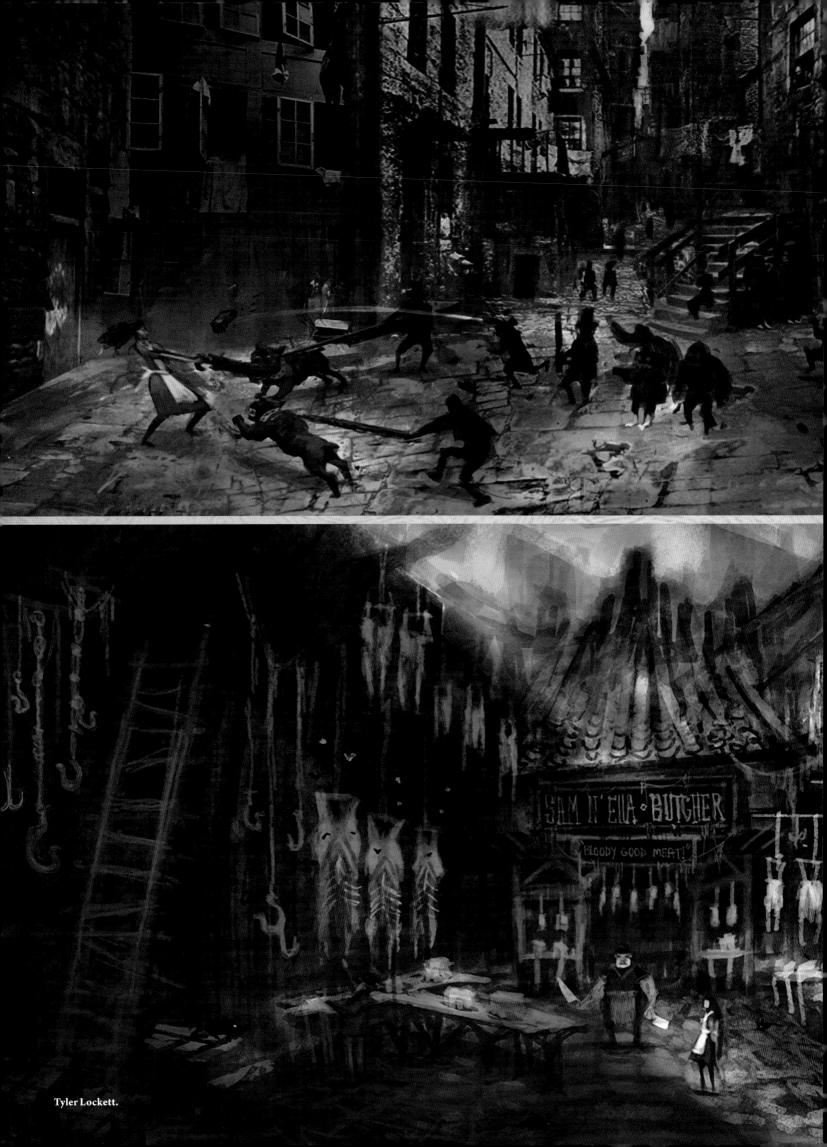

Tyler Lockett.

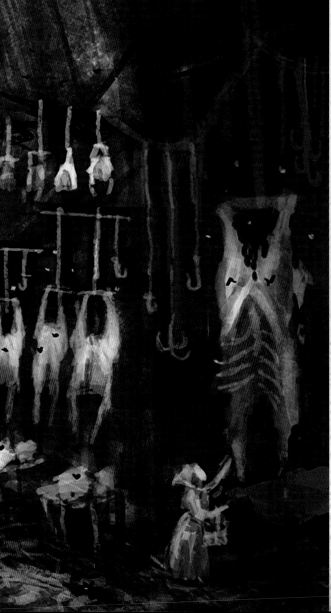

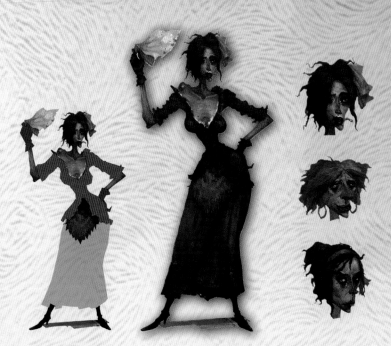

Hong Lei. *KW: Most London characters were designed with multiple heads and the ability to change the color of their clothes.*

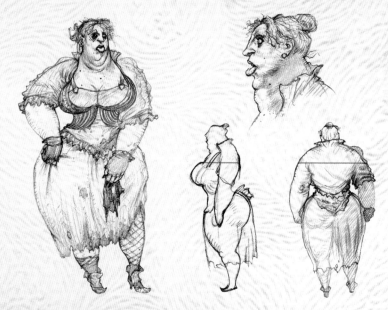

Jin Lei. *KW: The Nanny. Originally a prostitute, she was later upgraded to a madam.*

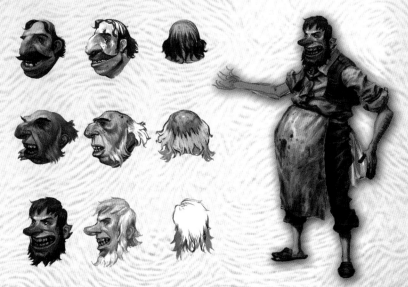

Luis Melo. The street merchants in London—nothing honest, intelligent, or clean about them, however you may switch their heads around.

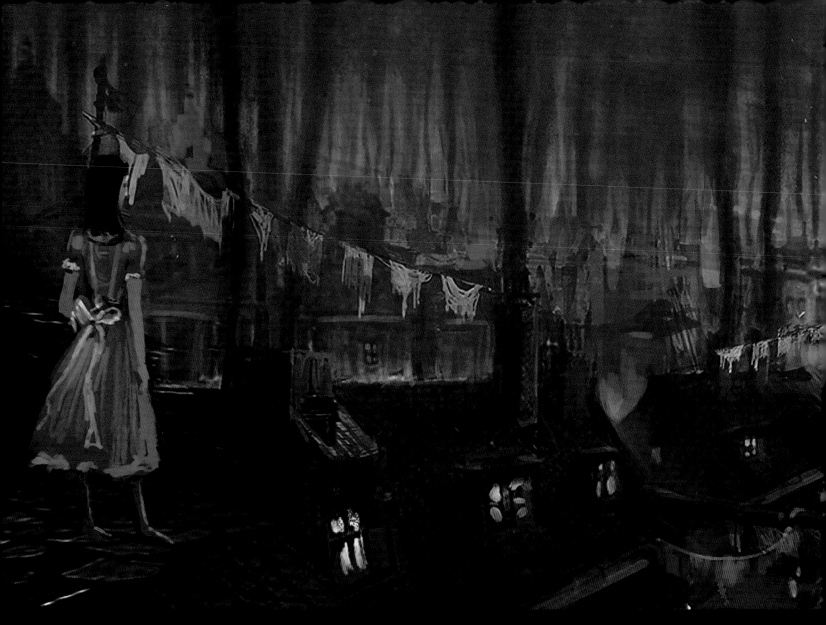

Sun GuoLiang. Alice on top of a London house, based on Tyler's art. It looks quite good.

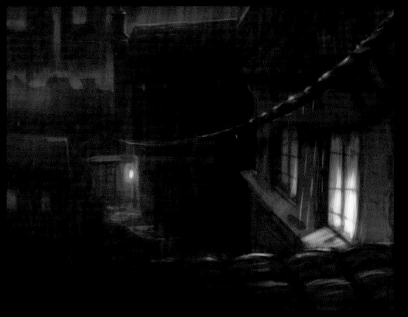

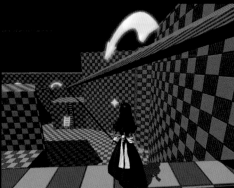

Sun GuoLiang. *KW: Early on we tried designing environments as "white boxes," including indicators for where gameplay should occur. An artist then did a "paint-over" of these scenes to design the visuals. We didn't find a lot of success in this approach, and had more success giving semifinished scenes to the artists to improve set dressing and lighting or to design hero pieces.*

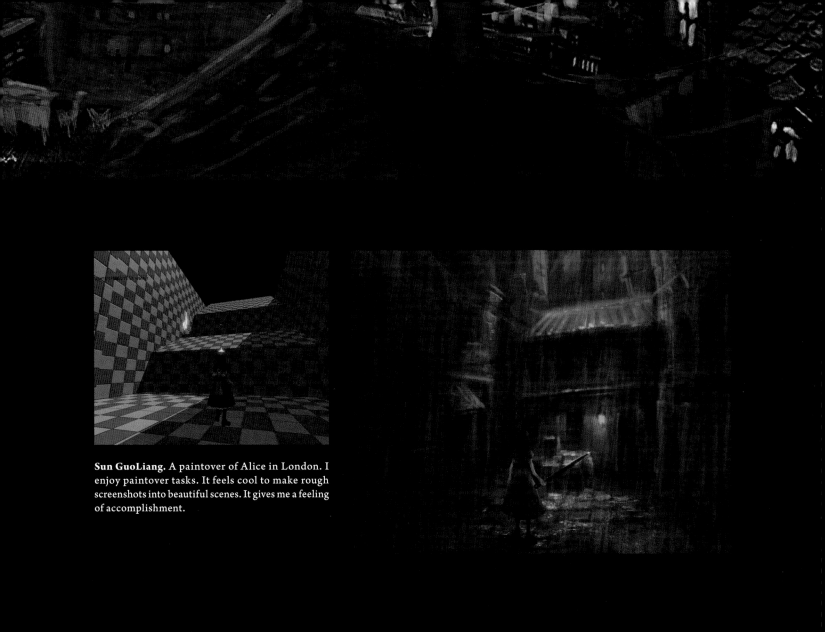

Sun GuoLiang. A paintover of Alice in London. I enjoy paintover tasks. It feels cool to make rough screenshots into beautiful scenes. It gives me a feeling of accomplishment.

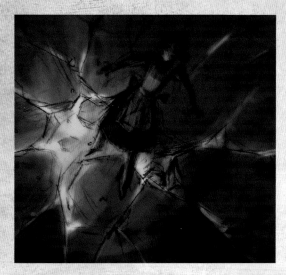

TOP: Tyler Lockett. *KW: The Mangled Mermaid scene in the game doesn't stray too far from the original concept art.*

ABOVE AND RIGHT: Nako. The transition to Wonderland. When Alice enters Wonderland, she is in a familiar scene that she remembers from when she was a child. But later she sees something new, a lot of dolls and train parts, in dark smoke. This lets the players know that Alice will experience a whole new adventure.

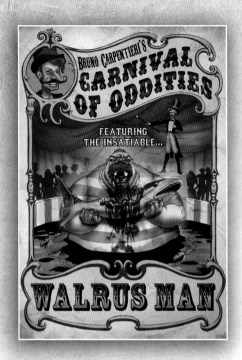

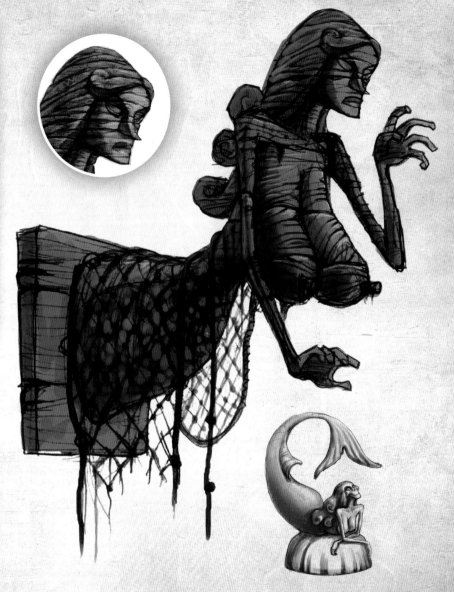

TOP: **Tyler Lockett.** A brawl erupts outside the Mangled Mermaid.

ABOVE: **Luis Melo.** Everything in Wonderland has a "real" London counterpart. The Carpenter's twisted musical is too twisted to be fabricated by even Alice's mind alone. She must have seen something in real life that impressed her a great deal. Maybe just the poster for a freak show featuring the insatiable Walrus Man was enough material to feed her nightmares. *KW: A hint of things to come.*

RIGHT: **Yuan ShaoFeng.** *KW: Decorations for inside the Mangled Mermaid.*

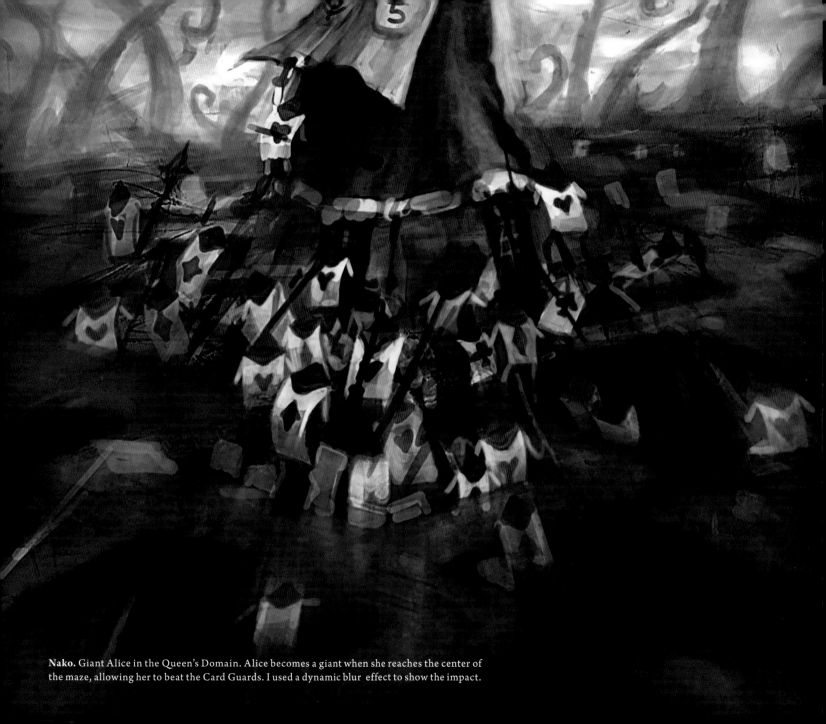

Nako. Giant Alice in the Queen's Domain. Alice becomes a giant when she reaches the center of the maze, allowing her to beat the Card Guards. I used a dynamic blur effect to show the impact.

WONDERLAND

WONDERLAND is split into several main areas, which we came to call "domains," plus a few smaller areas to break up the pacing. Some Alice has visited before; others were designed as entirely new experiences, with some familiar faces to guide the way.

The world design of the *Star Wars* and *The Lord of the Rings* movies heavily influenced the art direction. Each domain is strongly built around specific colors, materials, and shapes, controlled through style guides and color scripts. I wanted to keep a lot of variation between locations to give each a distinct, unique atmosphere.

Designing Wonderland was both incredibly fun and hugely challenging for the Spicy Horse concept-art team. We were excited about creating a psychological dream space where anything goes—we could break the rules of logic, gravity, geography, architecture, and consistency and still have it all work as a surreal, compelling environment. Everything in Wonderland is amplified and mutated by Alice's disturbed imagination, filtered through her uniquely insane understanding.

However, we soon found we all had different ideas of what should be considered *our* Wonderland or *our* Alice. It became apparent to us that the world we set out to create *did* have certain lines that couldn't be crossed, and we spent hours arguing about what those lines were. Eventually we came up with a somewhat rough guide, including:

—Keep things bold and simple. Don't overdesign.
—Anything Alice experiences in Wonderland comes from something she's seen or read or heard about in London.
—Avoid demons or other religious content.
—Keep designs "Alice"—feminine, artistic, and playfully surreal.

Still, the issue of tone was never put to rest. We had to craft an experience for both die-hard fans of *Alice*, and for people who own Xboxes and PlayStations. How dark was *dark enough*? Were butterflies okay? Were dead babies okay? Were we going too colorful? Not colorful enough? The pressure was only increased knowing we would be compared against both the original game and the upcoming big-budget film from Tim Burton and Disney. Not to mention the scores of other *Alice* works in film, stage, and illustration.

Looking back over all this art from the past two and a half years, I find myself incredibly proud of how each artist rose to the challenge, developing skills they never knew they had, to spin out this fantastically rich, horribly devious world of imagination and nightmares. I'm similarly very sad we didn't get to include more of these amazing designs in the game. Some were cut because of time, others because of technical challenges, and some because they just didn't quite fit the direction the game was moving in at the time.

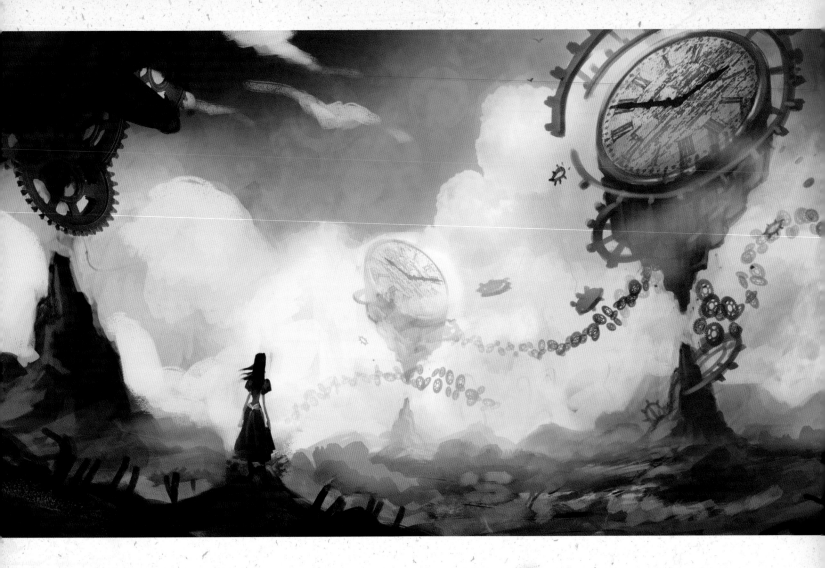

VALE OF TEARS

THE VALE OF TEARS was originally conceived as the last happy remnant of Alice's original Wonderland. It's a lush forest filled with mushrooms, flowers, and childhood toys. As the story developed we realized we wanted to return to the Vale after the Infernal Train had defiled it.

Our initial concept of the train's destruction was like a ground-splitting earthquake, inspired by "The Nothing" in *The NeverEnding Story*. We also introduced elements of the train—oil, smoke, ash, and fire. Finally, the sky became a swirling, fiery maelstrom, with red lightning inspired by photographs of the eruption of Eyjafjallajökull, the volcano in Iceland.

Nako. The mock sparrows have different personalities. The male ones are fierce and agile and love fighting. To make this more obvious I gave them red feathers, sharp horns, and cruel eyes. The female ones are mild and look clumsy and weak, but when they are angry, even the bulls feel fear.

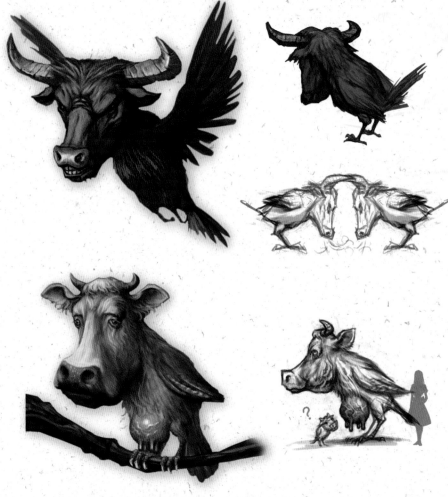

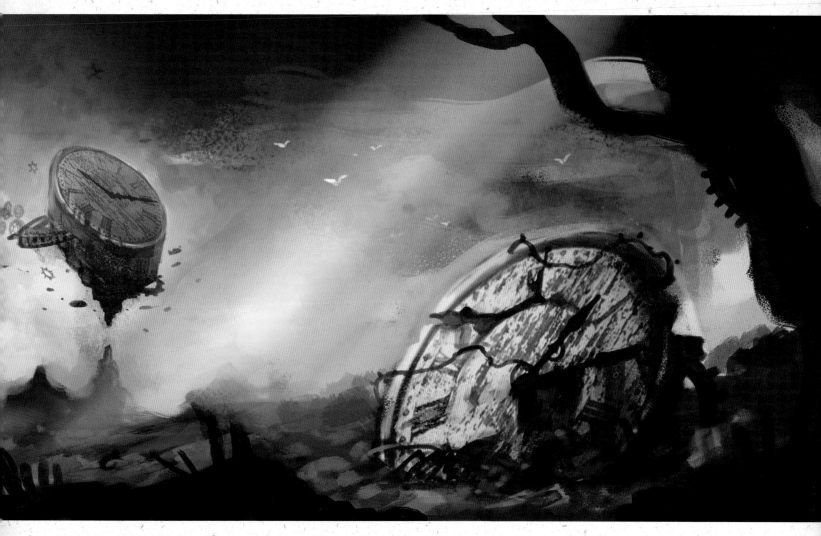

Sun GuoLiang. This is one of my designs for Wonderland, a floating clock mountain, with a lot of clock parts around it. Alice is standing near the forest, looking at the mountain. The adventure is about to begin!

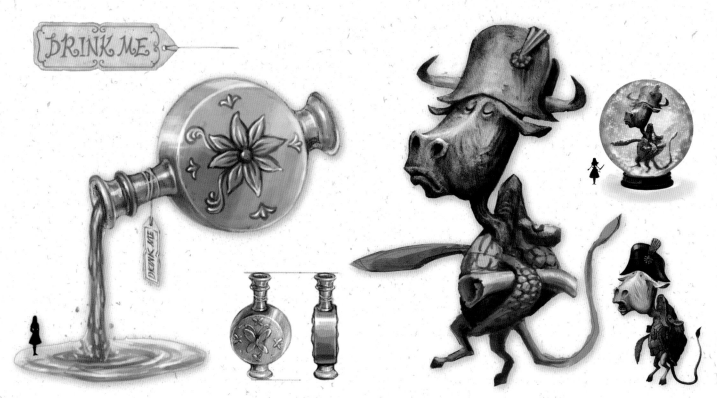

Nako. Everybody is familiar with the "drink me" bottle, which can make Alice small. We originally used a butterfly pattern on it, but switched to a flower pattern once the "shrink flower" came about. This flower will appear later in the game. I made the water purple so that it looks more magical.

Sun GuoLiang. Ken asked me to depict the Mock Turtle standing inside a snow globe and holding a chart. I was interested in this task, and finally both Ken and I were satisfied with this design. *KW: This Mock Turtle design is based on a painting I did in 2005.*

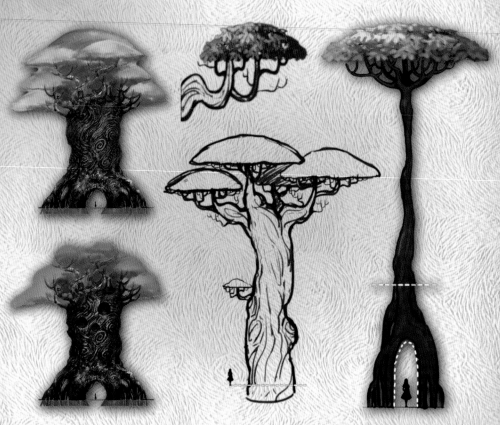

Jin Lei and Hong Lei. HL: This is a tree for the Vale of Tears.

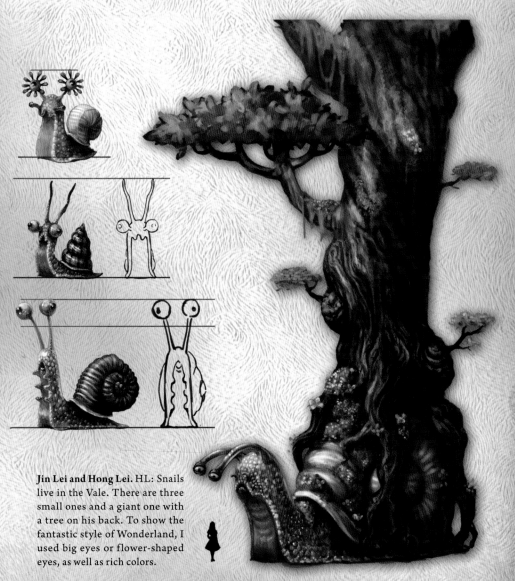

Jin Lei and Hong Lei. HL: Snails live in the Vale. There are three small ones and a giant one with a tree on his back. To show the fantastic style of Wonderland, I used big eyes or flower-shaped eyes, as well as rich colors.

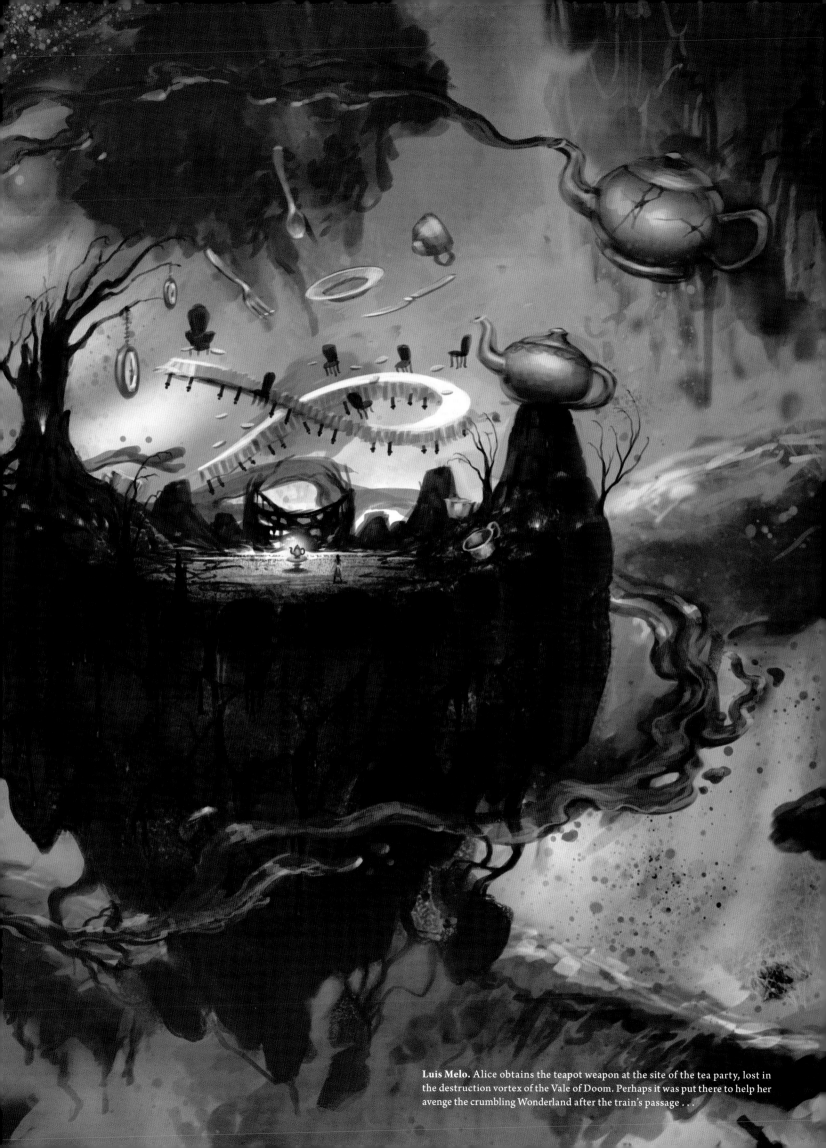

Luis Melo. Alice obtains the teapot weapon at the site of the tea party, lost in the destruction vortex of the Vale of Doom. Perhaps it was put there to help her avenge the crumbling Wonderland after the train's passage . . .

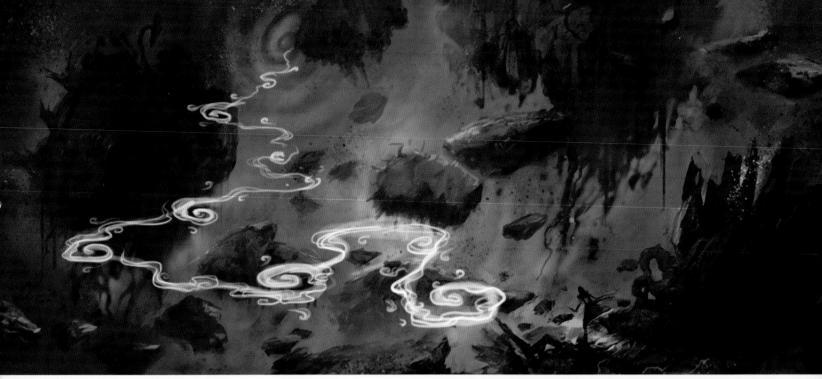

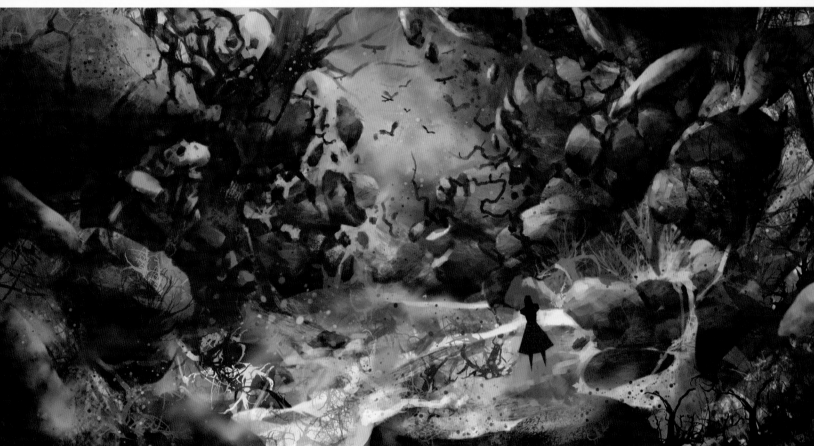

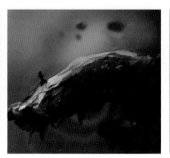

Jin Lei. KW: *These drawings were done to portray the transformation of the Vale of Tears into the Vale of Doom.*

 THE ART OF *ALICE: MADNESS RETURNS*

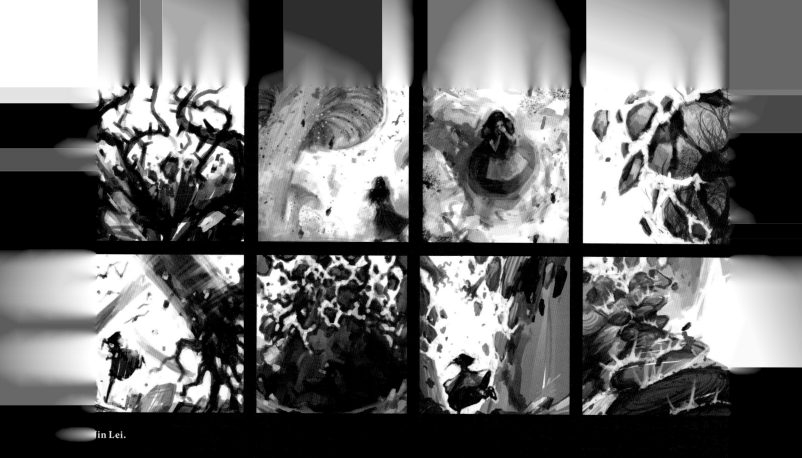

in Lei.

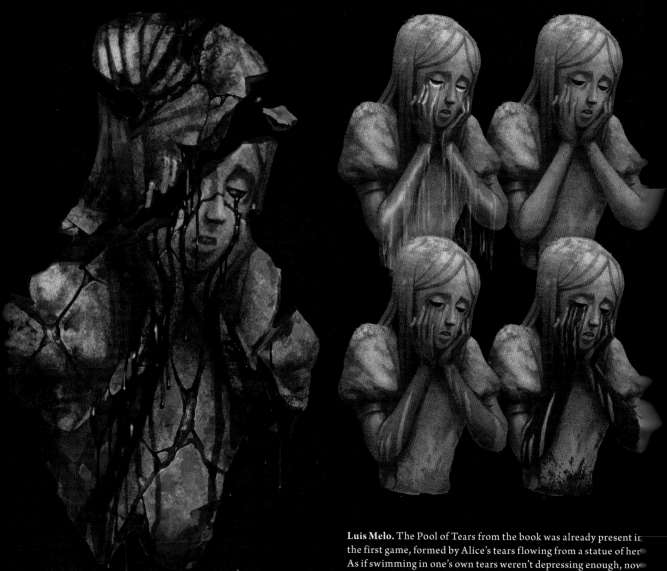

Wu YueHan

Luis Melo. The Pool of Tears from the book was already present in the first game, formed by Alice's tears flowing from a statue of her. As if swimming in one's own tears weren't depressing enough, now Alice starts crying blood . . . what could that mean? *KW: I think if we had time we would have included a lot more self-images of Alice throughout her subconscious landscape.*

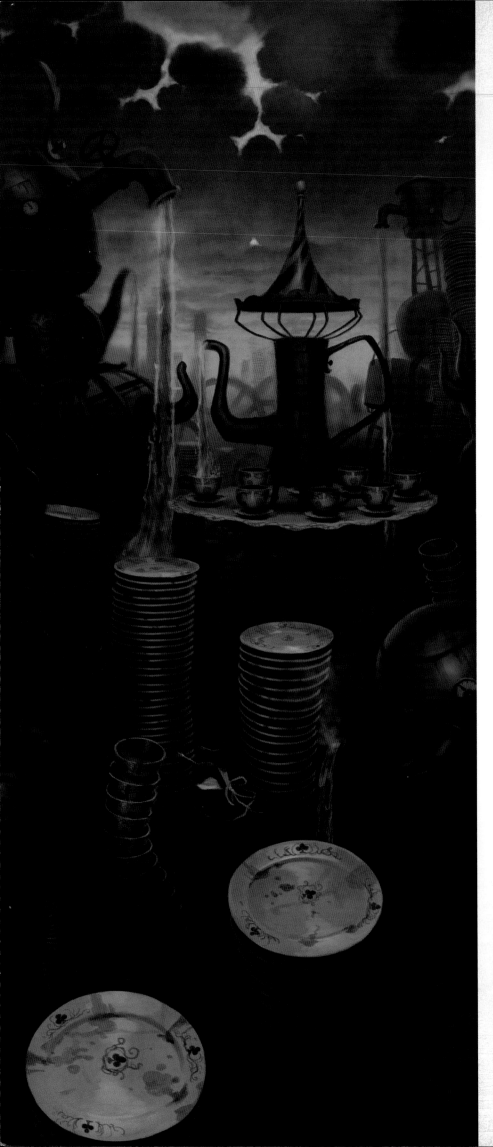

HATTER'S DOMAIN

WE KNEW FROM the beginning that Alice would return to the domain of the Mad Hatter. Not only is he an iconic, fun character, but his environment and lore allow for a lot of really cool imagery.

In the original game, we meet the March Hare and the Dormouse, victims of the Hatter's cruel, mechanical torture experiments. They urge Alice on to the end of the level where Alice battles the Hatter himself on a giant clock face.

For this second visit, our early idea was that the freed March Hare and Dormouse had taken over the domain. To proceed in her quest, Alice would need to seek out the lost pieces of her former foe, the Mad Hatter, and they would forge an uneasy alliance in order for Alice to discover the next stage in her quest, and for the Hatter to reclaim his domain from its new rulers.

When the Infernal Train was introduced, we decided that the Hare and Dormouse had been tricked into turning the Hatter's delicate, precise clockwork into a factory for creating the Infernal Train. This mirrored the Industrial Revolution occurring in Alice's real world. As we designed, we started to make a distinction between the original, ornate style of the Hatter's domain and the crude, industrial style of the new rulers.

Luis Melo. Another tea party–inspired image, from the section of the book in which Alice finds piles of dirty cups and dishes. It would be a part of the Hatter's Domain, and gameplay would involve tricky platforming balance on very unstable grounds. *KW: At one point we tried to create this level quite literally, but the plate towers posed a huge technical challenge. It eventually evolved into the area now known as Always Elevenses.*

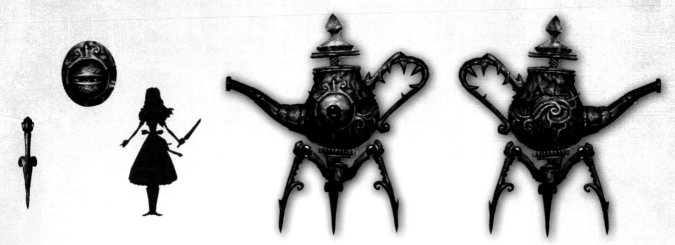

Sun GuoLiang. The single-eyed teapot in the Hatter's domain is an enemy players will face in the starting stage. I thought about an angry monster with one eye. It is really a challenge to design something that can walk with three legs. I spent a lot of time on this, and finally I got it.

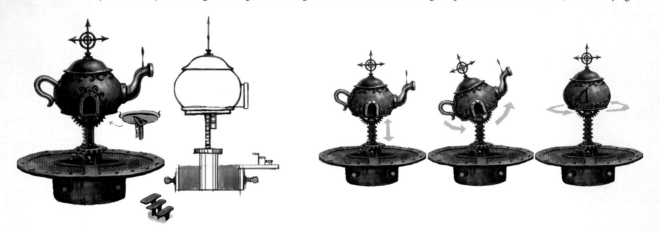

Nako. A teapot cannon. After Alice enters, she shoots out and flies to the target location. The aiming reticule part on the top shows the function of the device.

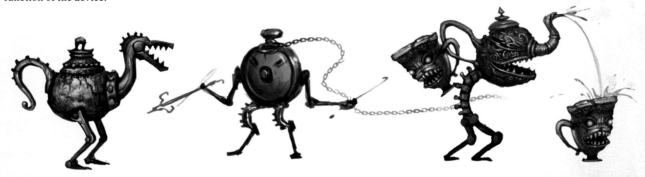

Sun GuoLiang. Enemy designs for the Hatter's Domain. I tried a lot of teapot- and cup-styled things. They are really interesting, though we finally didn't use them in the game. *KW: These critters came up too late to be included in the game. It's unfortunate, because they're all awesome designs.*

RIGHT: Sun GuoLiang. Ken told me that we needed a key concept for the tearoom. The first image that appeared in my mind was hot tea powering mechanisms and clocks, as Alice tries to dodge between them. The bottom of the room is covered by hot tea. The final design looks just like this.

Sun GuoLiang. In this level, Alice needs to find the Hatter's head. In the original *Alice*, she broke him into parts, and now she needs to put them back together. I designed the room in which Alice finds the Hatter's head, and then the head tells her where to find other parts.

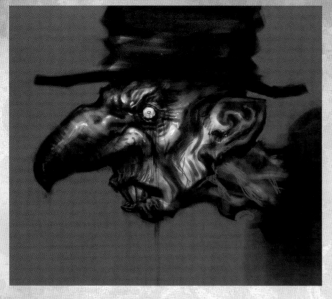 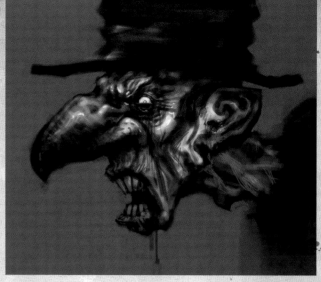

Tyler Lockett. The Hatter eats some stale porridge.

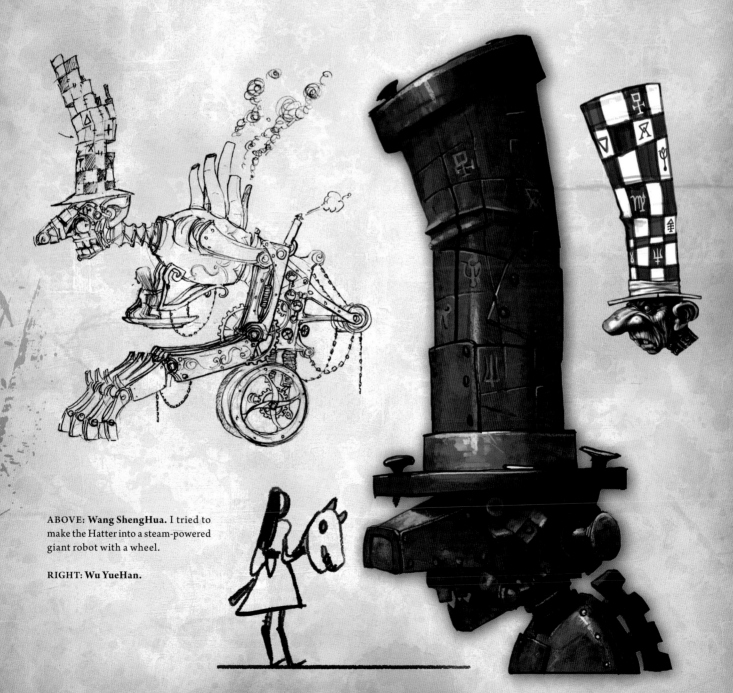

ABOVE: **Wang ShengHua.** I tried to make the Hatter into a steam-powered giant robot with a wheel.

RIGHT: **Wu YueHan.**

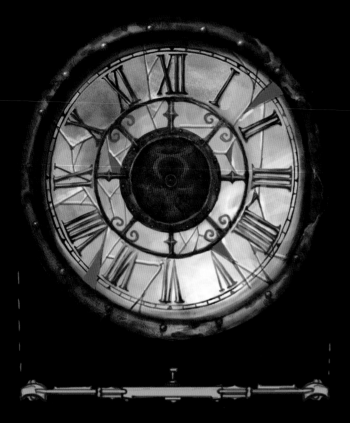

ABOVE: Yuan ShaoFeng.

BELOW: Ken Wong. A very quick painting to portray the reconstruction room, the junk chamber where Alice meets the remains of the Hatter.

Nako. There is a giant hub in the center of the Hatter's Domain, and this is the top of it. The design is based on the original game.

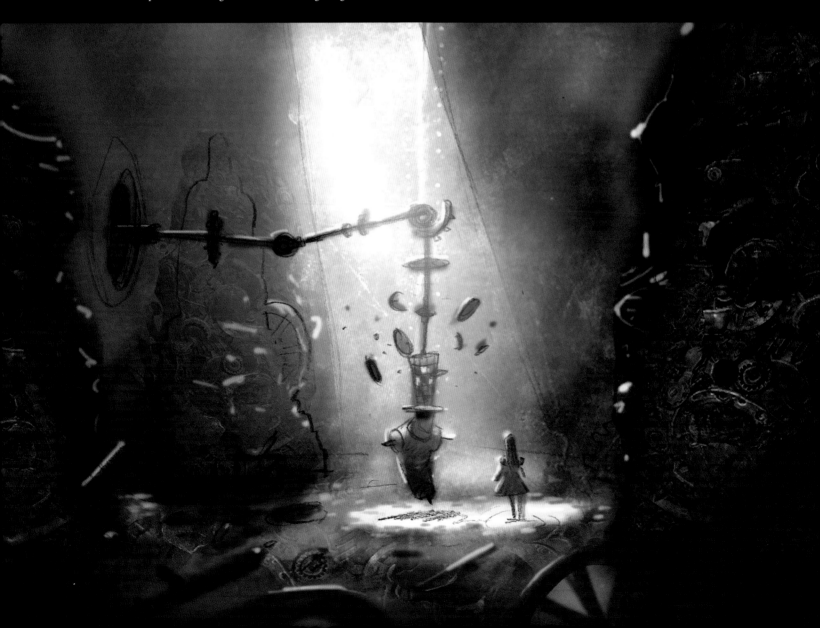

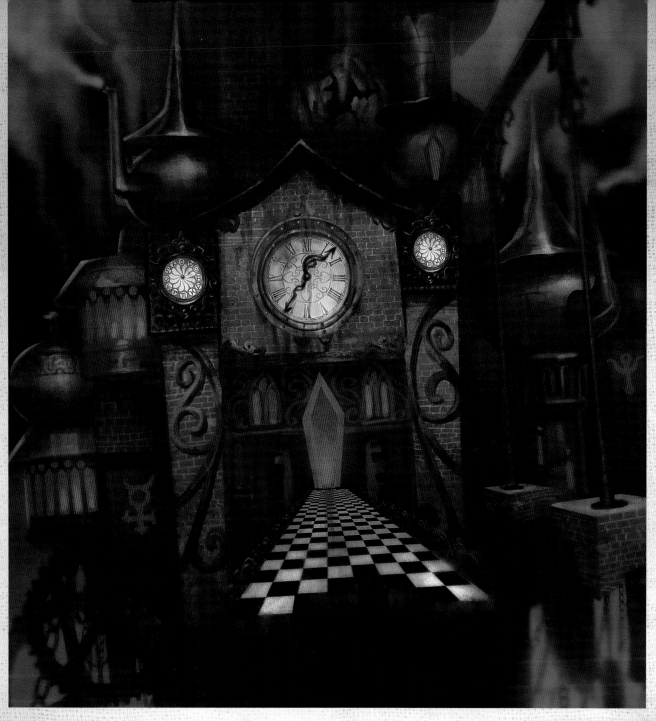

Luis Melo. This is an approach to the floating buildings that's closer to the first game and heavier in materials and darkness, although the teapot elements are everywhere. There's a stronger feeling of a sort of dimensional void, as it's impossible to tell if it's day or night.

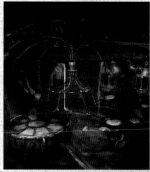

Luis Melo. Here is the gate of the domain, which Alice reaches by crashing the cable car. As the clouds clear, it all looks abandoned, the machinery looks broken through the cracked walls, and it seems there's no way in. Or is there? Well, no choice but to look for one; there's no going back now.

Luis Melo. Just a quick study of scale and depth in the level, and of a few elements that can be used to make or block Alice's path.

Luis Melo. There was an idea that the hub of this stage would be a big clock face. This picture is also a bit of an experiment with a different palette and lighting

Ken Wong. A paintover of an early version of the Teamaker, the area that eventually came to be known as Always Elevenses.

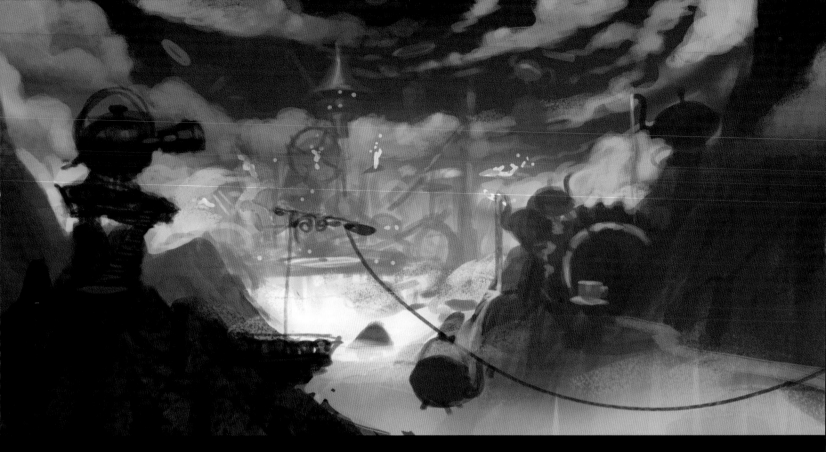

Luis Melo. The Hatter's Domain in the first game is rich in alchemical symbology. It's built out of heavy materials and seems to be surrounded by a dark void. We wanted to keep that feeling of a surreal place, but make the approach gradual, tying it with the previous location—the Vale of Tears—because some of the story develops in this transition. We sent Alice into the clouds in a teapot cable car, and looming out of the clouds appears the Hatter's Domain.

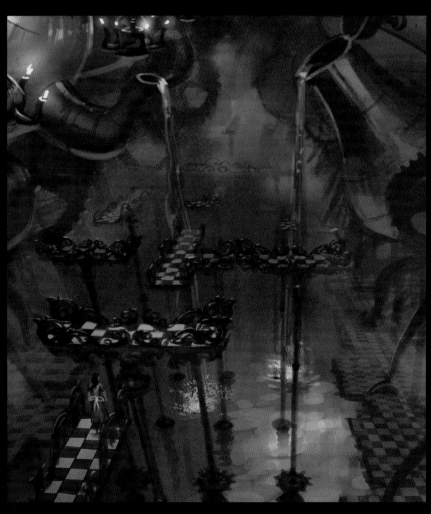

Luis Melo. Being an essentially mechanical level, there was plenty of opportunity for device puzzles in the Hatter's Domain. Here, Alice must make herself a safe path over boiling tea by controlling simple levers that rotate some platforms.

Nako. At that time, we didn't know what the interior of the smelting factory should look like. We tried a lot of designs. This one was made when I was listening to the soundtrack of the first *Alice*. I could really feel the fantastic style of the game.

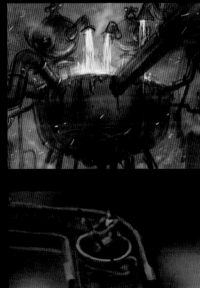

Luis Melo. This puzzle would work in the exact same way as the previous one, except the path to be connected would be made out of pipes, which would contain a flow of tea. Alice would then navigate along the flow by floating on an empty teacup.

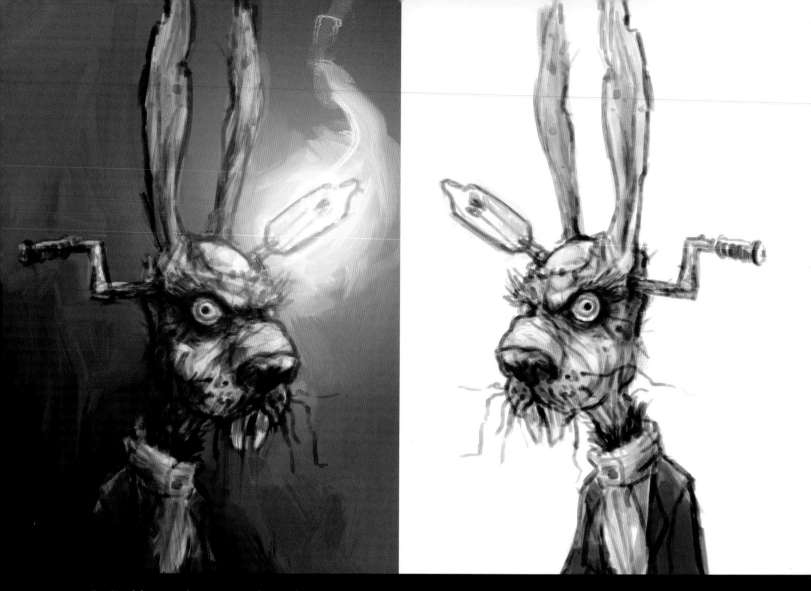

Ben Kerslake. An early variation on the March Hare, here somewhat less mechanized than our final design. All the characters encountered in the Hatter's Domain are driven by an unnaturally manic energy. *KW: An excellent, rare piece of Ben Kerslake art.*

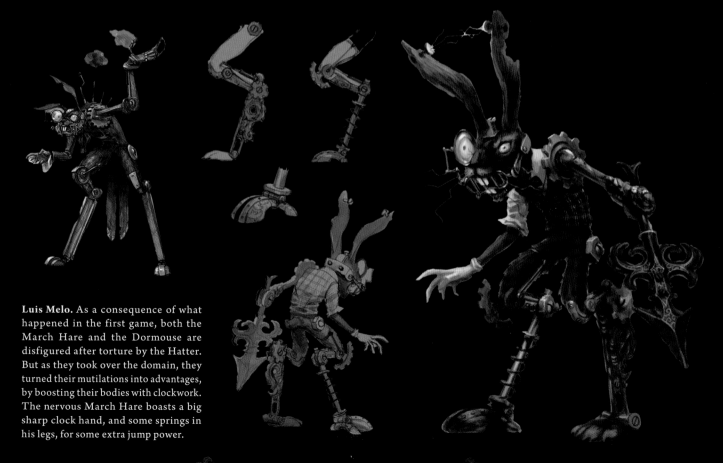

Luis Melo. As a consequence of what happened in the first game, both the March Hare and the Dormouse are disfigured after torture by the Hatter. But as they took over the domain, they turned their mutilations into advantages, by boosting their bodies with clockwork. The nervous March Hare boasts a big sharp clock hand, and some springs in his legs, for some extra jump power.

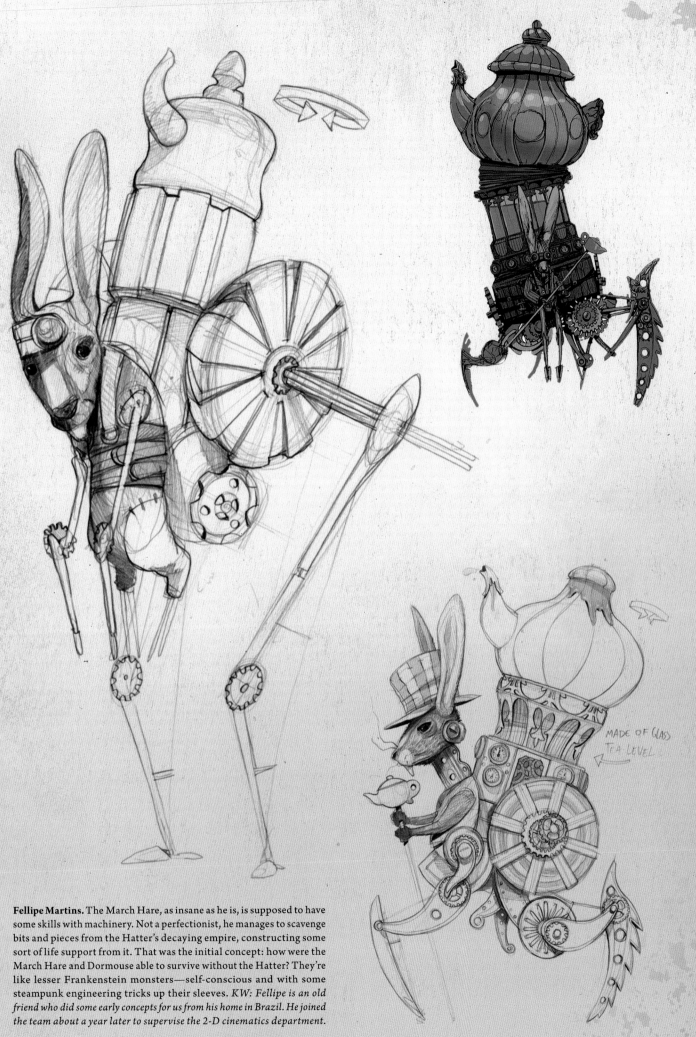

MADE OF GLASS
TEA LEVEL

Fellipe Martins. The March Hare, as insane as he is, is supposed to have some skills with machinery. Not a perfectionist, he manages to scavenge bits and pieces from the Hatter's decaying empire, constructing some sort of life support from it. That was the initial concept: how were the March Hare and Dormouse able to survive without the Hatter? They're like lesser Frankenstein monsters—self-conscious and with some steampunk engineering tricks up their sleeves. *KW: Fellipe is an old friend who did some early concepts for us from his home in Brazil. He joined the team about a year later to supervise the 2-D cinematics department.*

TOP: Sun GuoLiang. This is a paintover based on the maps created by level designers. There was just a very rough structure and I needed to put in some ideas to make it into an interesting factory.

ABOVE AND RIGHT: Luis Melo. In the book, the Dormouse is constantly falling asleep, so he forcefully keeps his eyelids wide open. Unfortunately that's not enough, and he also needs to be wound up like a toy mouse in order to keep awake.

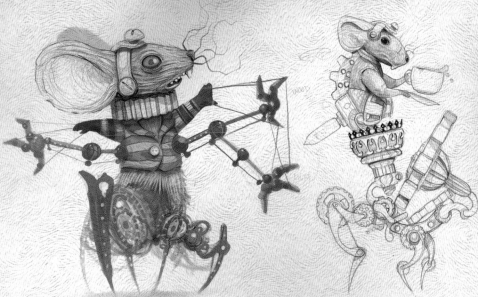

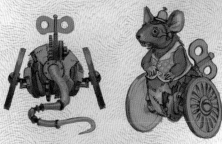

Fellipe Martins. The March Hare is a lesser Hatter, and Dormouse is a lesser March Hare. Initially, both characters were supposed to act by themselves as separate bosses, fighting against Alice. At some point, they would merge, like two pieces of a bigger robot. How to connect both characters was tricky, but fun to conceptualize.

RIGHT: Luis Melo.

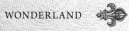

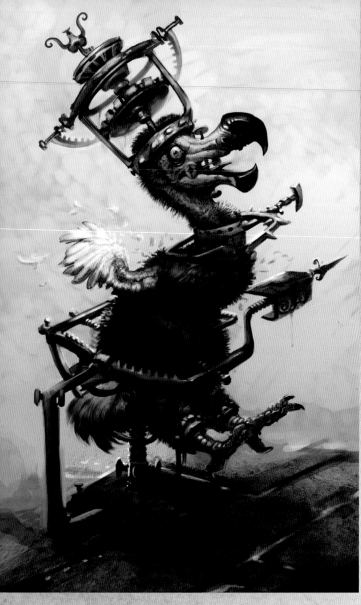

Sun GuoLiang. Dodo is an important character in the Alice story. My task was to make him look like he is suffering. I got some ideas and references from the famous movie *A Clockwork Orange*. I got rid of all of his feathers and made him look pained.

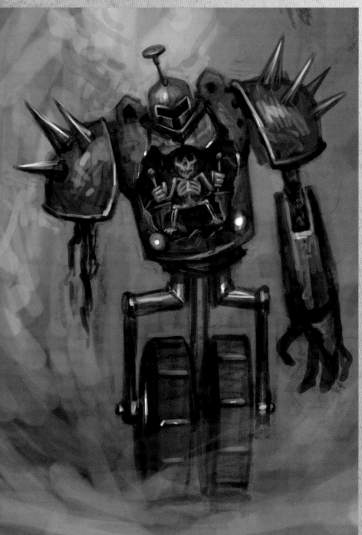

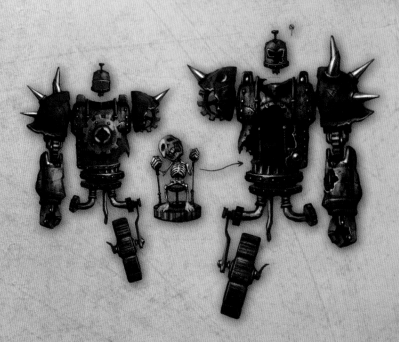

Nako. This robot was defeated by Alice in the last game. Now he is damaged and cannot move anymore. The madcap that controls him has become a skeleton.

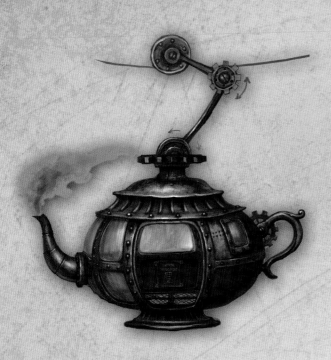

Nako. This is the carriage that brings Alice from the junkyard to the Hatter's Domain proper. We used a lot of teapots in this level, and in this case we designed a more mechanical one.

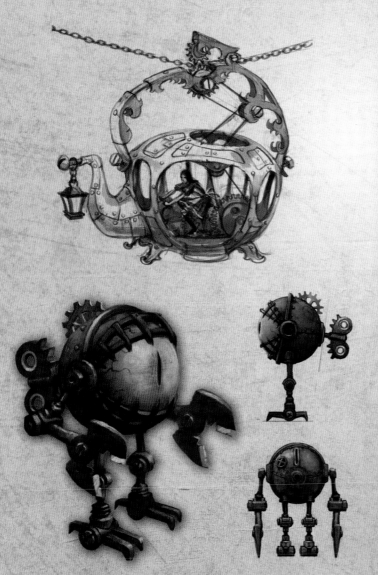

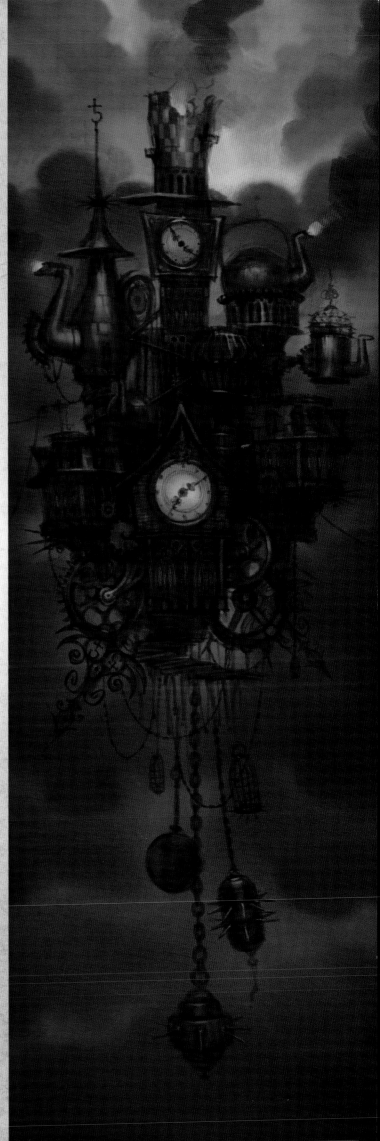

ABOVE: Jin Lei. *KW: The development of this character, the Automaton, was particularly tormented.*

RIGHT: Luis Melo. The first draft of the cable car that Alice uses to get to the domain's gate. This one involved a lot of pedaling.

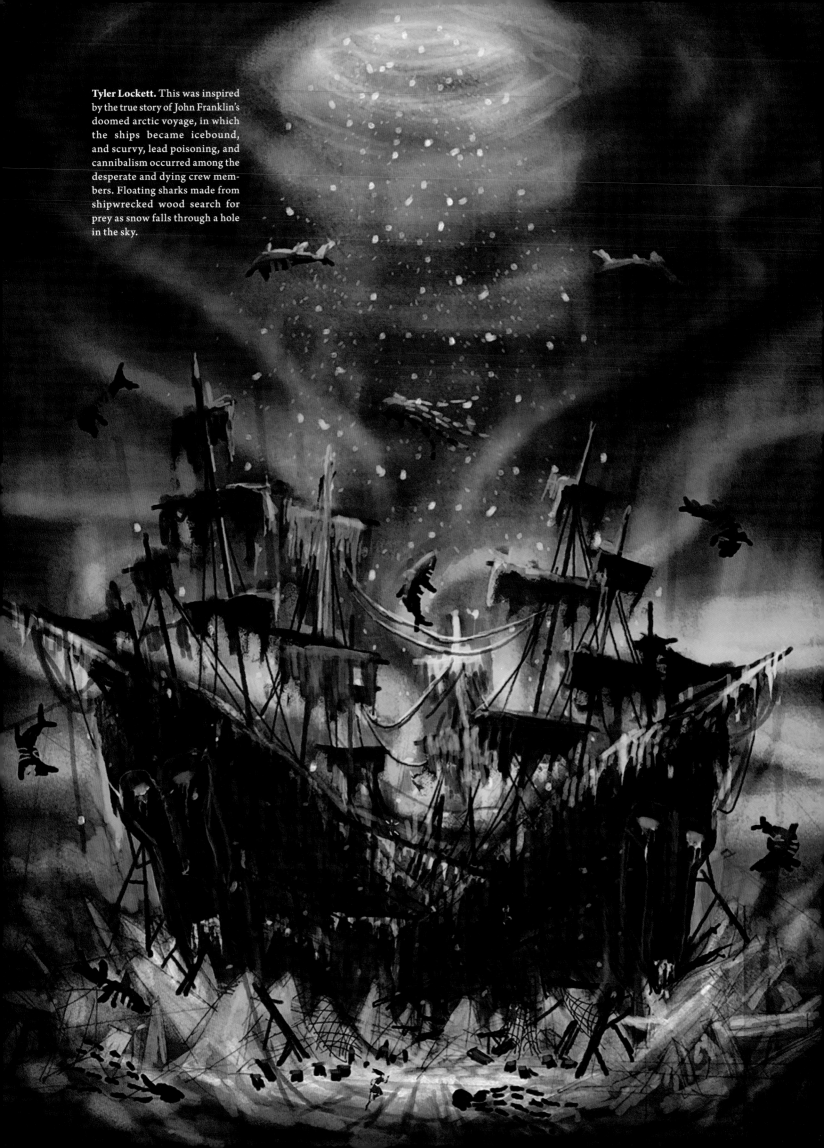

Tyler Lockett. This was inspired by the true story of John Franklin's doomed arctic voyage, in which the ships became icebound, and scurvy, lead poisoning, and cannibalism occurred among the desperate and dying crew members. Floating sharks made from shipwrecked wood search for prey as snow falls through a hole in the sky.

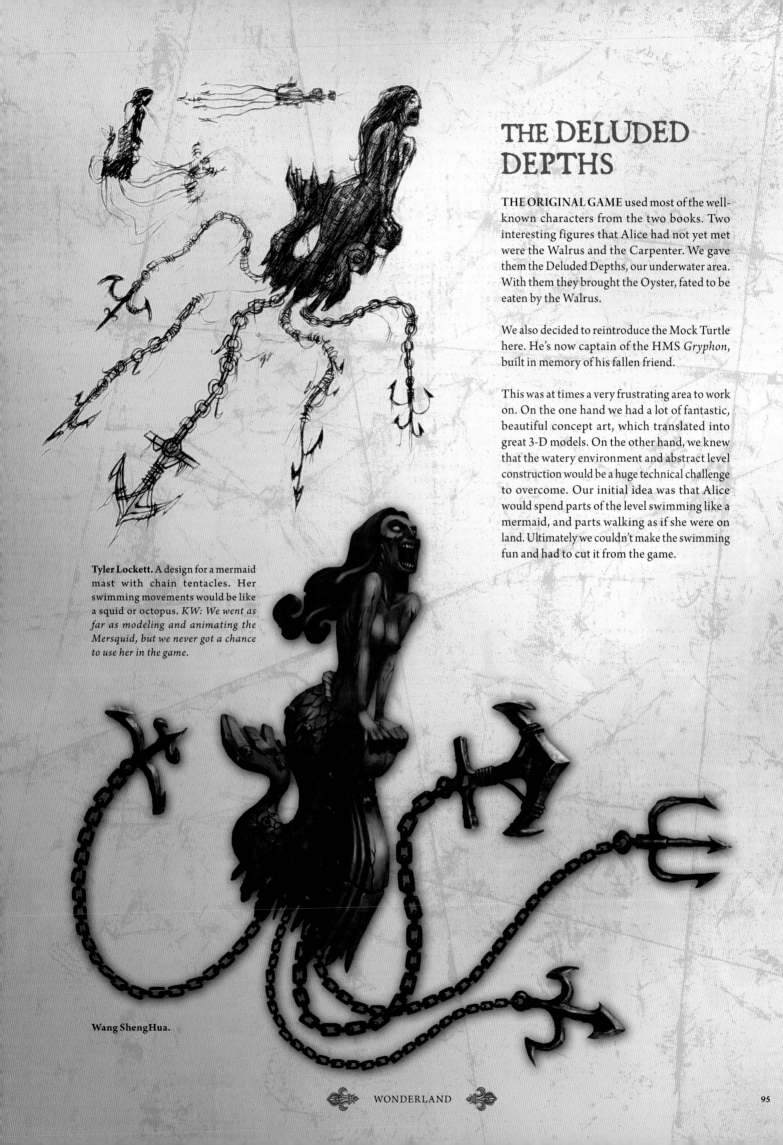

THE DELUDED DEPTHS

THE ORIGINAL GAME used most of the well-known characters from the two books. Two interesting figures that Alice had not yet met were the Walrus and the Carpenter. We gave them the Deluded Depths, our underwater area. With them they brought the Oyster, fated to be eaten by the Walrus.

We also decided to reintroduce the Mock Turtle here. He's now captain of the HMS *Gryphon*, built in memory of his fallen friend.

This was at times a very frustrating area to work on. On the one hand we had a lot of fantastic, beautiful concept art, which translated into great 3-D models. On the other hand, we knew that the watery environment and abstract level construction would be a huge technical challenge to overcome. Our initial idea was that Alice would spend parts of the level swimming like a mermaid, and parts walking as if she were on land. Ultimately we couldn't make the swimming fun and had to cut it from the game.

Tyler Lockett. A design for a mermaid mast with chain tentacles. Her swimming movements would be like a squid or octopus. *KW: We went as far as modeling and animating the Mersquid, but we never got a chance to use her in the game.*

Wang ShengHua.

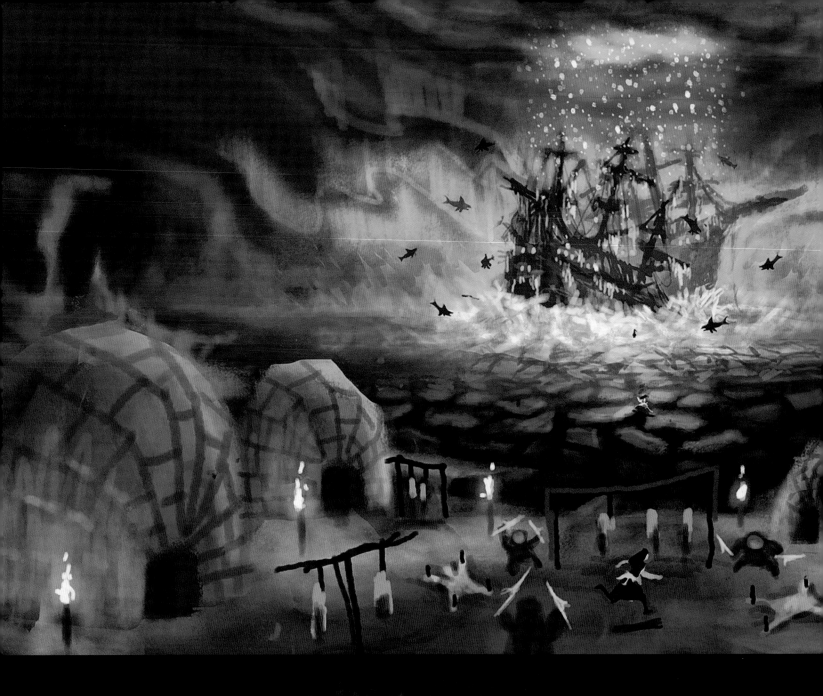

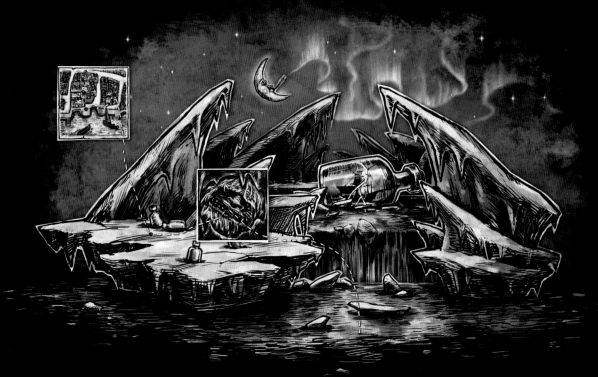

THE ART OF *ALICE: MADNESS RETURNS*

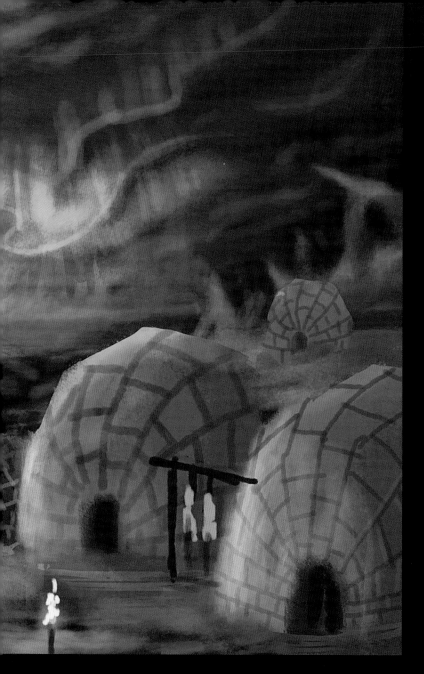

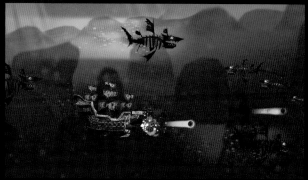

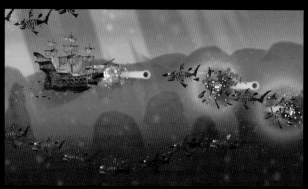

LEFT: Tyler Lockett. In a prologue to exploring the icebound ships, Alice encounters a cannibalistic Inuit village. *Not* based on a true story. Inuit people are perfectly civil.

ABOVE: Ben Kerslake. Early previsualization for the 2.5-D "Ship Shooter." Images such as these provide early targets for art and gameplay design.

OPPOSITE: Hong Lei. A map of the water level. I used a Victorian rendering style to fit with the style of the game.

RIGHT: Pu JinSong. Animals from the original *Alice* story. They are frozen and cannot move. Maybe they are still alive when they are being eaten by the ice sharks? *KW: I told Pu JinSong the easiest way of conveying the textures we wanted would be to just paint on top of photographs.*

FOLLOWING PAGES: Nako. We were asked to paint over some existing level layouts to improve the visuals. We had to consider where our designs would create problems for 3-D or technical art. I tried my best to give it a peaceful atmosphere, like a dream.

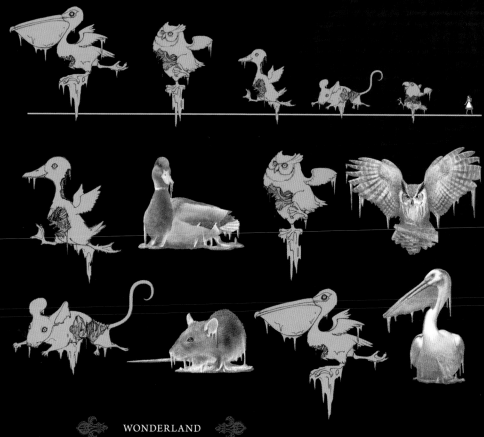

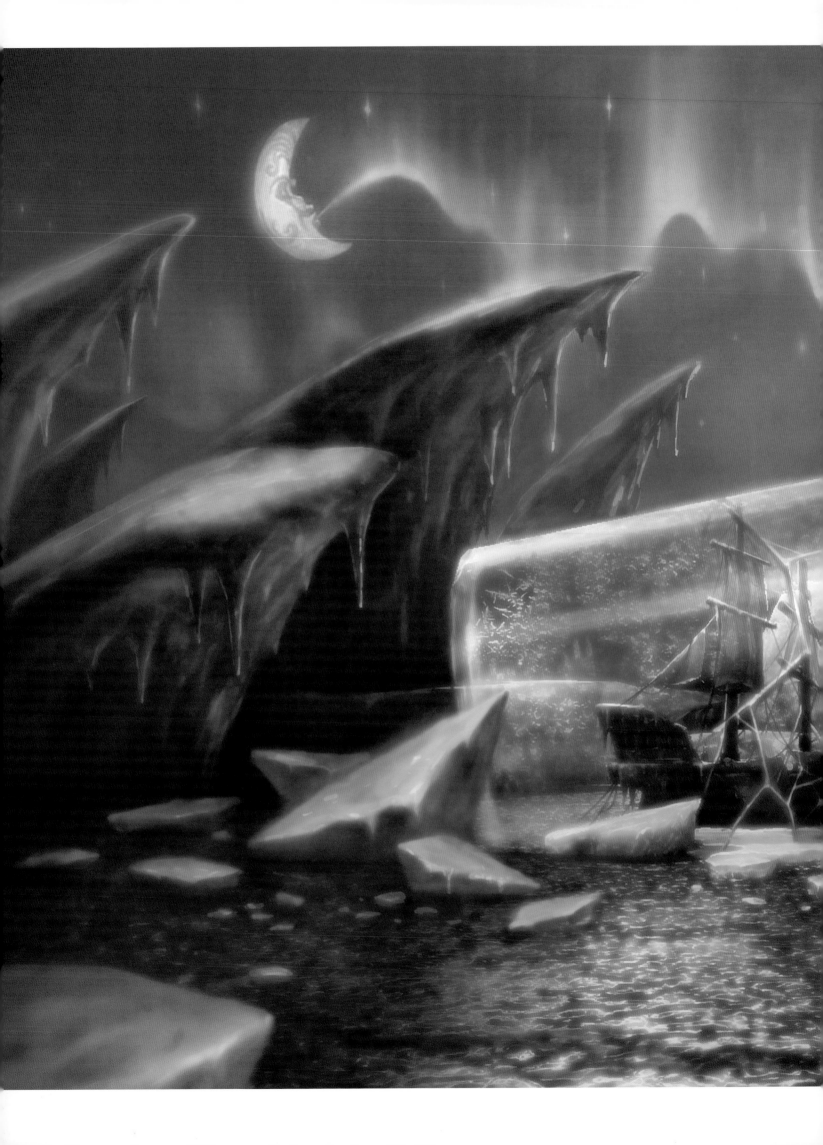

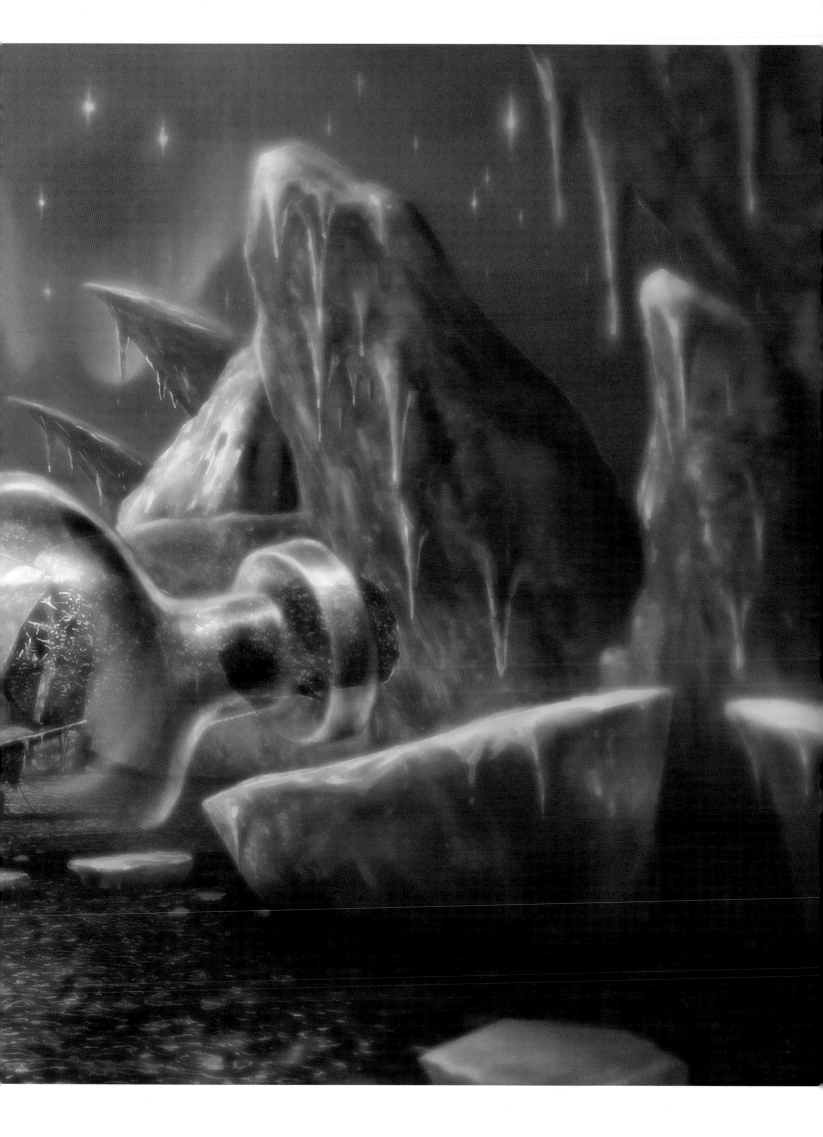

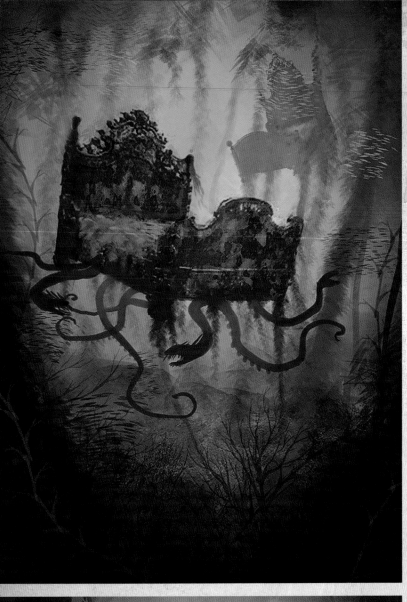

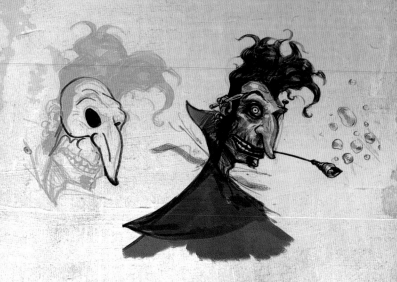

LEFT: **Luis Melo.** It has been said that sometimes things are not what they seem in Wonderland, but other times they are overly literal, which is practically the same. This oyster bed is deceiving . . . even if you imagine it to be like a real bed, you won't expect the deadly tentacles.

ABOVE: **Luis Melo.** These are the first drafts of the Carpenter character, an enticer and a manipulator who gets what he wants through his showmanship and charisma. It's clear there's something fishy about him, but no one wants to miss the show. In fact, morbid curiosity about what the show is really about is what makes it so popular. A marketing strategy to keep in mind.

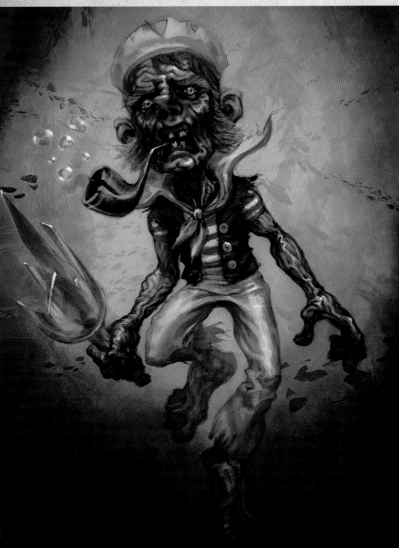

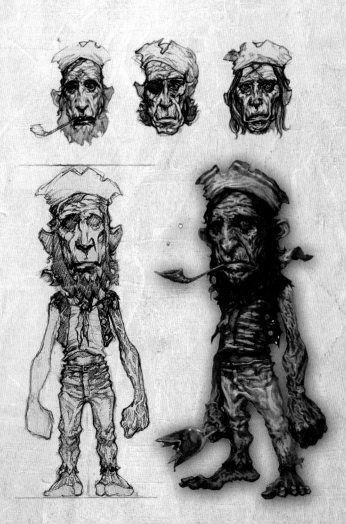

Luis Melo. The first rendering of the ghost sailors as homeless souls, drunken and angry from being assaulted and robbed of their lives and their ships by the Carpenter. They go around in undead form, picking fights with anyone and anything until someone puts their souls to rest.

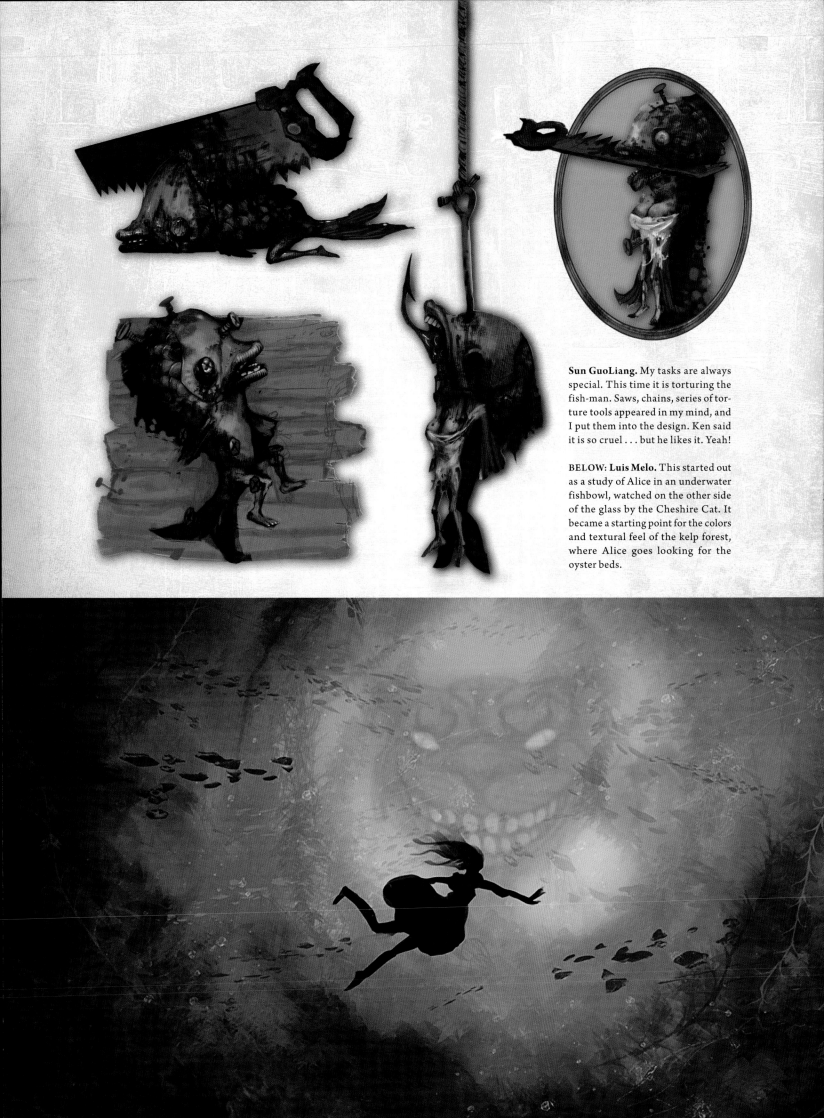

Sun GuoLiang. My tasks are always special. This time it is torturing the fish-man. Saws, chains, series of torture tools appeared in my mind, and I put them into the design. Ken said it is so cruel . . . but he likes it. Yeah!

BELOW: Luis Melo. This started out as a study of Alice in an underwater fishbowl, watched on the other side of the glass by the Cheshire Cat. It became a starting point for the colors and textural feel of the kelp forest, where Alice goes looking for the oyster beds.

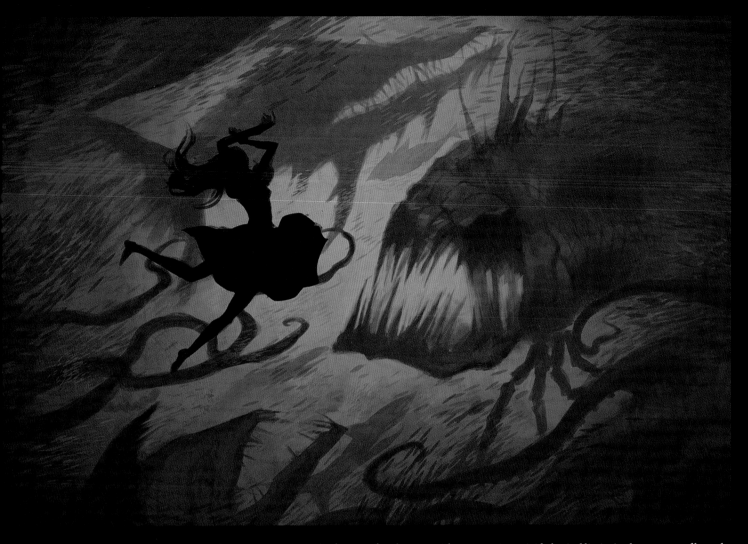

Luis Melo. The "fish barrier" was an idea to limit Alice's range of exploration without imposing a rigid physical limit. As she went out of bounds, some small fish would start nibbling at her, causing damage. If she ended up going too far, she would be reduced to prehistoric deep-sea fish rations, as the view would go dark in an almost shapeless overwhelming swarm.

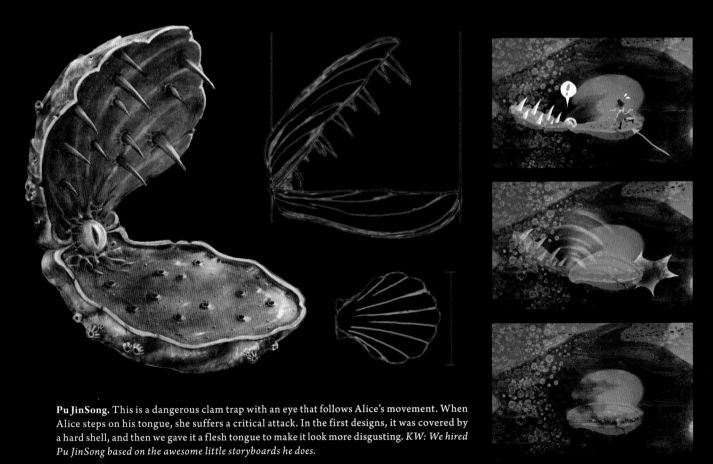

Pu JinSong. This is a dangerous clam trap with an eye that follows Alice's movement. When Alice steps on his tongue, she suffers a critical attack. In the first designs, it was covered by a hard shell, and then we gave it a flesh tongue to make it look more disgusting. *KW: We hired Pu JinSong based on the awesome little storyboards he does.*

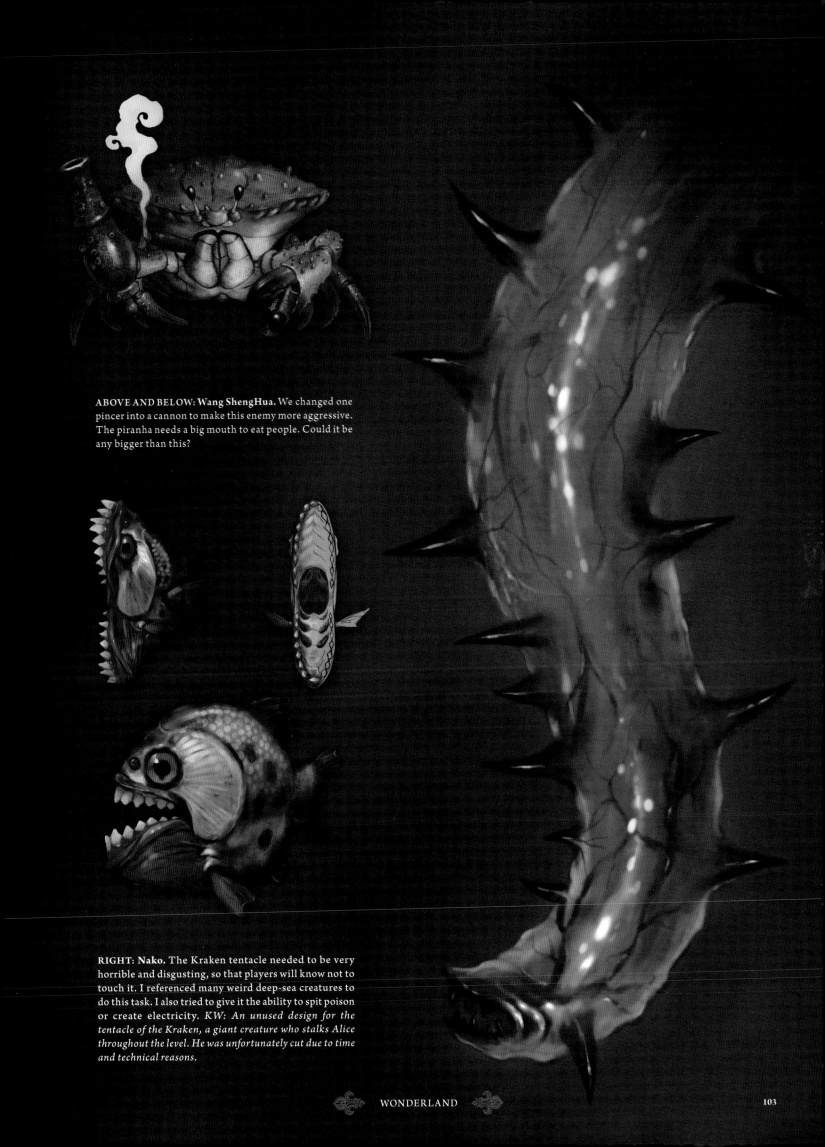

ABOVE AND BELOW: Wang ShengHua. We changed one pincer into a cannon to make this enemy more aggressive. The piranha needs a big mouth to eat people. Could it be any bigger than this?

RIGHT: Nako. The Kraken tentacle needed to be very horrible and disgusting, so that players will know not to touch it. I referenced many weird deep-sea creatures to do this task. I also tried to give it the ability to spit poison or create electricity. *KW: An unused design for the tentacle of the Kraken, a giant creature who stalks Alice throughout the level. He was unfortunately cut due to time and technical reasons.*

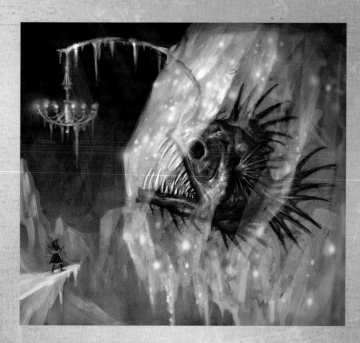

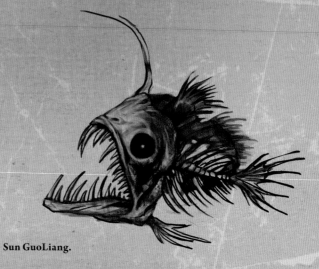

Sun GuoLiang.

LEFT: **Nako.** A big fish frozen in ice. It was originally a normal fish, just a little bit horrible. But later we decided to make it a skeleton fish with rotten flesh.

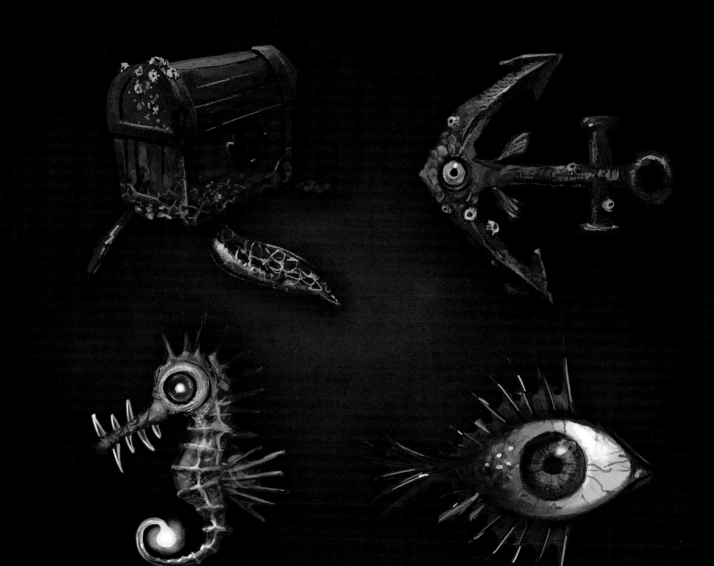

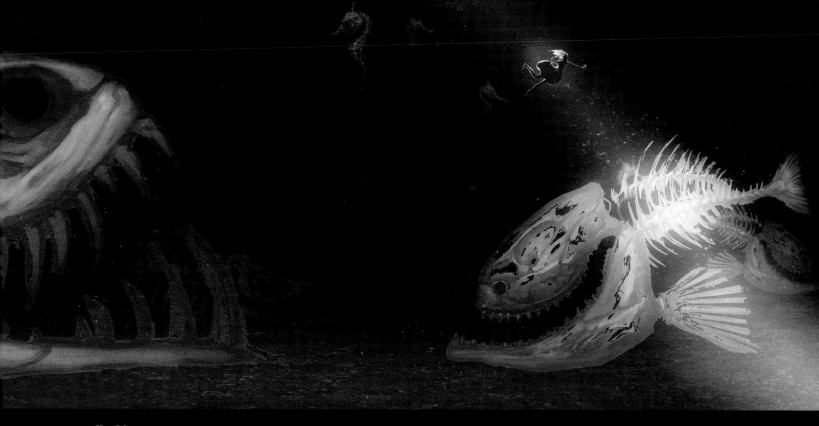

Ken Wong.

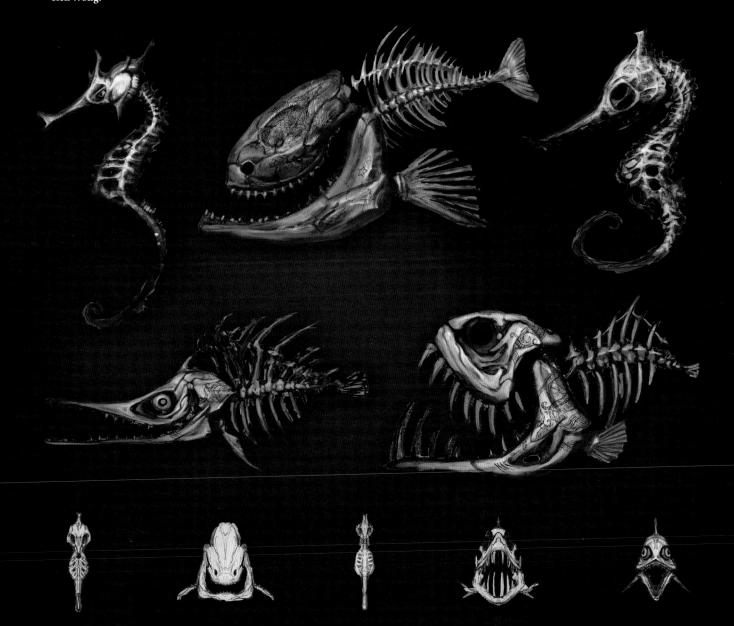

Sun GuoLiang. I spent a lot of time collecting reference and trying ideas for this undersea desert.

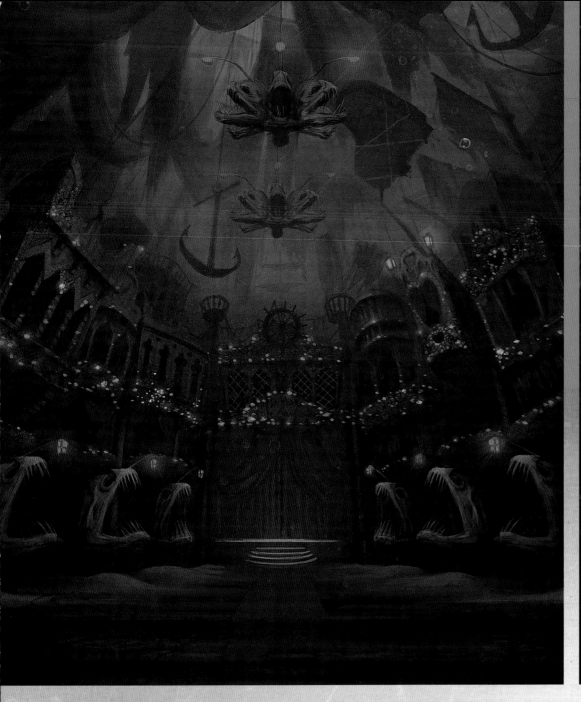

Luis Melo. The theater setting is inspired by nineteenth-century theaters and operettas, and it's the hub for the underwater chapter. It's where Alice gets her objectives and brings the show together. It's built from sunken ship parts and the remains of ocean creatures. This piece still leaves things quite open about the space's scale and as to what would happen in it.

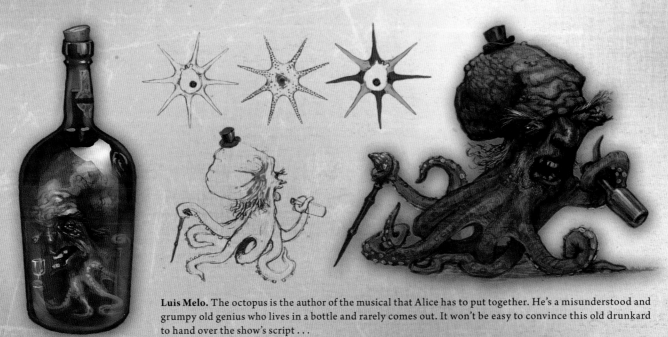

Luis Melo. The octopus is the author of the musical that Alice has to put together. He's a misunderstood and grumpy old genius who lives in a bottle and rarely comes out. It won't be easy to convince this old drunkard to hand over the show's script . . .

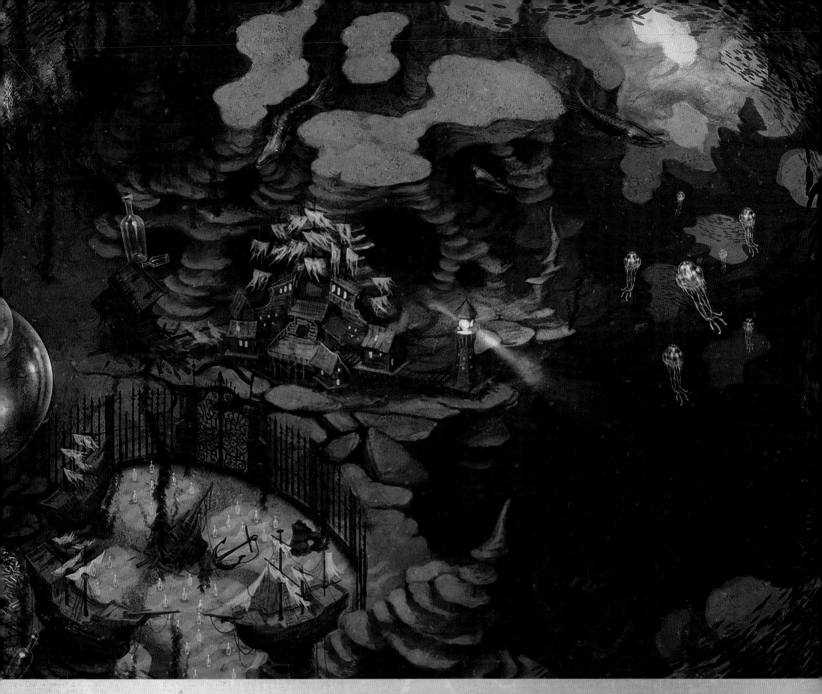

Luis Melo. An attempt to structure many of the ideas for underwater areas into a world. These would range from deep, dark rifts to underwater caves, a kelp forest, and a giant fishbowl. The theater town is the hub for exploration. **BELOW: Luis Melo.** Our original production for the musical was quite ambitious! It involved all kinds of sea artists and props. Some of the most exuberant were the Can-Can-Crab dancers and their dizzying choreography.

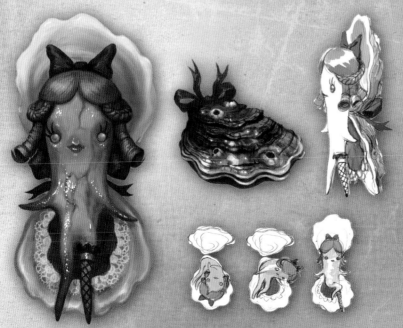

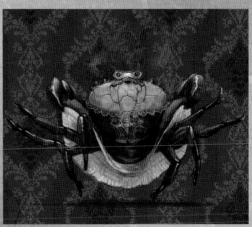

LEFT: Luis Melo. The slimy oysters are the stars of the show. They dream of going on stage. They're also the objects of the Walrus's lusty hunger—they are simply irresistible. They're wearing their wigs and dressed up in lace, with sparkling shells. Little do they know about their impending finale. There will be no encore.

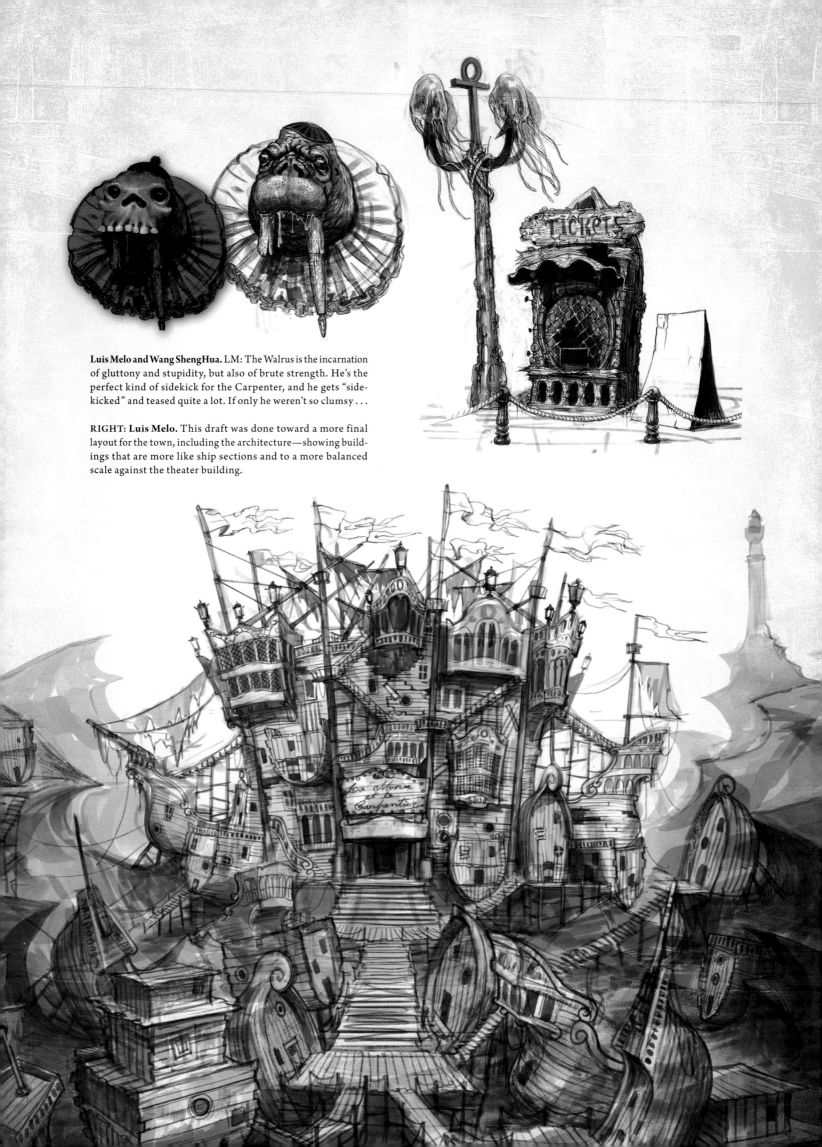

Luis Melo and Wang Sheng Hua. LM: The Walrus is the incarnation of gluttony and stupidity, but also of brute strength. He's the perfect kind of sidekick for the Carpenter, and he gets "side-kicked" and teased quite a lot. If only he weren't so clumsy . . .

RIGHT: **Luis Melo.** This draft was done toward a more final layout for the town, including the architecture—showing buildings that are more like ship sections and to a more balanced scale against the theater building.

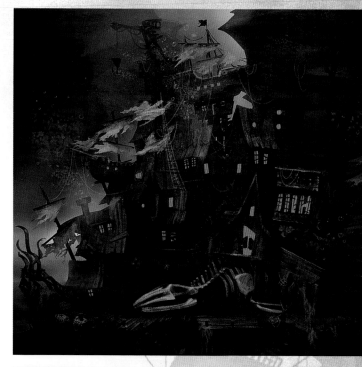

Sun GuoLiang. Why did they give this landmark task to me? Because it is dark and bloody! I am good at this . . . This time the victim is a flatfish. We carved letters on its body, and it is still alive! *KW: Each of these signs had to be localized into five additional languages.*

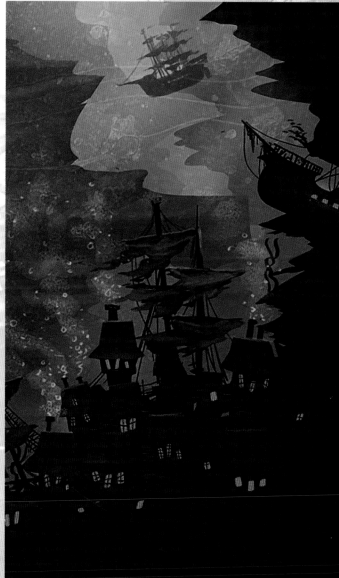

Sun GuoLiang. Another victim; hope it doesn't feel too much pain.

FACING: **Luis Melo.** Here is a detail of the elements and style we wanted to bring together to build the town's structures: parts from ships (from the rotten wood hulls to anchors) together with sea creatures and their remains, all covered in a layer of sea grit and barnacles. Somehow the mix of these should also be reminiscent of nineteenth-century (or even earlier) theatrical environments.

Luis Melo. These are two initial keys for the color scheme of the deep ocean and an approach to the town, before we had decided where to go with the architecture. You can see some whale bones there as well. The lighting and colors of these were pretty much kept all the way through.

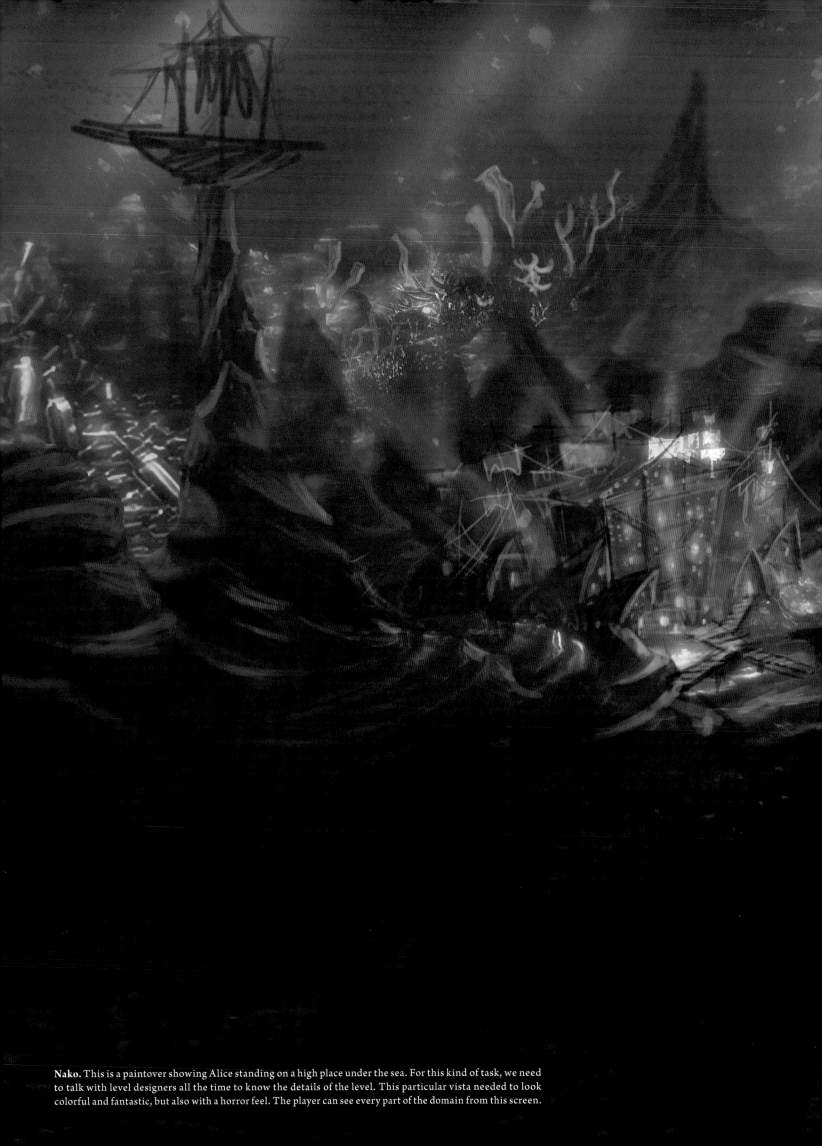

Nako. This is a paintover showing Alice standing on a high place under the sea. For this kind of task, we need to talk with level designers all the time to know the details of the level. This particular vista needed to look colorful and fantastic, but also with a horror feel. The player can see every part of the domain from this screen.

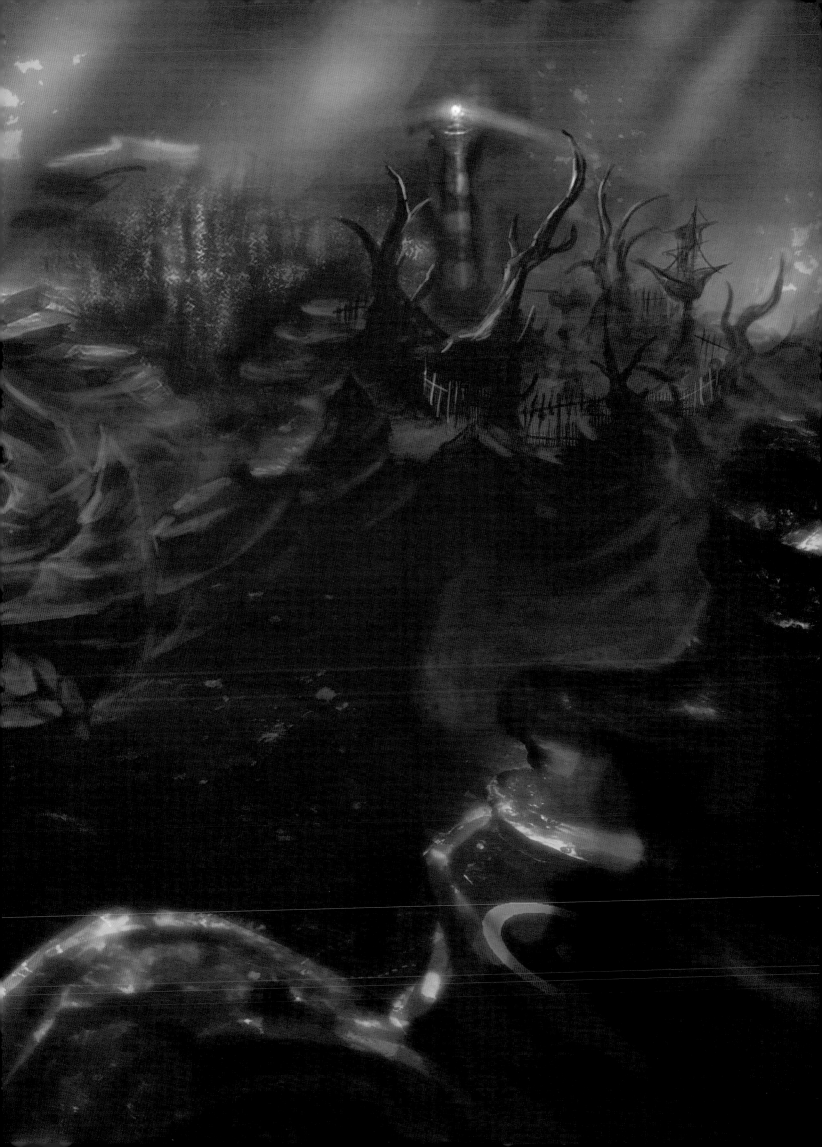

LEFT: Luis Melo. One of the concepts for the horn section that Alice needed to find for the musical show was basically . . . a horn blowfish. He could play himself. **RIGHT: Yuan ShaoFeng.** *KW: This fish was to be used as a swimming hazard. Alice could only attack him when he was puffed up.*

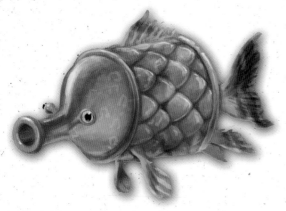

Yuan ShaoFeng. *KW: The final design of the Music Fish. He's a bottle because there used to be bottles in the ice area that also contained sound.*

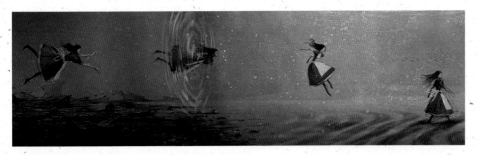

ABOVE: Yuan ShaoFeng.

BELOW: Luis Melo. "Heavy" water is mainly present in the darker chasms and the far reaches of the ocean, in which Alice needs to travel quickly. Central areas, which Alice has to explore thoroughly and where she does a lot of combat, are in "light" water. Here you can see how the colors and light change accordingly.

Luis Melo. In some underwater areas, Alice might find it easier to walk rather than swim. To distinguish these areas, we had "heavy" and "light" water, differently colored.

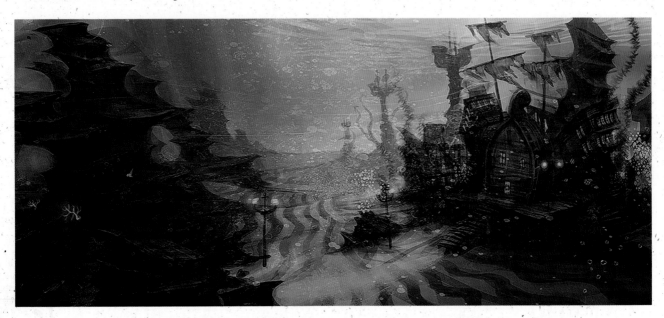

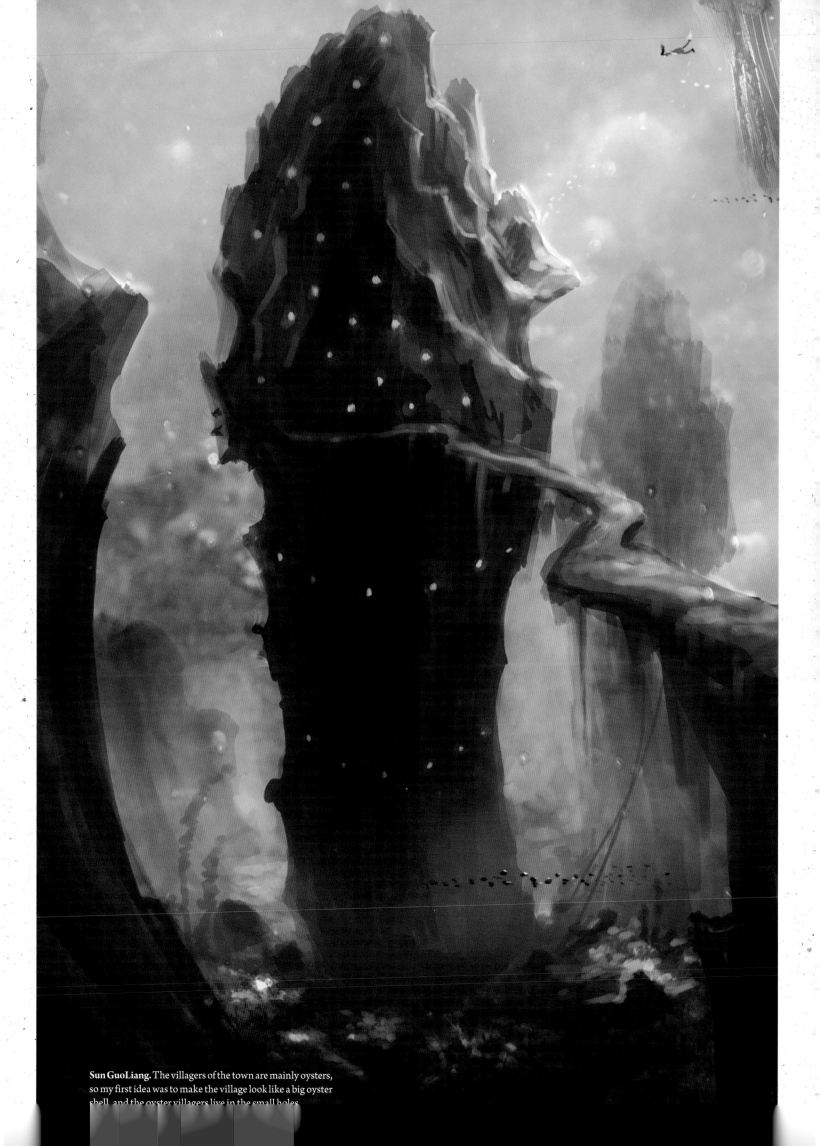

Sun GuoLiang. The villagers of the town are mainly oysters, so my first idea was to make the village look like a big oyster shell, and the oyster villagers live in the small holes.

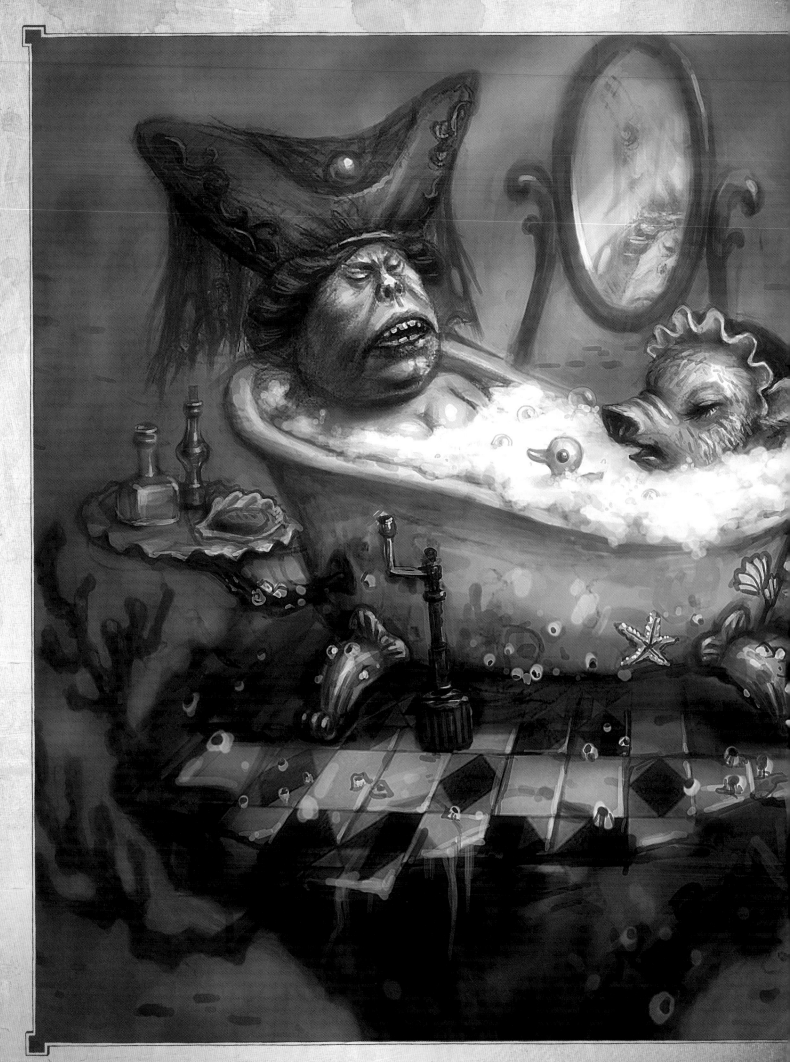

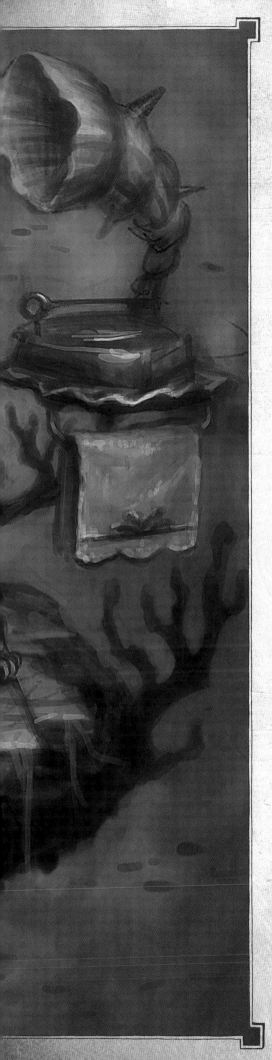

Nako. In the original design, the Duchess lived undersea—maybe that's because the director thought it's cool to bathe under the sea?—so we wanted to add more Victorian bathroom elements. We put the Duchess and her pig into a standard Victorian bathtub. *KW: The Duchess originally had no role in the game, so we created this bizarre scene for her and her Pigbaby. Even the pepper grinder shows up, as it wasn't a weapon yet. All of this was modeled before the Duchess was reassigned to the Vale of Tears, and we had to ask Nako to give the Duchess back her clothes.*

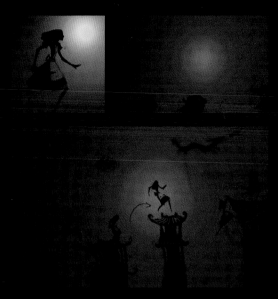

Jin Lei.

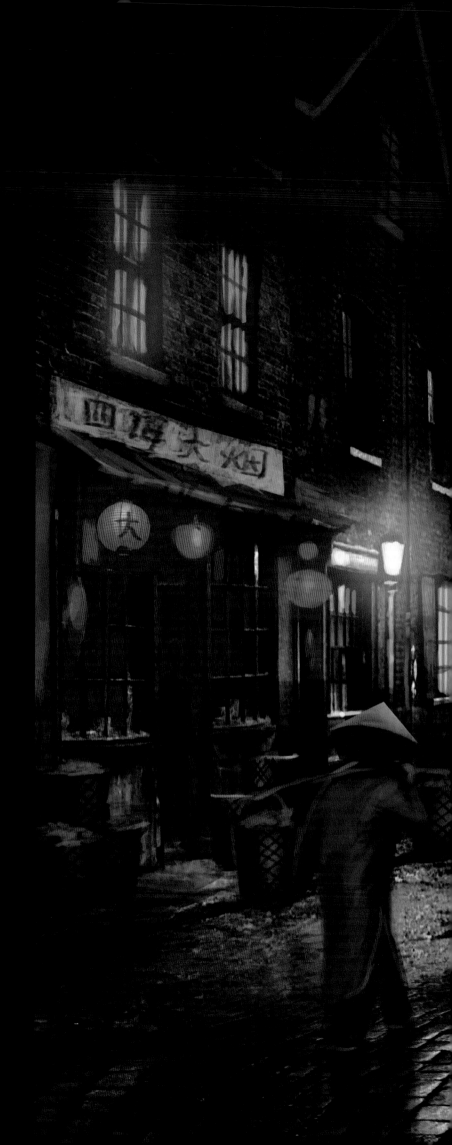

THE MYSTERIOUS EAST

EARLY IN DEVELOPMENT, the art department was asked to design an Oriental-themed domain that Alice would explore while shrunk down to insect size in her quest to locate the Caterpillar.

We thought our Chinese artists would have an easy time riffing on their own culture. However, we soon discovered they had very different ideas about what was "exotic" or "interesting" or "classical" about their own art and history. Where the Western designers and I might find certain antiques or styles kitschy and fascinating and ripe for reinterpretation through Alice's vision, the Chinese artists often found these things matter of fact or ordinary. What made matters worse is we wanted Alice's experience to really be "Oriental" in the sense that the Victorians often mashed Japanese, Chinese, and other surrounding cultures together in their worldview.

On top of that, we wanted to convey that Alice had shrunk down to insect size in this world. Early on this created a lot of frustration. We eventually loosened up on this, knowing that there were "giant" props scattered all over Wonderland, so scale was never very consistent.

Once again, the artists rose to the challenge, crafting a world of tyrannical wasps, beautiful hand-carved landscapes, and massacred origami.

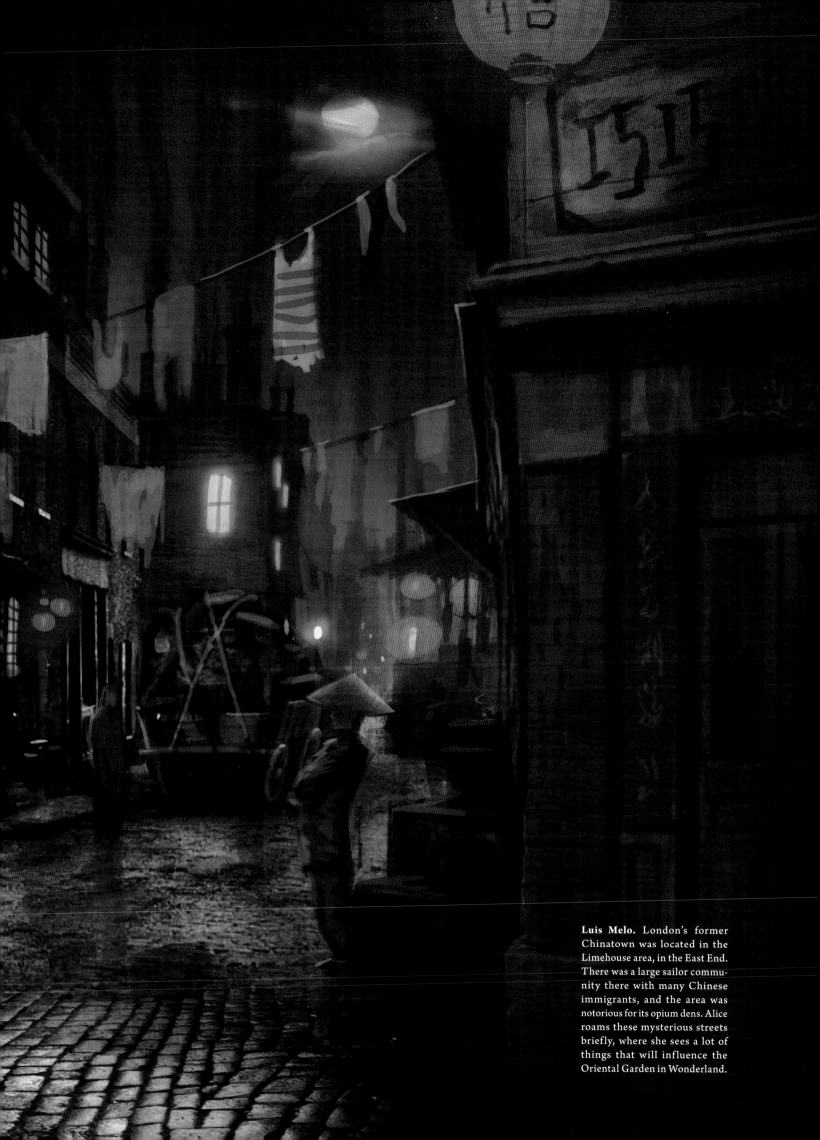

Luis Melo. London's former Chinatown was located in the Limehouse area, in the East End. There was a large sailor community there with many Chinese immigrants, and the area was notorious for its opium dens. Alice roams these mysterious streets briefly, where she sees a lot of things that will influence the Oriental Garden in Wonderland.

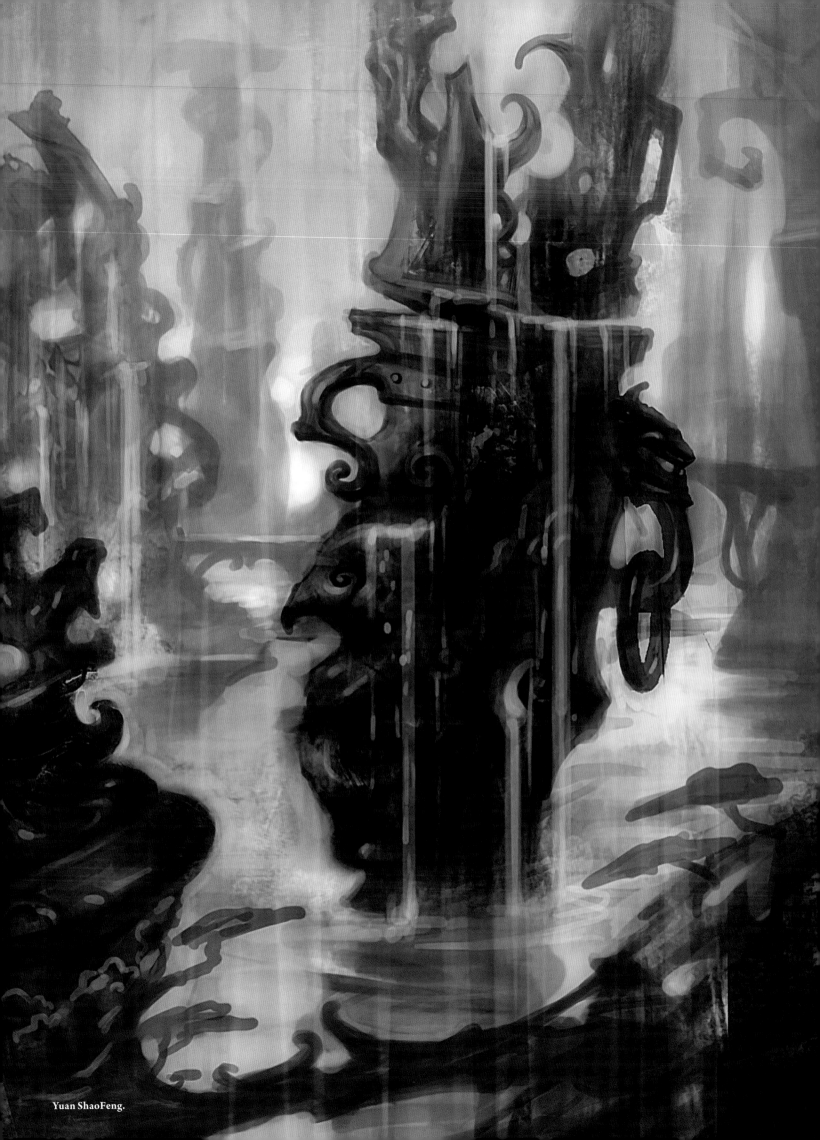

Yuan ShaoFeng.

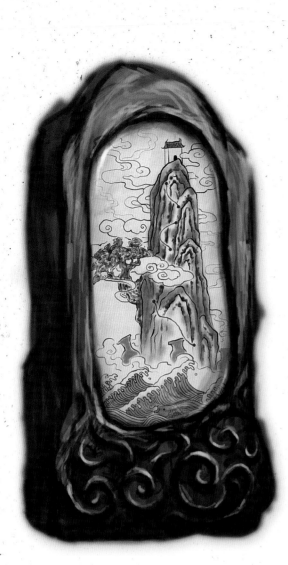

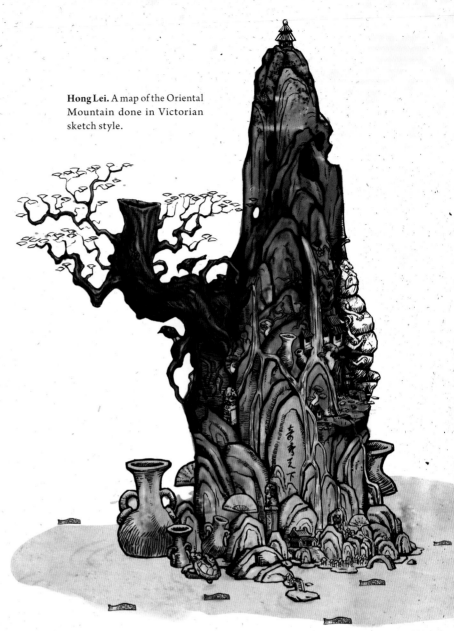

Hong Lei. A map of the Oriental Mountain done in Victorian sketch style.

Nako. A map design for the Shadow Room. It is a Chinese-style map on a rock.

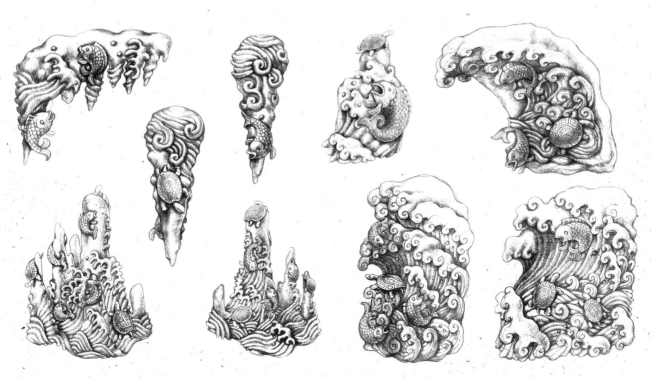

Nako. This is one of the first batch of Oriental level designs. I am Chinese, so it is easy for me to do this. Though most of us initially thought it was not a good idea to make an Eastern level in Wonderland, we liked it more the more we worked on it.

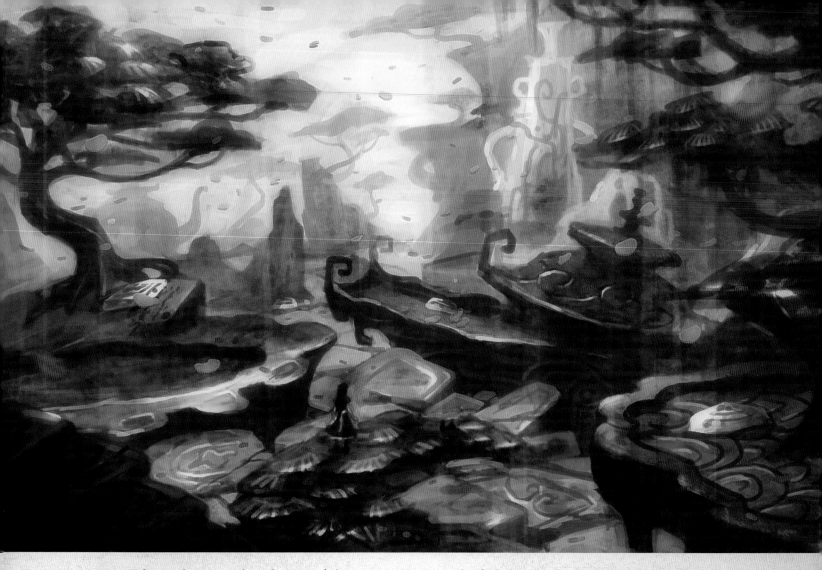

ABOVE: **Nako.** Another concept shows the Eastern feel. BELOW: **Sun GuoLiang.** Alice finds the Oriental rock in the Vale of Tears. The smoke coming out of the top temple is from the Caterpillar. Alice will shrink and enter this Oriental world later.

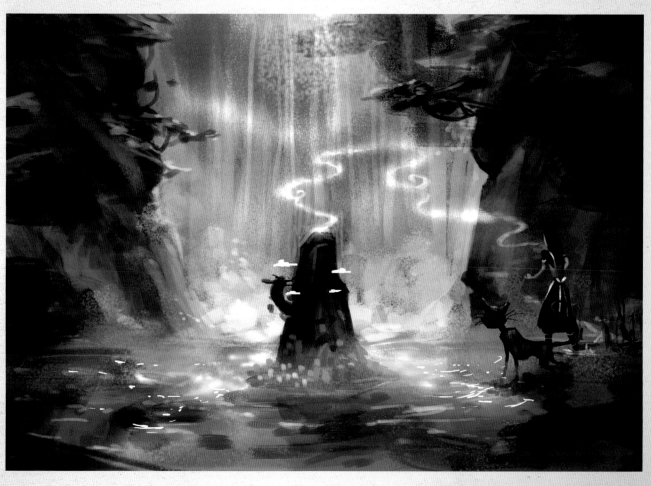

❧ THE ART OF *ALICE: MADNESS RETURNS* ❧

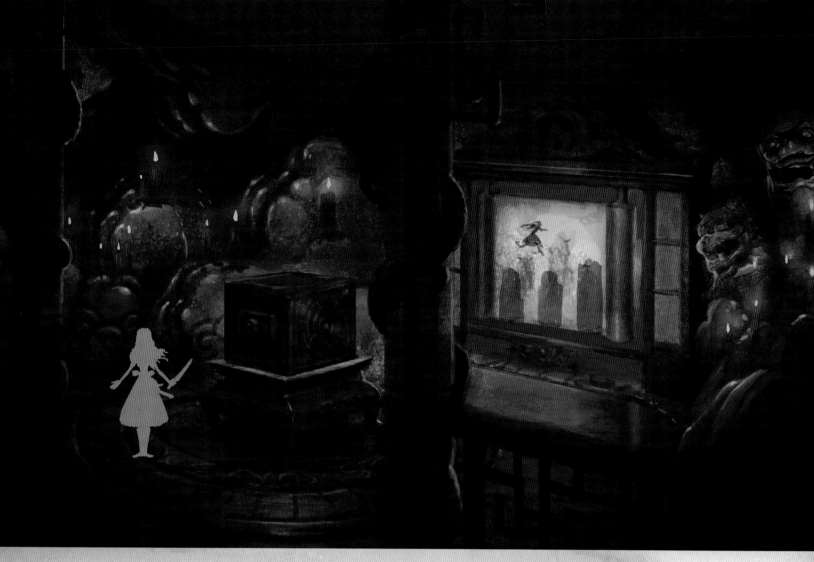

Luis Melo. An idea for how Alice might transition into the 2-D shadow platforming sections of the Oriental Garden: a projection room, where the 2-D gameplay would appear projected on a scrolling painting.

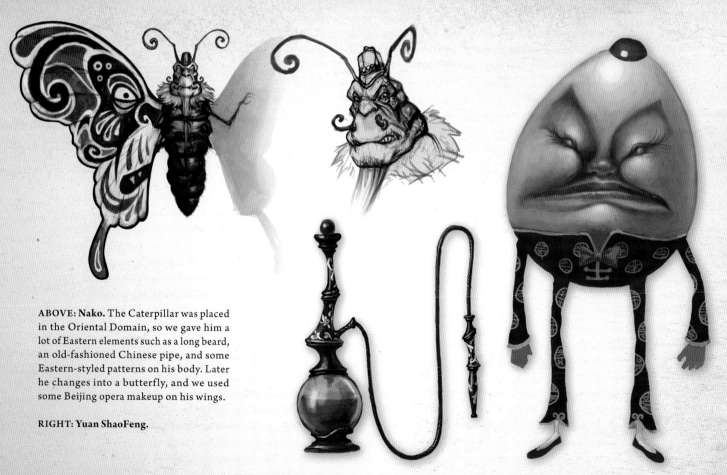

ABOVE: Nako. The Caterpillar was placed in the Oriental Domain, so we gave him a lot of Eastern elements such as a long beard, an old-fashioned Chinese pipe, and some Eastern-styled patterns on his body. Later he changes into a butterfly, and we used some Beijing opera makeup on his wings.

RIGHT: Yuan ShaoFeng.

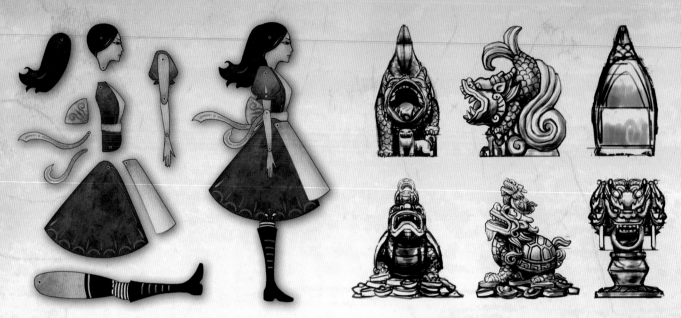

LEFT: 3-D asset render. *KW: Alice as she appears in the game's Shadow Path levels.* RIGHT: **Hong Lei.** Three holy beast statues. They were heavily referenced from actual antiques. We should still remember that this is a micro world; everything that looks big is actually tiny.

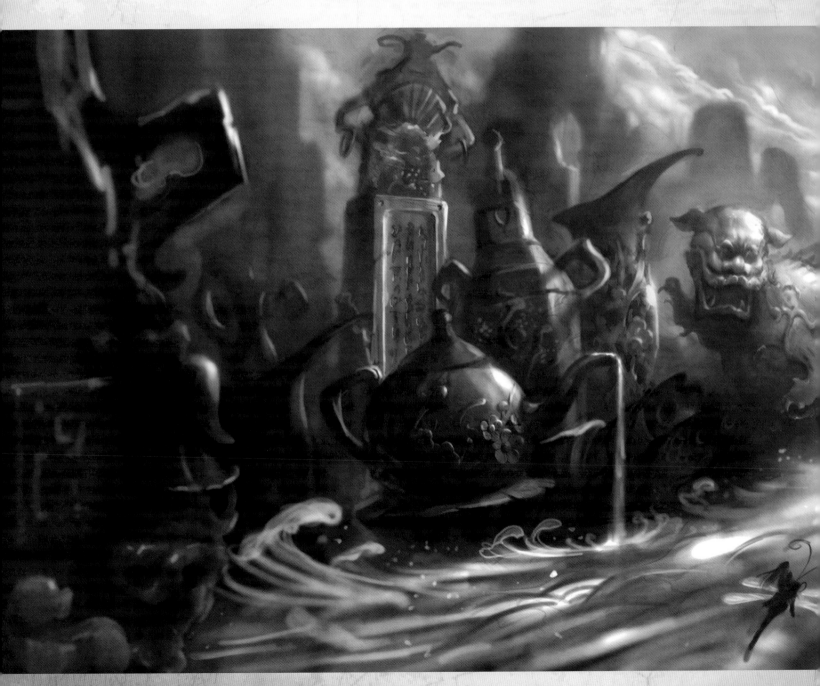

THE ART OF ALICE: *MADNESS RETURNS*

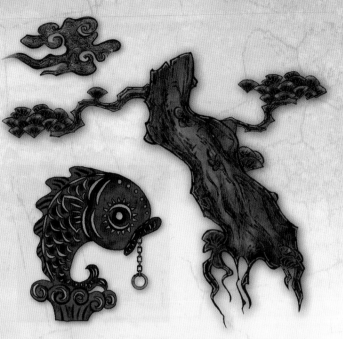

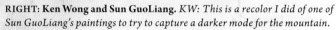

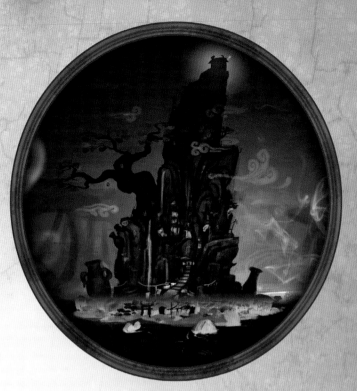

RIGHT: **Ken Wong and Sun GuoLiang.** *KW: This is a recolor I did of one of Sun GuoLiang's paintings to try to capture a darker mode for the mountain.*

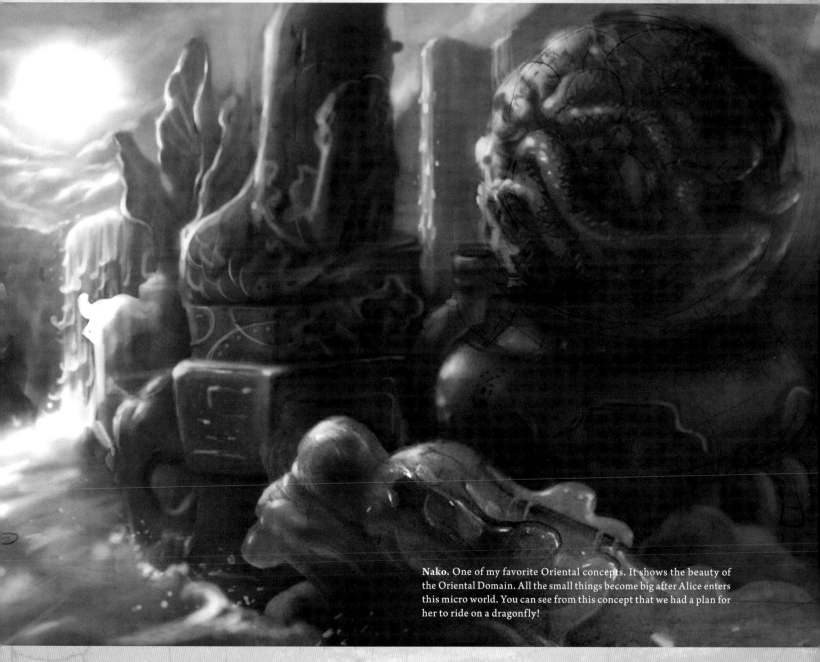

Nako. One of my favorite Oriental concepts. It shows the beauty of the Oriental Domain. All the small things become big after Alice enters this micro world. You can see from this concept that we had a plan for her to ride on a dragonfly!

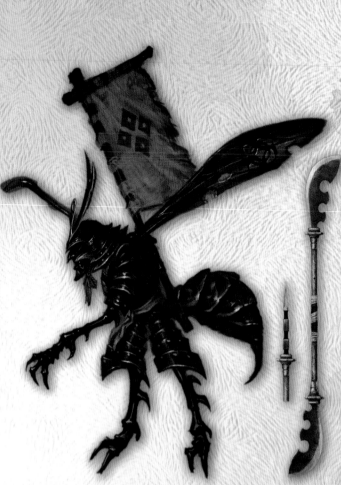

Nako. These are the Wasp Warriors, based on Japanese samurai. We combined the dark feeling of samurai and the evil spirit of the wasps to make them feel dangerous.

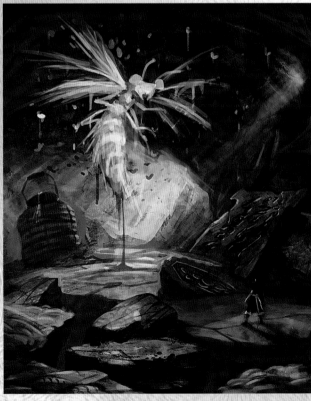

Nako. An early design for the Wasp Empress was a white ink wasp. She comes out of a Chinese red lantern.

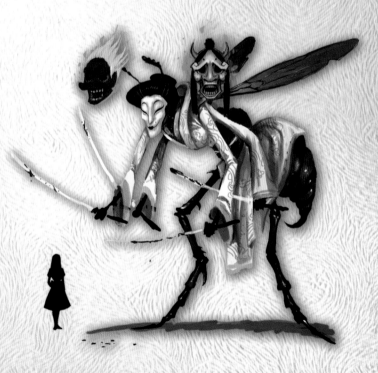

Sun GuoLiang. The final design of the Wasp Empress. I added some Japanese elements into it. She was inspired by Lucy Liu in *Kill Bill*. I gave her a beautiful kimono and three traditional Japanese masks. She is wielding katana with four arms.

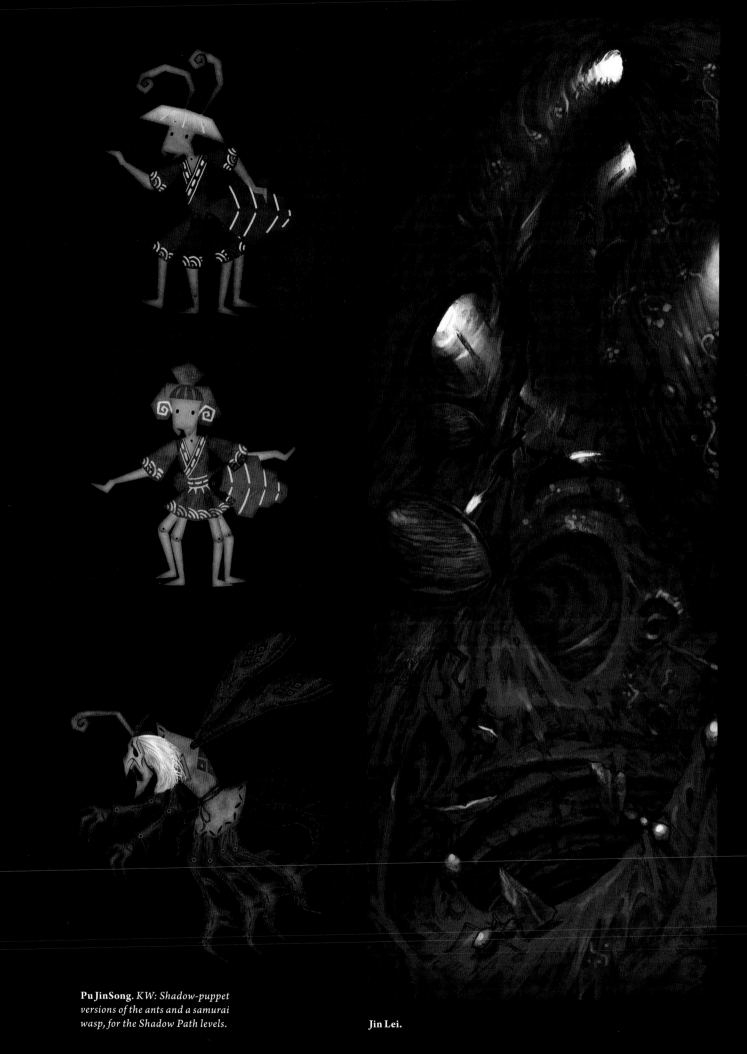

Pu JinSong. *KW: Shadow-puppet versions of the ants and a samurai wasp, for the Shadow Path levels.*

Jin Lei.

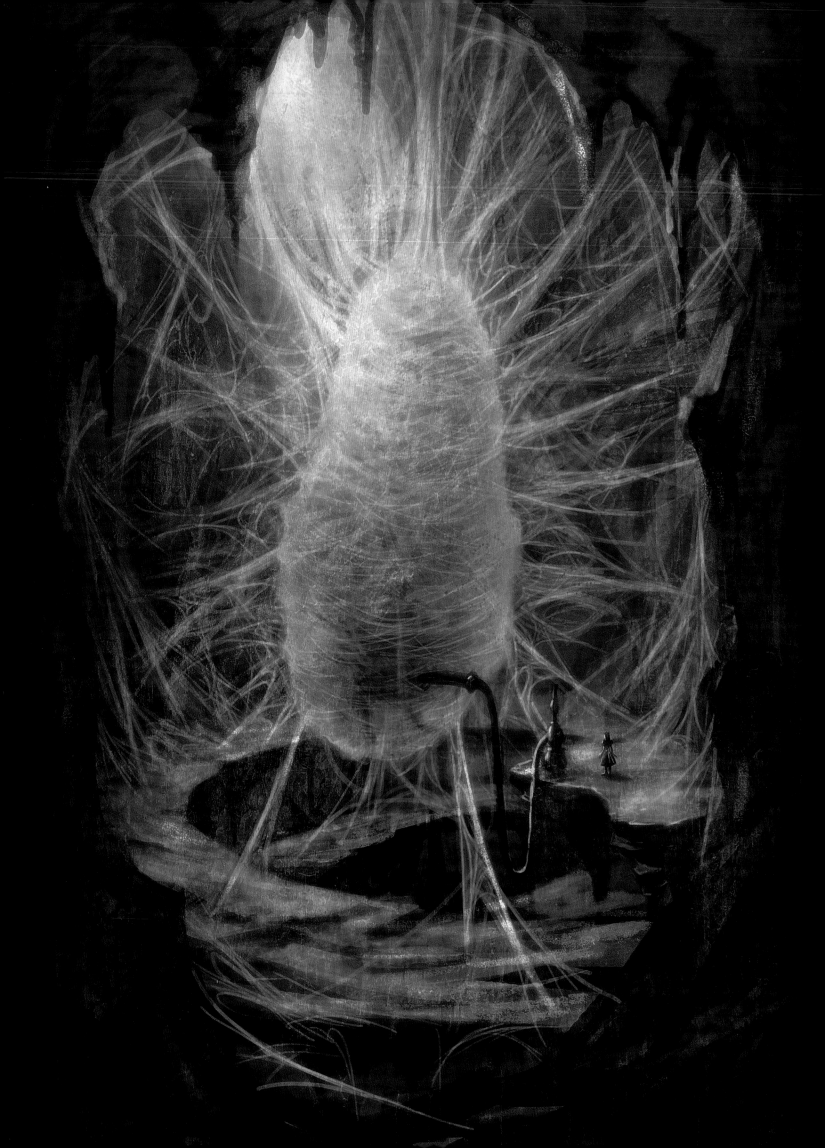

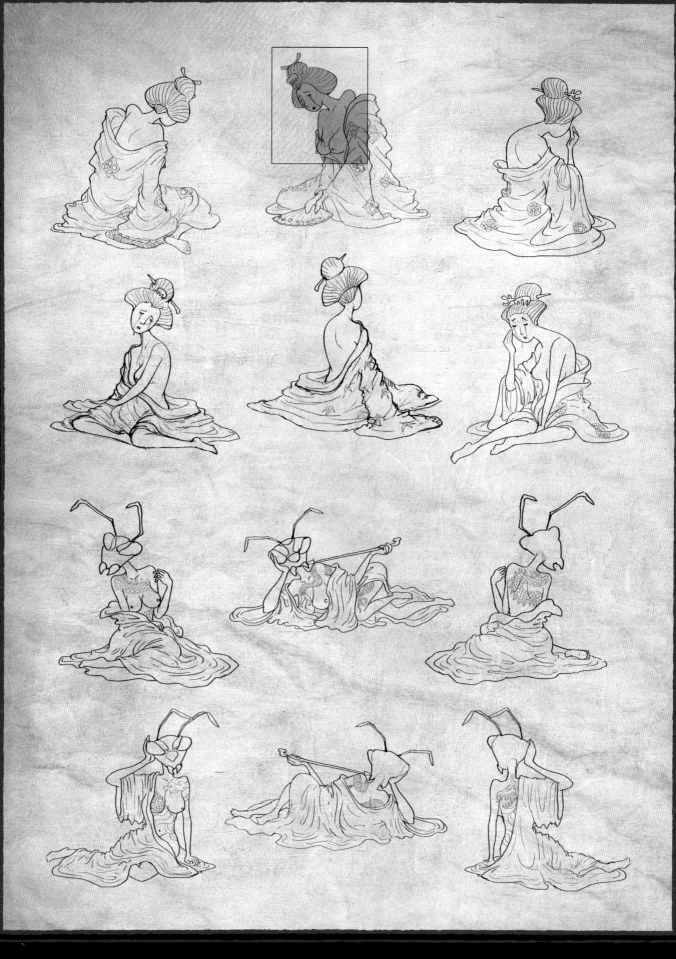

ABOVE: Yuan ShaoFeng. OPPOSITE: Nako. Alice meets the Caterpillar. Alice
is very small at this point, so I made the cocoon very big to create contrast.

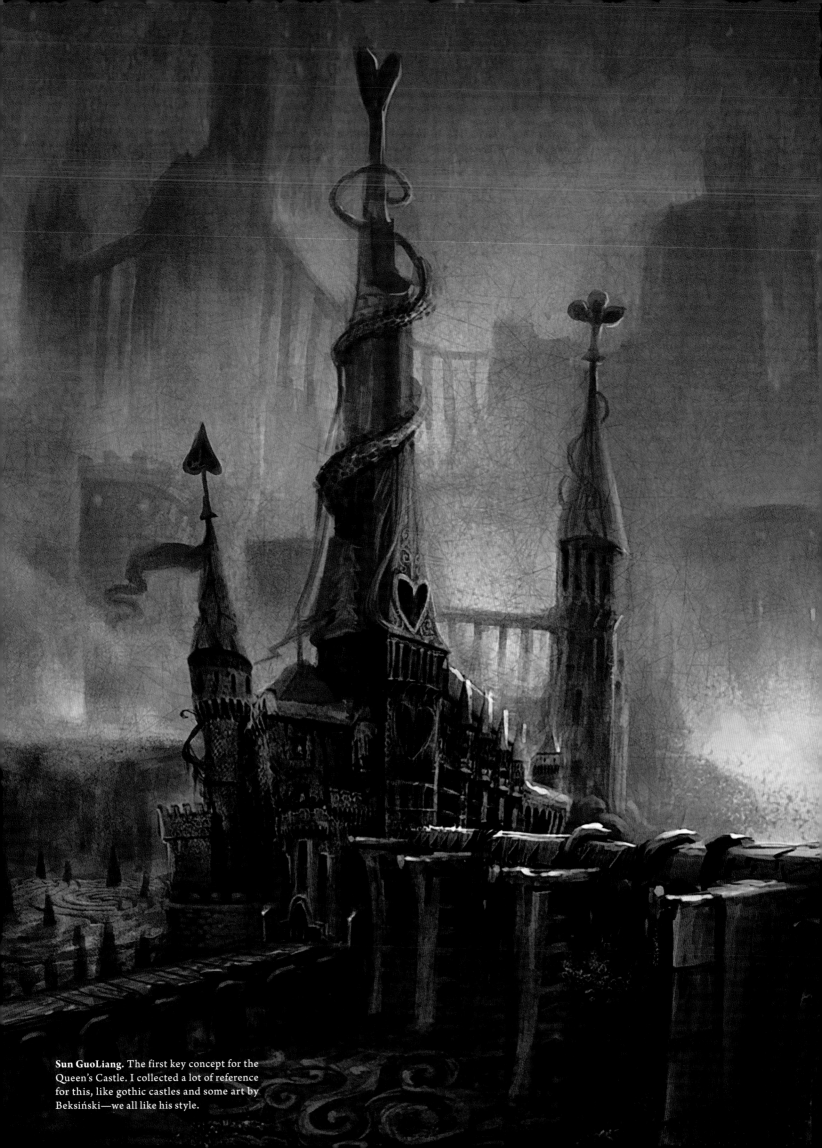

Sun GuoLiang. The first key concept for the Queen's Castle. I collected a lot of reference for this, like gothic castles and some art by Beksiński—we all like his style.

QUEENSLAND

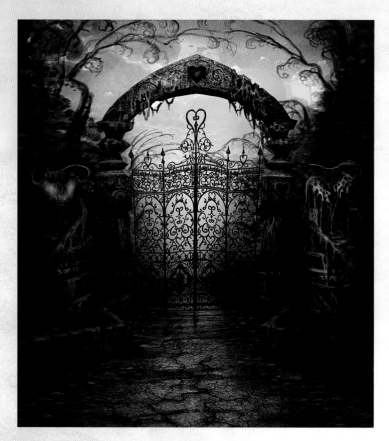

QUEENSLAND WAS PERHAPS the easiest area to design. In the original game, the Queen of Hearts was Alice's archnemesis, a strange, grotesque reflection of her. Her power was represented by giant fleshy tentacles, which spread out throughout all of Wonderland. Parts of her castle seemed made out of meat or flesh. Other parts were inspired by Gothic cathedrals.

For this second game we thought it would be interesting if all that flesh had dried out, like mummification. Her castle became a dried, dusty husk. We were inspired by the incredible work of Polish painter Zdzisław Beksiński, who mixed architecture with organic material to create stunning, surreal landscapes. We thought this perfectly mirrored the way the Queen and the castle were really one and the same. We also thought the Queen was not completely vanquished, and that somewhere in a tomb the castle remained wet and fleshy, as the Queen slowly regained her strength.

Sun GuoLiang's loose, flowing style and ability to mix references in with his painting were perfect for this domain. He took charge with several early key pieces, and then did a lot of the iconic, early asset designs.

Luis Melo. Alice is back at what remains of the Queen's maze. All life seems sucked out of it, but not the evil. The hedges are petrified and crumbling, the stone blocks are somehow rotting, and it's all too silent. Something definitely still lurks around in the maze.

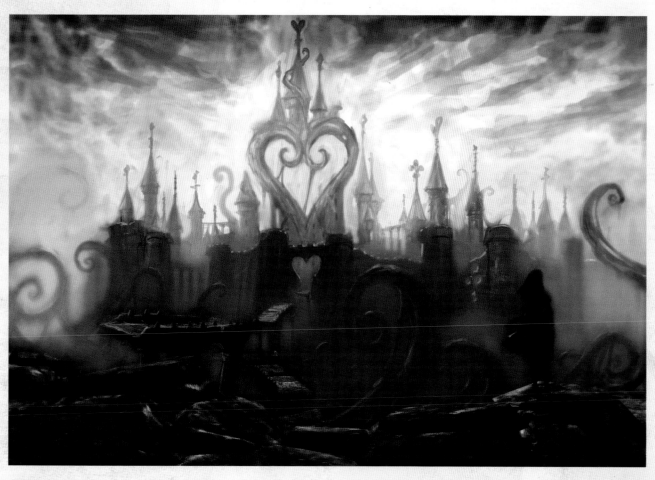

Nako. Giant Alice in the Queen's Castle.

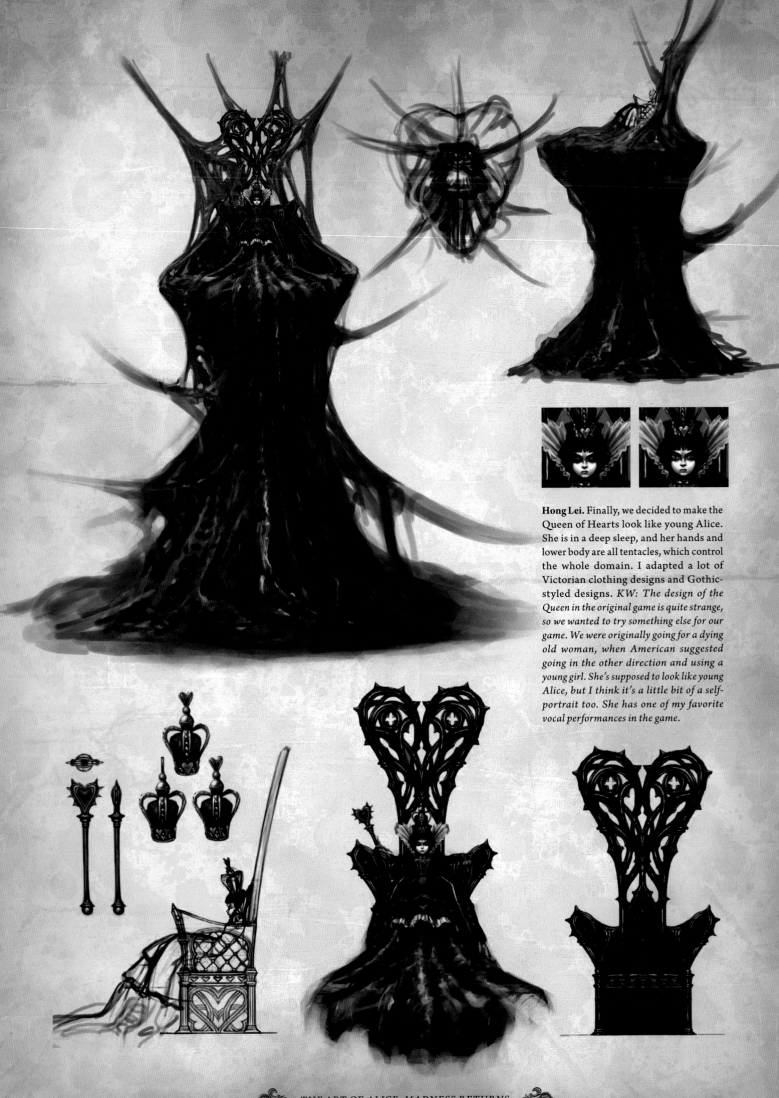

Hong Lei. Finally, we decided to make the Queen of Hearts look like young Alice. She is in a deep sleep, and her hands and lower body are all tentacles, which control the whole domain. I adapted a lot of Victorian clothing designs and Gothic-styled designs. *KW: The design of the Queen in the original game is quite strange, so we wanted to try something else for our game. We were originally going for a dying old woman, when American suggested going in the other direction and using a young girl. She's supposed to look like young Alice, but I think it's a little bit of a self-portrait too. She has one of my favorite vocal performances in the game.*

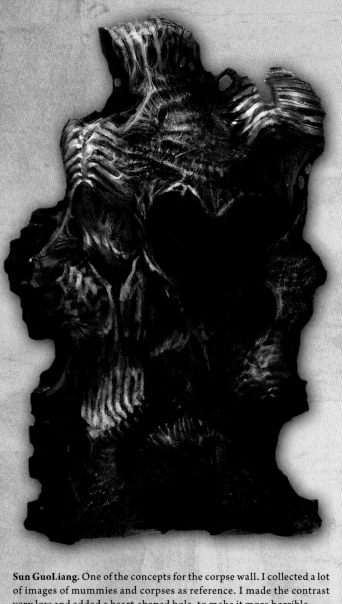

Sun GuoLiang. The finger wall is similar to the corpse wall. You can see the dry fingers crossing each other; it feels really horrible.

Sun GuoLiang. One of the concepts for the corpse wall. I collected a lot of images of mummies and corpses as reference. I made the contrast very low and added a heart-shaped hole, to make it more horrible.

BELOW: Sun GuoLiang. One of my ideas. Some tentacles suddenly come out from the ground and attack Alice. I think this will scare players and make them excited. *KW:Sometimes Sun GuoLiang absolutely nails an idea right on the first speed paint.*

Hong Lei. A device in the Queen's Domain, inspired by Beksiński.

Nako. The White King is bound by the Queen's tentacles. Alice needs to break the King to get through. I spent a lot of time on the details of the King's pained face.

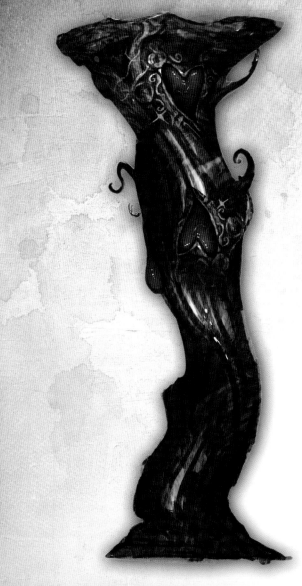

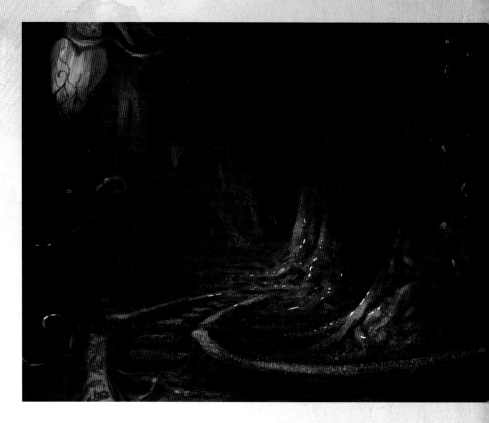

Sun GuoLiang. This is a flesh pillar in the Queen's Domain. I tried to add some carvings and decorations on the organs.

Sun GuoLiang. The underground part of the Queen's Domain is in fact her body and organs. They become part of the buildings. When you are walking in it, it feels like you are in the stomach of a giant monster. *KW:Sun GuoLiang and I tried to preserve a sense of Gothic architecture among the organic forms.*

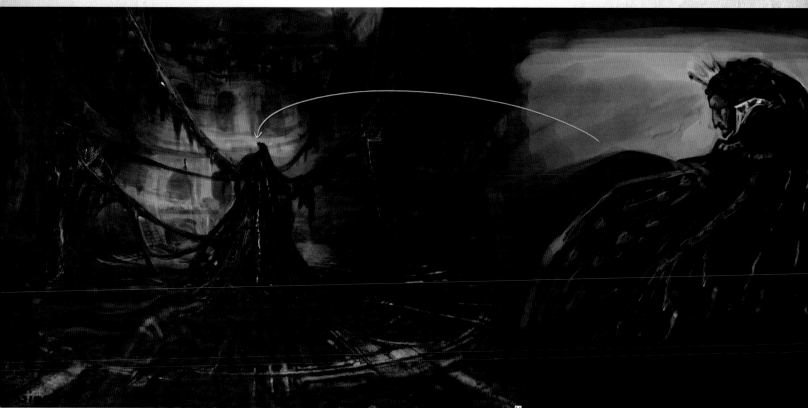

Hong Lei. This is the first design of the Queen. We referenced King Theoden from *The Two Towers* to show a feeling of weakness and near death. *KW: The chamber was inspired by the space-jockey scene in* Alien.

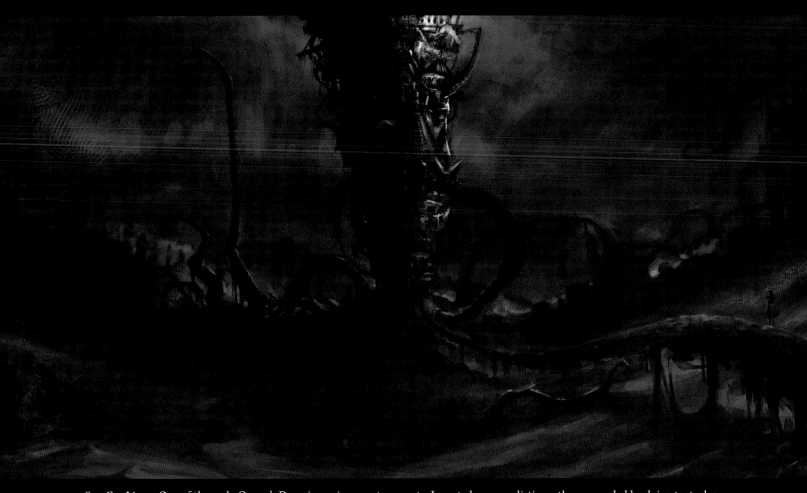

Sun GuoLiang. One of the early Queen's Domain environment concepts. I created an unrealistic castle surrounded by dying tentacles. Alice is walking toward it.

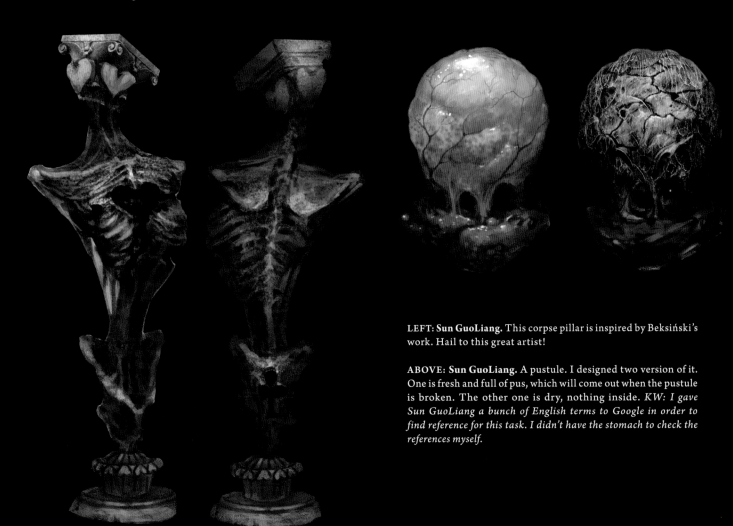

LEFT: **Sun GuoLiang.** This corpse pillar is inspired by Beksiński's work. Hail to this great artist!

ABOVE: **Sun GuoLiang.** A pustule. I designed two version of it. One is fresh and full of pus, which will come out when the pustule is broken. The other one is dry, nothing inside. *KW: I gave Sun GuoLiang a bunch of English terms to Google in order to find reference for this task. I didn't have the stomach to check the references myself.*

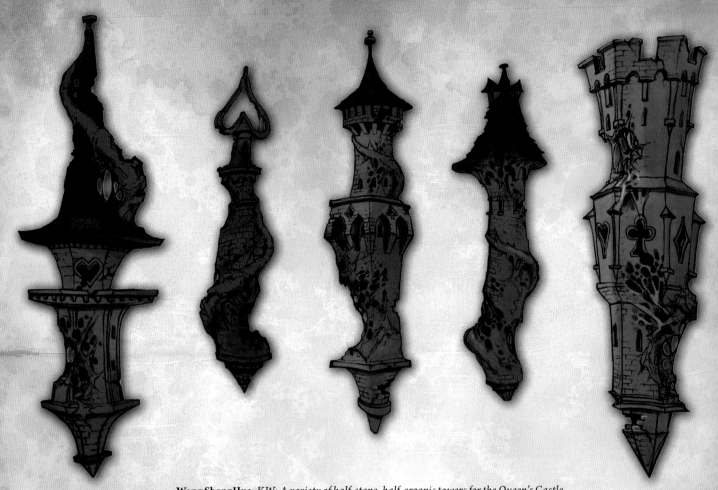

Wang ShengHua. *KW: A variety of half-stone, half-organic towers for the Queen's Castle.*

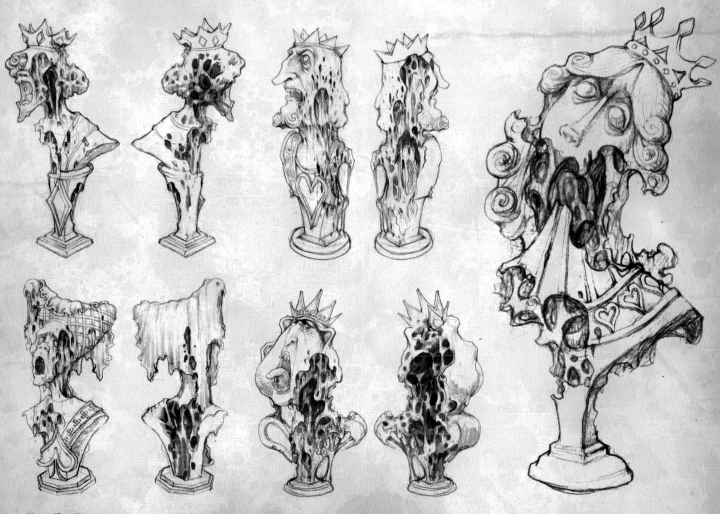

Yuan ShaoFeng.

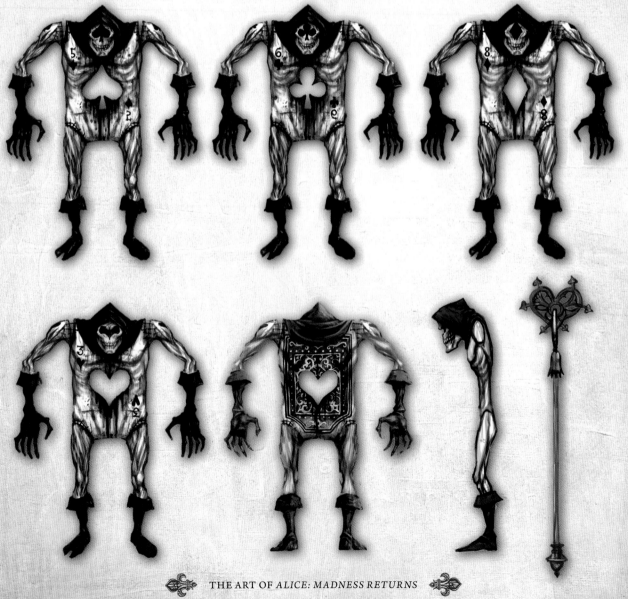

THE ART OF *ALICE: MADNESS RETURNS*

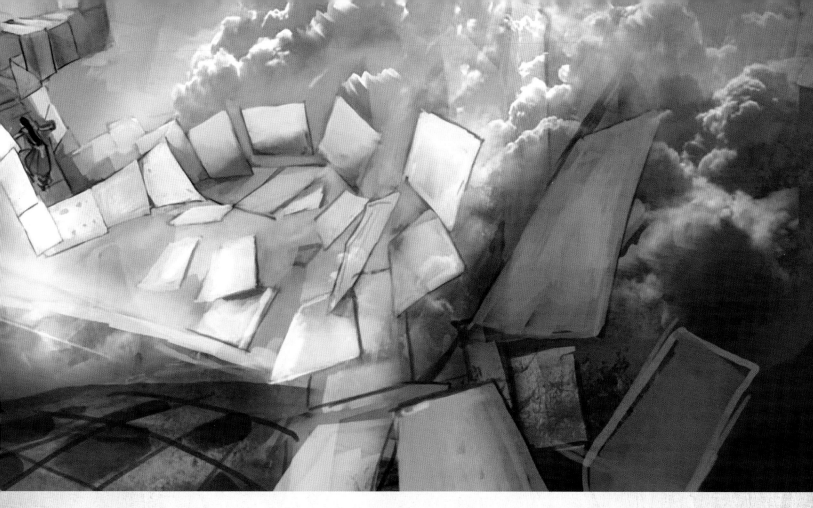

Julie Dillon.

Nako. *KW: Nako actually made this when he misunderstood what I wanted for some paintovers of this transition. It's pretty sweet, though.*

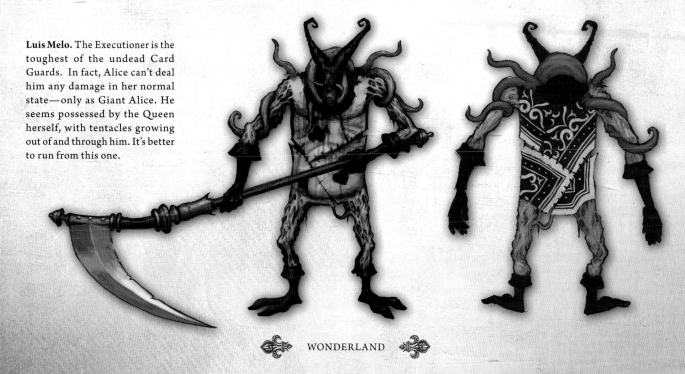

Luis Melo. The Executioner is the toughest of the undead Card Guards. In fact, Alice can't deal him any damage in her normal state—only as Giant Alice. He seems possessed by the Queen herself, with tentacles growing out of and through him. It's better to run from this one.

Sun GuoLiang. The flesh tunnel in the Queen's Domain. I don't want to talk a lot about it . . . looks very evil.

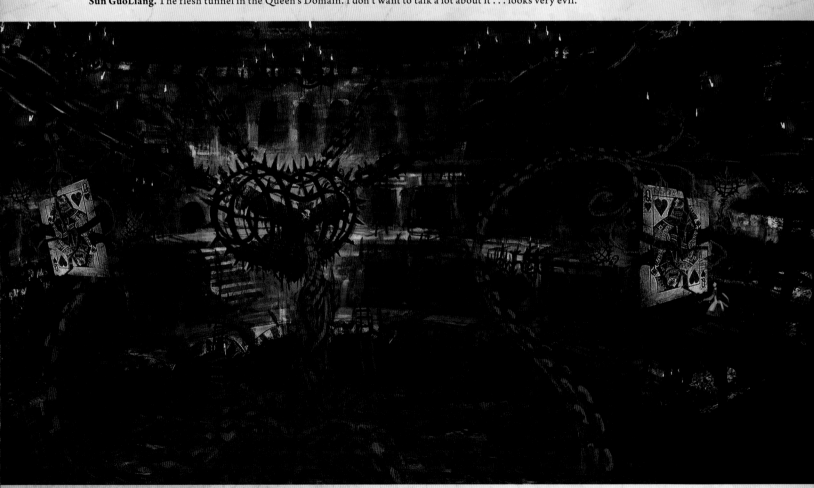

Tyler Lockett. The Queen's Catacomb. Although she's imprisoned in a heart-shaped cell, the tentacles have continued to grow from her chest and are puppeteering some angry, mace-toting playing cards.

 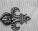

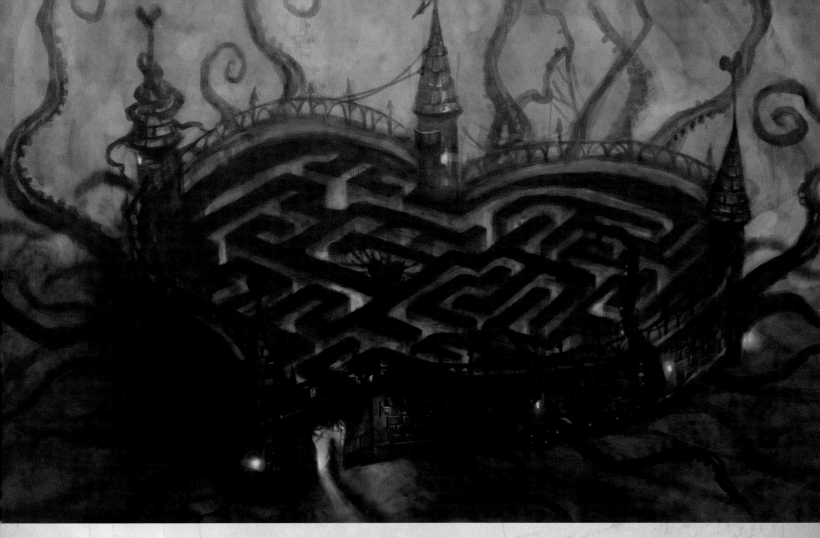

Nako. The maze is not big. Alice becomes Giant Alice once she reaches the center.

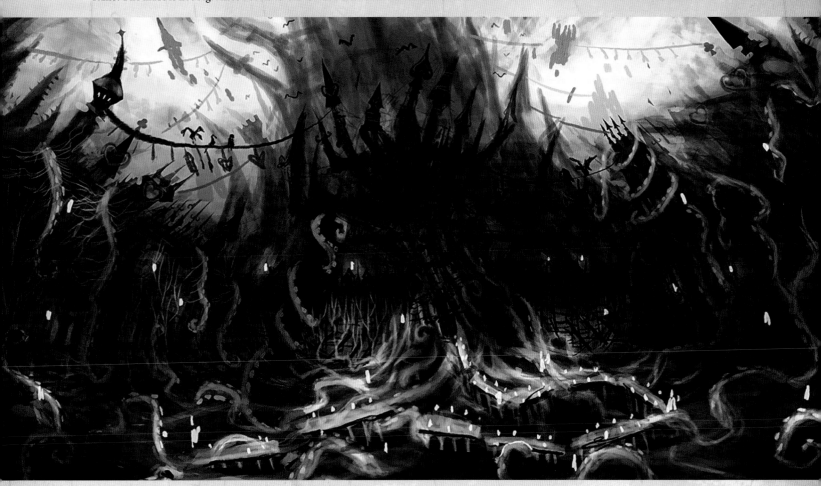

Tyler Lockett. An "atmosphere sketch" (i.e., lackluster draftsmanship) of the entrance to the Queen's Castle.

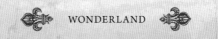

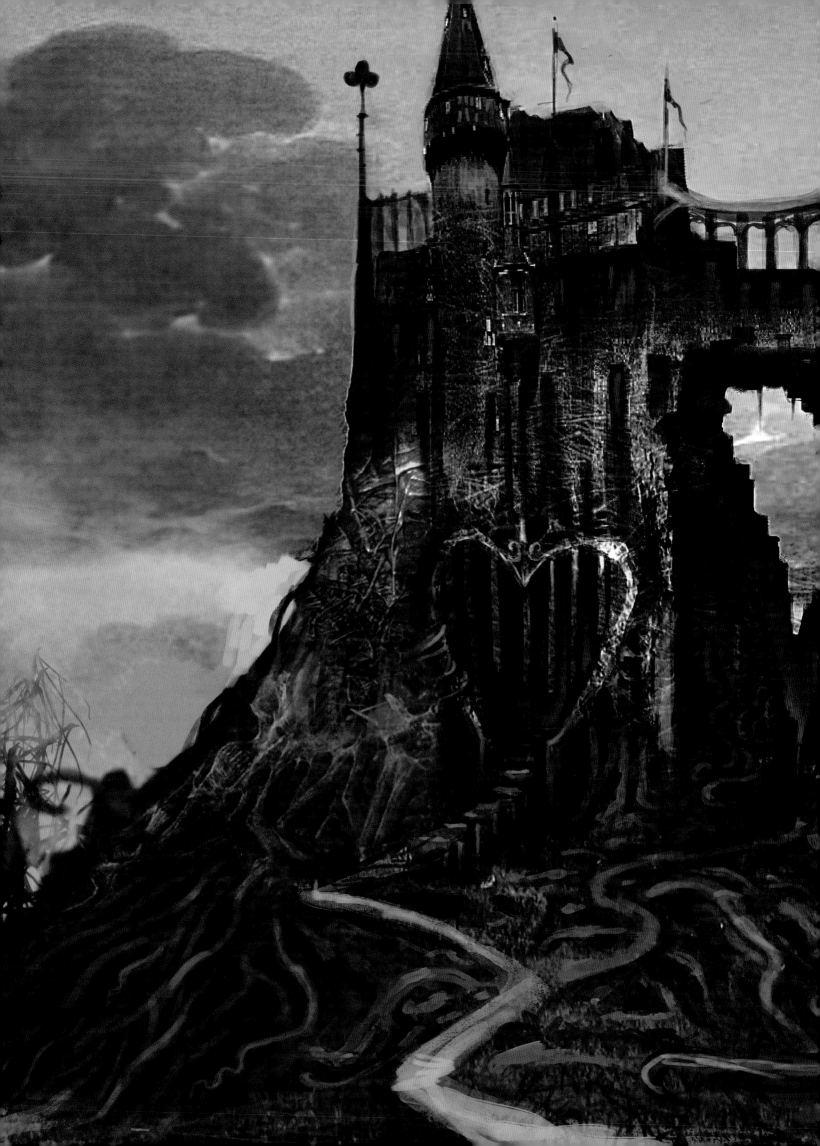

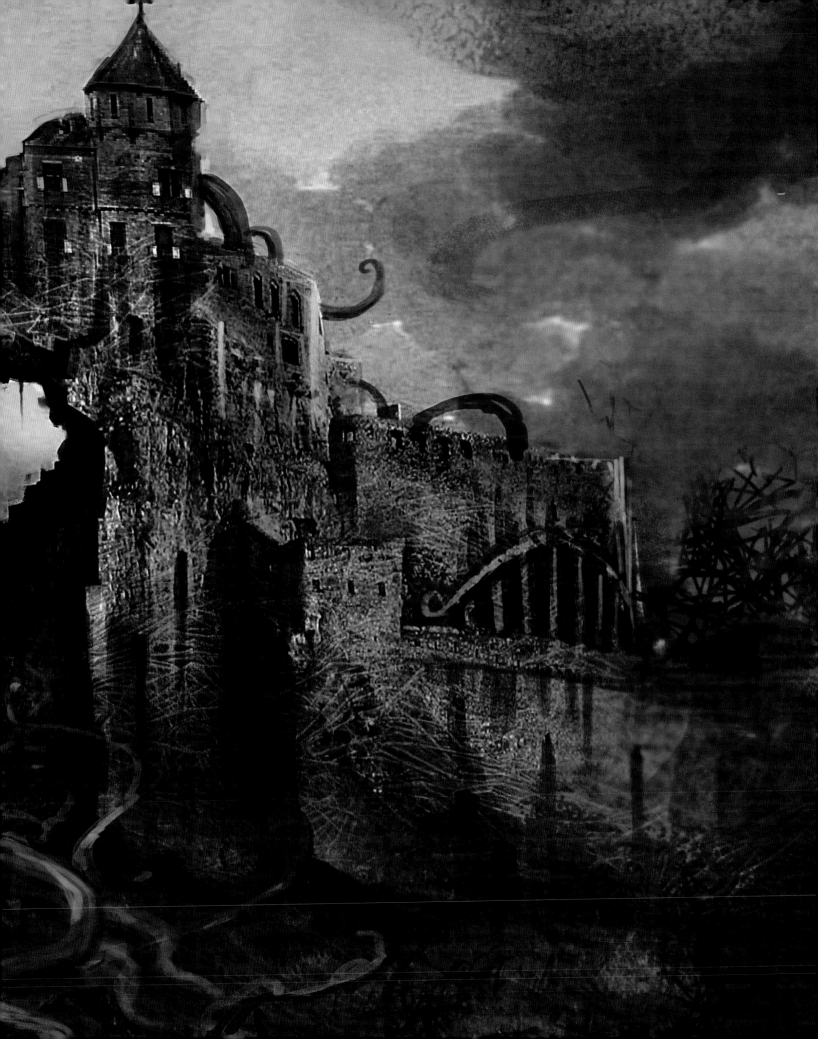

Sun GuoLiang. An old, broken scene near the entrance of the Queen's Castle.

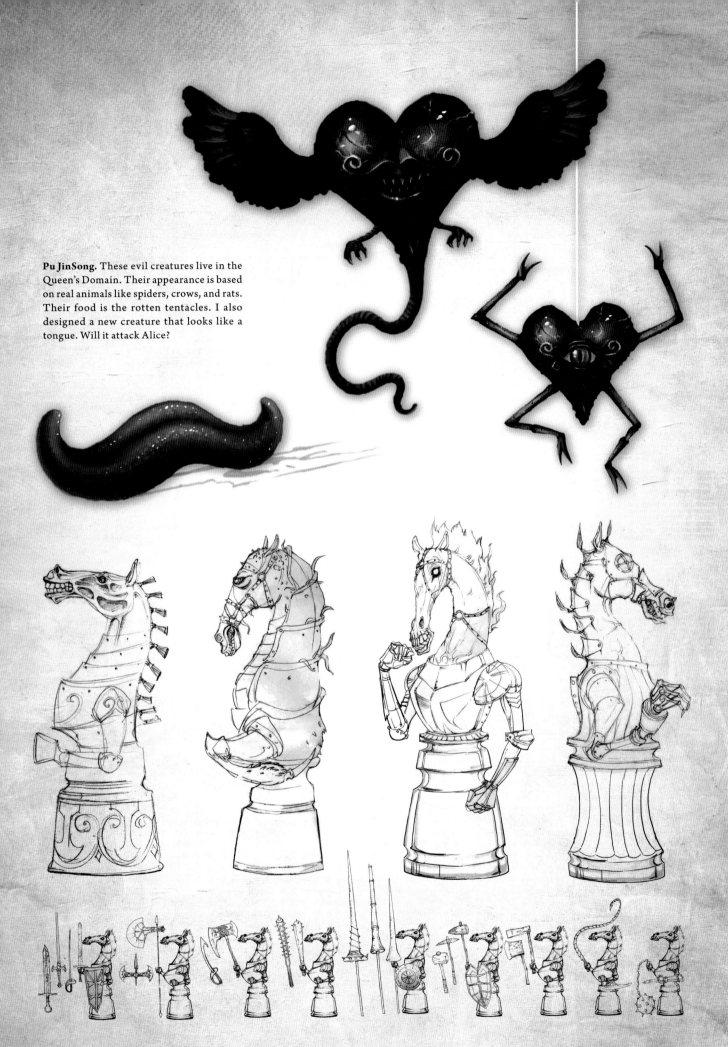

Pu JinSong. These evil creatures live in the Queen's Domain. Their appearance is based on real animals like spiders, crows, and rats. Their food is the rotten tentacles. I also designed a new creature that looks like a tongue. Will it attack Alice?

Wang ShengHua. I tried a lot of designs for the Chess Players: golden ones, transmuted ones, dead ones, and demon ones. I like the dead ones most, and I designed a lot of weapons for them.

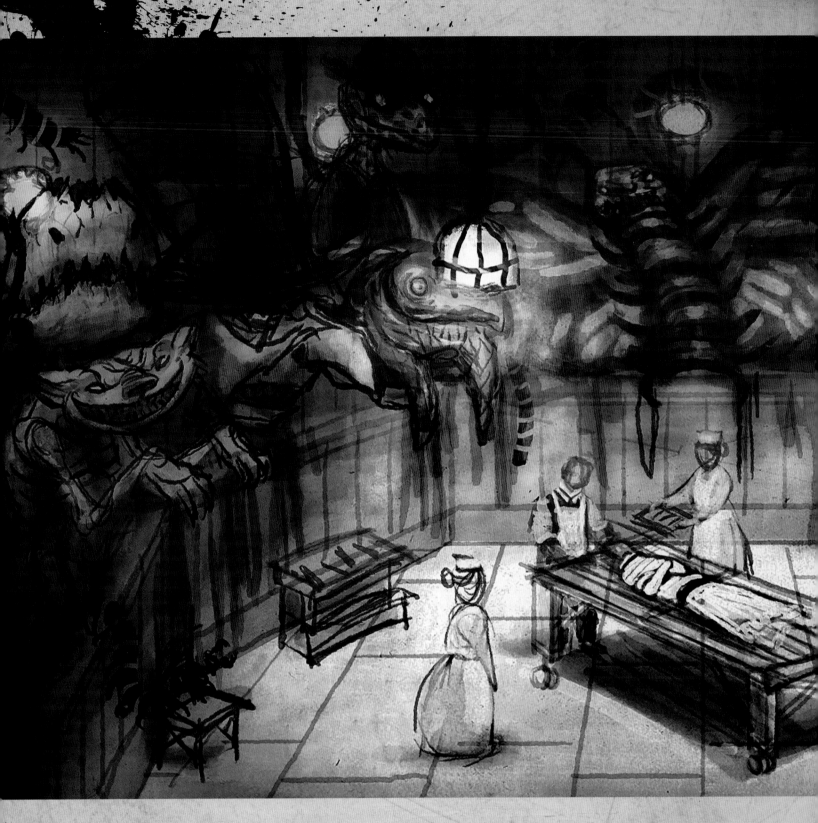

Tyler Lockett. Alice strapped down to a gurney, ready to receive a lobotomy, gets some moral support from her imaginary friends to break free.

RIGHT: **Nako.** The Tweedle brothers are very interesting characters in the first game. This time, they become orderlies in the Asylum, and will return to the original style when Alice is mad.

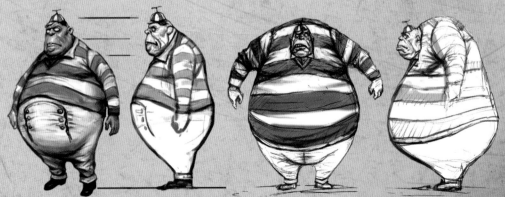

 THE ART OF ALICE: MADNESS RETURNS

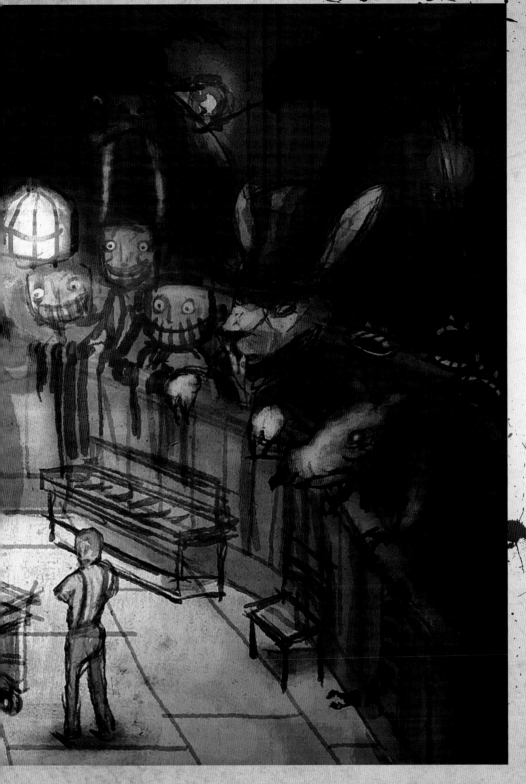

THE ASYLUM

THE SHORT Rutledge Asylum sequence was a chance for us to do some creepy stuff in a more familiar environment. We wanted to flicker between two worlds— the "normal" Asylum closer to what it was really like, and a surreal, white, "insane" Asylum, which is perhaps how Alice saw the place. Every prop and character here has two versions. The clean, white, insane motif gave us a chance to design some horrific stuff in a really different way. We were inspired by the art and photography of Gottfried Helnwein.

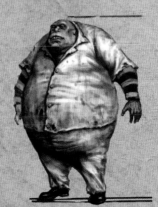
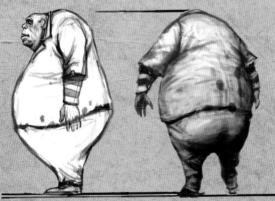
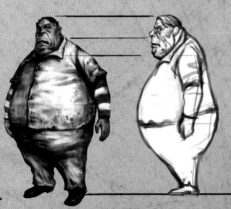

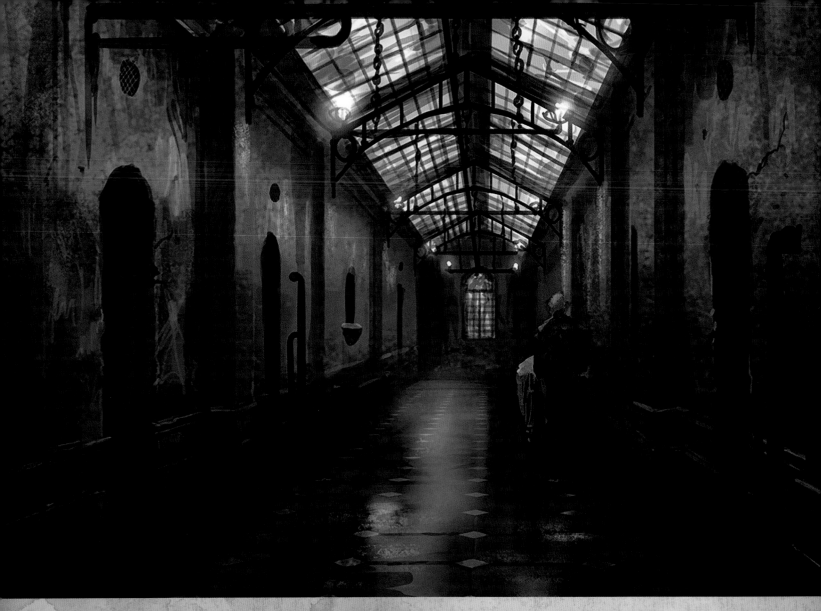

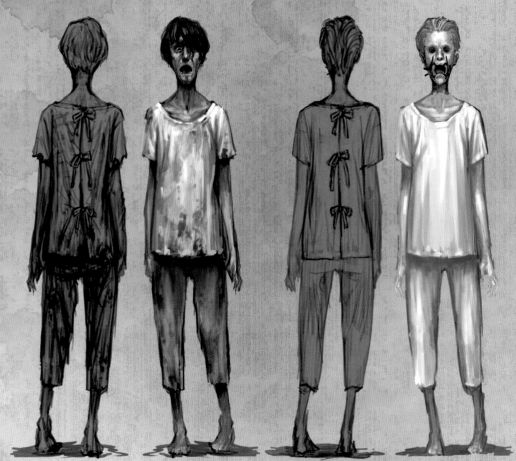

ABOVE: Luis Melo. Finding herself back in the Asylum, Alice is on the verge of insanity. At some point, within all the madness in these corridors, she can't handle reality anymore, so she enters a trancelike horror state in which hallucinations start to pour in and characters are distorted. Everything turns clean white, against which the blood flows painfully red after the strange atrocities that start occurring. Is it all really happening?

THE ART OF *ALICE: MADNESS RETURNS*

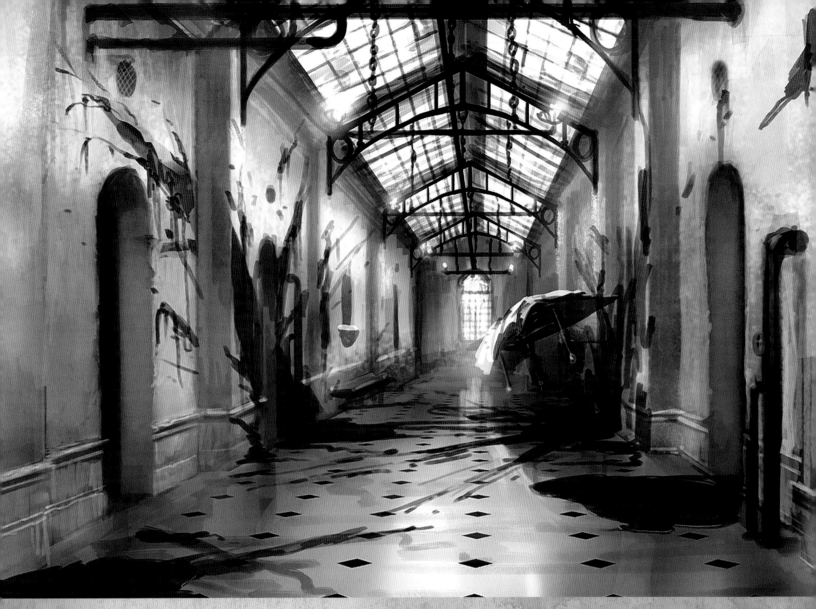

LEFT: Hong Lei. The male patient in the Asylum comes in two versions: normal and insane. When Alice becomes mad, both the people and the building turn into the insane versions.

RIGHT: Hong Lei. In the insane version, the patient is bound to show Alice's crazy mind.

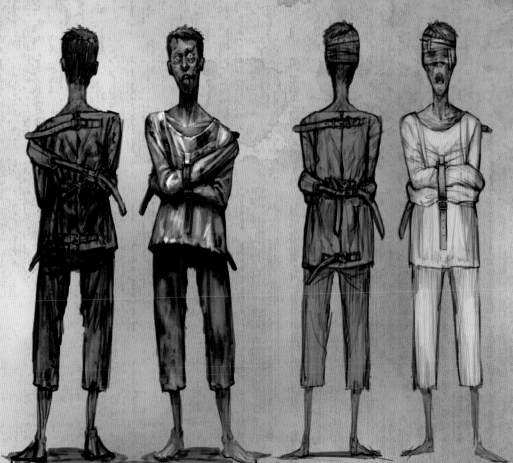

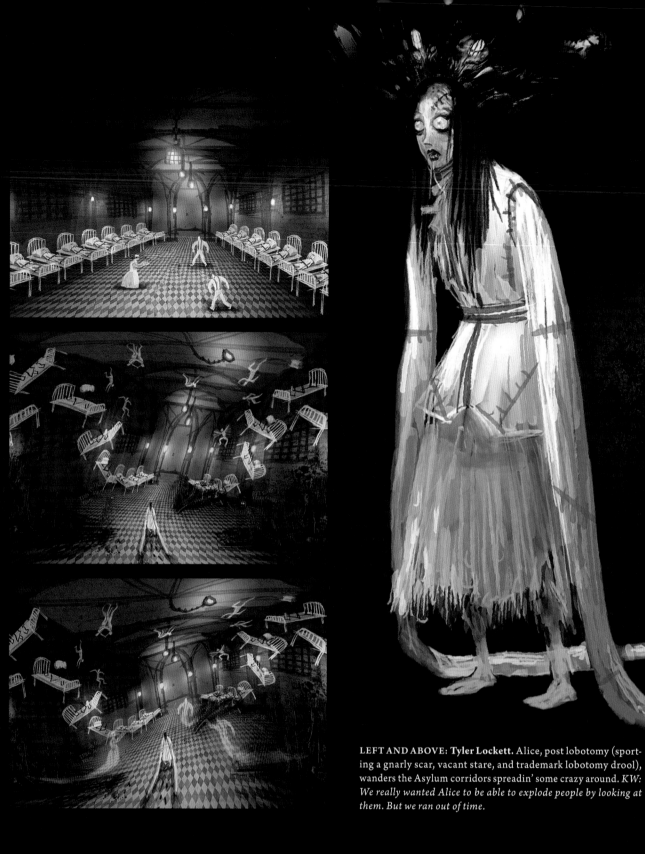

LEFT AND ABOVE: Tyler Lockett. Alice, post lobotomy (sporting a gnarly scar, vacant stare, and trademark lobotomy drool), wanders the Asylum corridors spreadin' some crazy around. *KW: We really wanted Alice to be able to explode people by looking at them. But we ran out of time.*

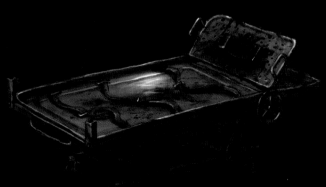

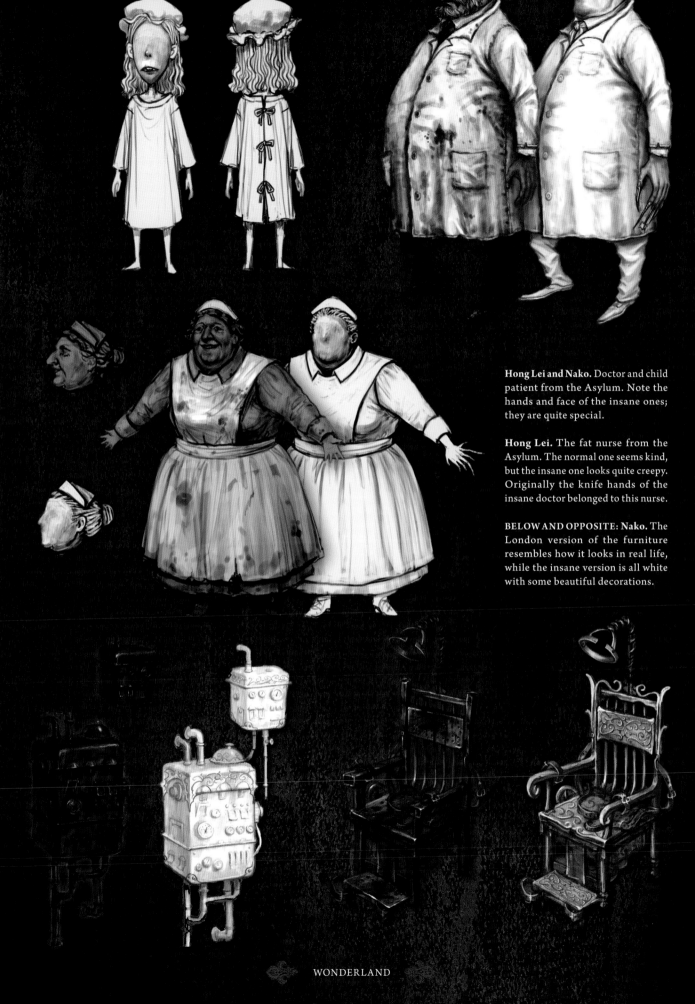

Hong Lei and Nako. Doctor and child patient from the Asylum. Note the hands and face of the insane ones; they are quite special.

Hong Lei. The fat nurse from the Asylum. The normal one seems kind, but the insane one looks quite creepy. Originally the knife hands of the insane doctor belonged to this nurse.

BELOW AND OPPOSITE: Nako. The London version of the furniture resembles how it looks in real life, while the insane version is all white with some beautiful decorations.

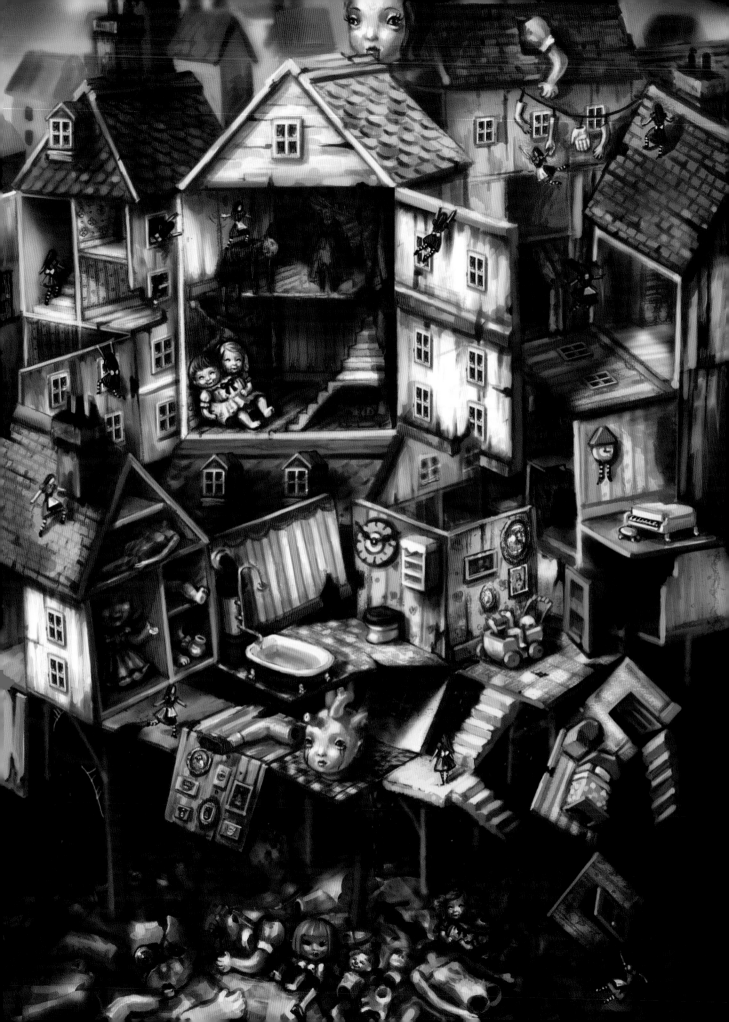

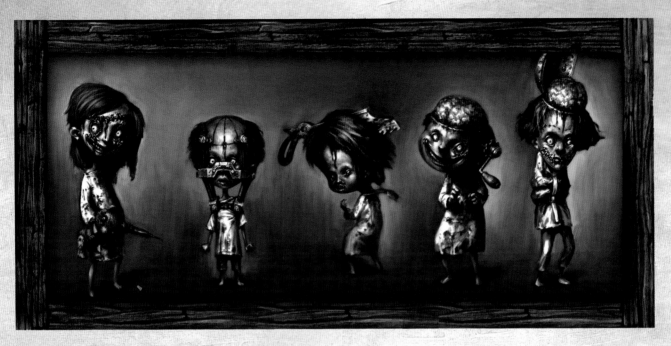

Hong Lei. The insane kids live in the dollhouse, as they did in the first *Alice*. We wanted them to be crazier this time, so I took references from some cerebral-surgery books. *KW: To connect the Dollhouse with the first game, we brought back these insane children, but we wanted to give them a bit of a redesign. Hong Lei recaptured their personalities perfectly.*

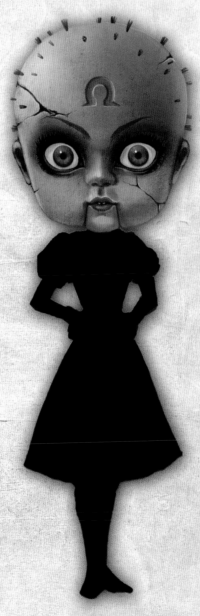

Pu JinSong. This is the doll-head version of Alice. We based it on Alice's face to differentiate it from other doll heads.

PREVIOUS PAGE: Hong Lei. The Dollhouse is an original area created for the game. We used Victorian dollhouses as reference and put in a lot of surreal and weird elements. In this concept art, we showed the bright and colorful style of this scene, as well as some gameplay elements.

THE DOLLHOUSE

WHEN WE SET out to design Wonderland, we brainstormed lots of new locations Alice could visit, themed around childhood or Victoriana or gameplay ideas. After Hong Lei created the image on the facing page, we knew we had to have a gigantic dollhouse level in the game.

As you can see, this one image contains a wealth of gameplay and design ideas, which we mined over the course of production. We really liked the idea of walls folding out, and we kept finding new ways to use doll limbs and heads in horrible ways.

The aesthetic for this area was inspired by the work of Mark Ryden and other lowbrow/*Hi-Fructose* artists. We used wood, porcelain doll parts, cake, and candles, unified with a pastel color scheme.

After Hong Lei's initial image, we wanted to explore the basement below the dollhouses. Our initial idea was that dolls were discarded down here. Then we became inspired by the work of the Brothers Quay and their amazing stop-motion puppet work. We thought this dark, dusty underworld was the perfect complement to the colorful yet twisted world above. Here, the wood is rougher, and nails and screws become more prevalent. Wires and sewing-machine parts appear, which later became a motif of the Dollmaker. We also had fun mixing bones and other creepy biological elements together.

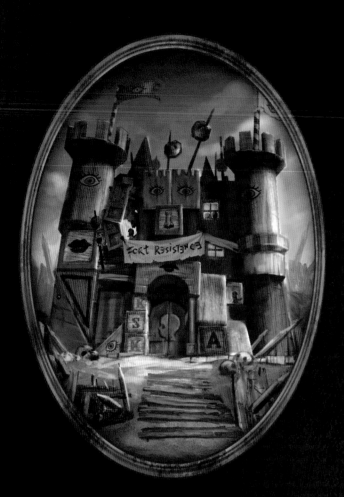

Nako. *KW: A paintover of the doll fort, the insane children's last stand.*

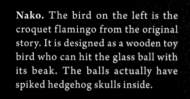

Nako. The bird on the left is the croquet flamingo from the original story. It is designed as a wooden toy bird who can hit the glass ball with its beak. The balls actually have spiked hedgehog skulls inside.

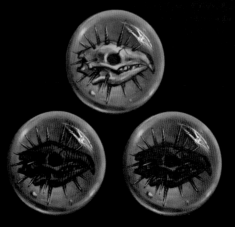

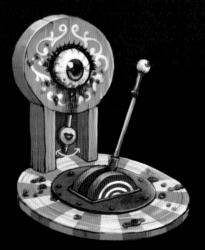

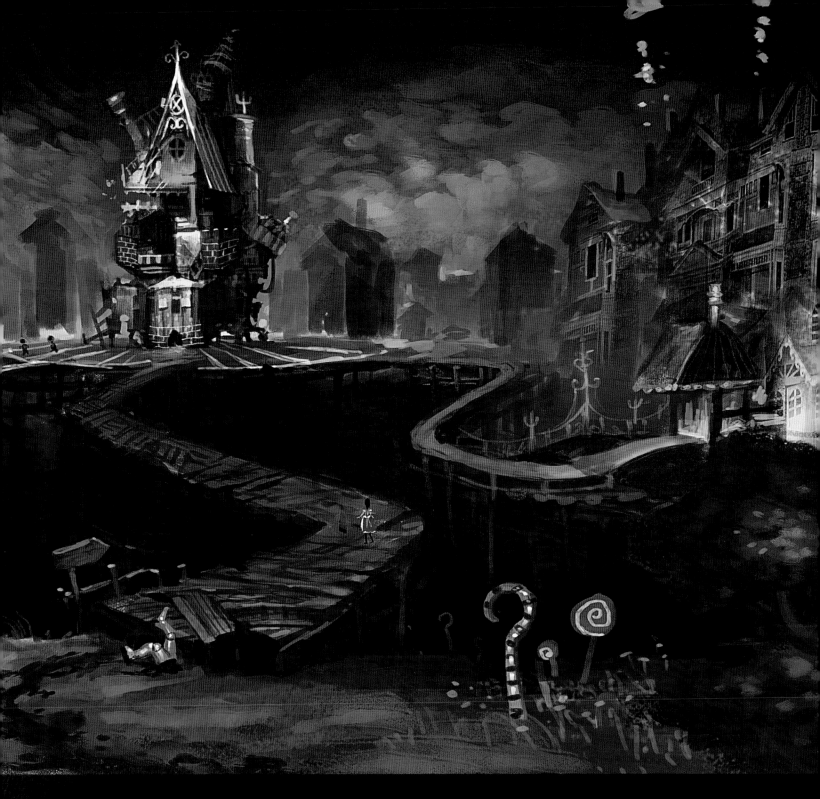

ABOVE: Sun GuoLiang. An early image describing the layout of the Dollhouse Domain. Dollboys live in the left area and Dollgirls in the right, and in the middle there is a castle. This is a rough image without much detail.

LEFT: Yuan ShaoFeng. *KW: We tried to reference characters from the original stories as much as possible.*

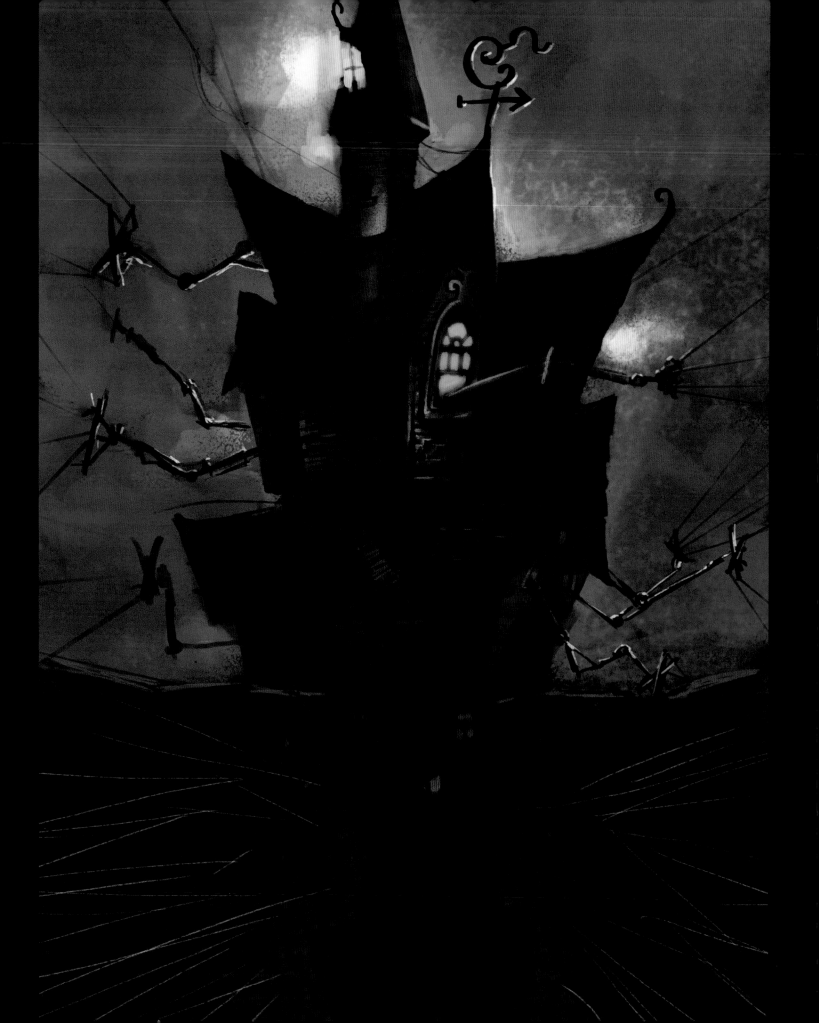

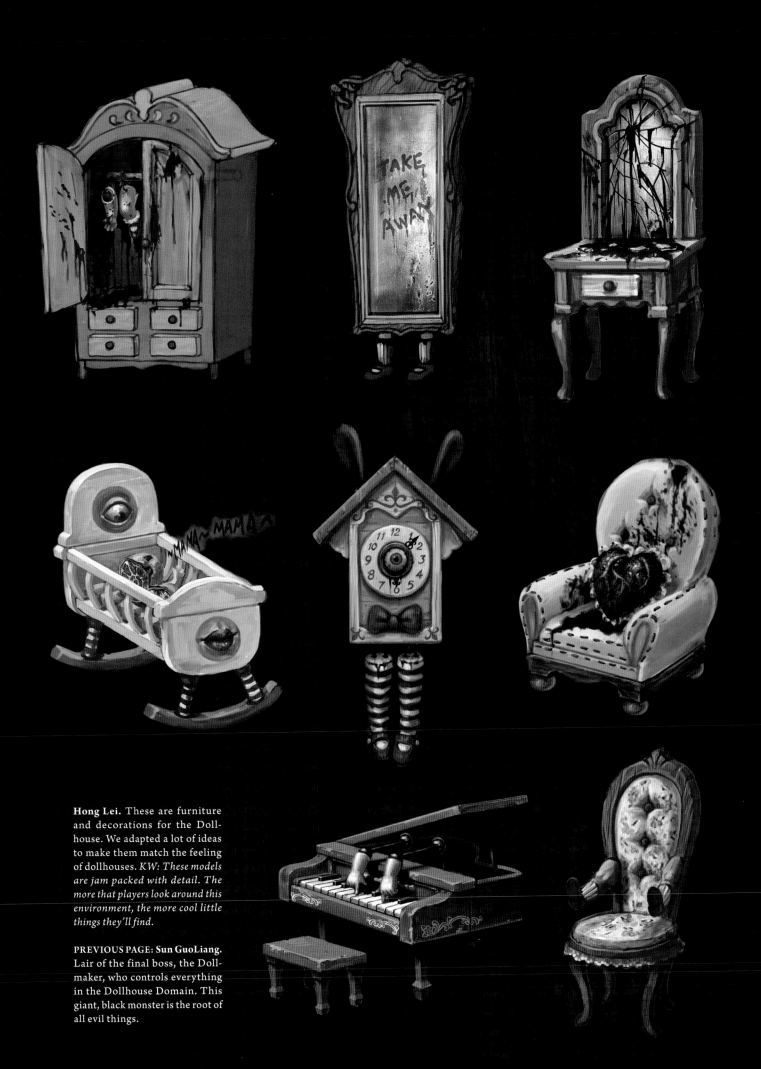

Hong Lei. These are furniture and decorations for the Doll-house. We adapted a lot of ideas to make them match the feeling of dollhouses. *KW: These models are jam packed with detail. The more that players look around this environment, the more cool little things they'll find.*

PREVIOUS PAGE: Sun GuoLiang. Lair of the final boss, the Doll-maker, who controls everything in the Dollhouse Domain. This giant, black monster is the root of all evil things.

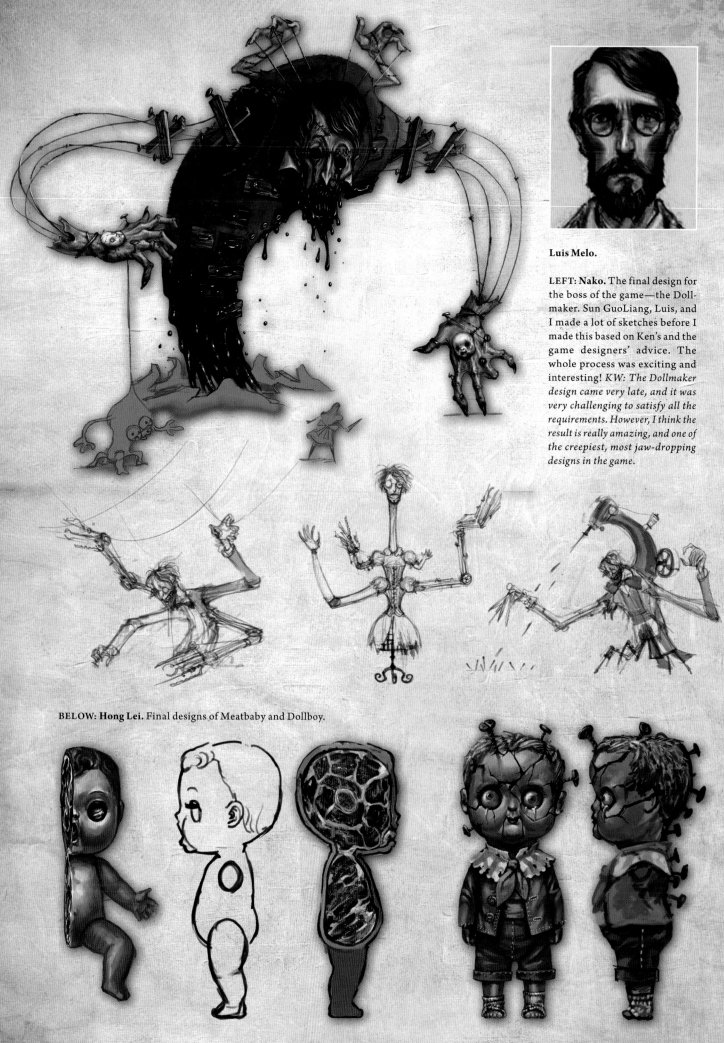

Luis Melo.

LEFT: **Nako.** The final design for the boss of the game—the Doll-maker. Sun GuoLiang, Luis, and I made a lot of sketches before I made this based on Ken's and the game designers' advice. The whole process was exciting and interesting! *KW: The Dollmaker design came very late, and it was very challenging to satisfy all the requirements. However, I think the result is really amazing, and one of the creepiest, most jaw-dropping designs in the game.*

BELOW: **Hong Lei.** Final designs of Meatbaby and Dollboy.

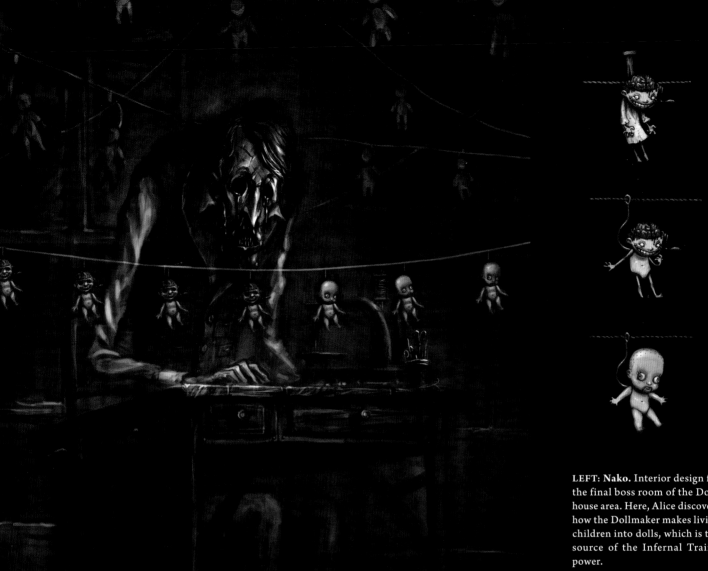

LEFT: **Nako.** Interior design for the final boss room of the Dollhouse area. Here, Alice discovers how the Dollmaker makes living children into dolls, which is the source of the Infernal Train's power.

BELOW: **Hong Lei and Wu YueHan.** *KW: These are the damage states for Dollgirl. A lot of the combat design came after the models were made, which meant we needed to go back and create damage states and weak points. Dollgirl's heart cavity is milky, an allusion to Alien.*

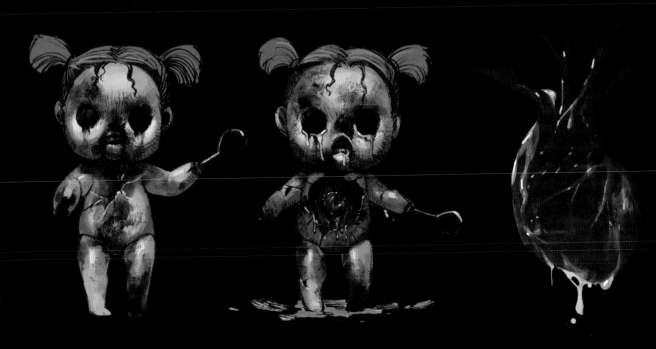

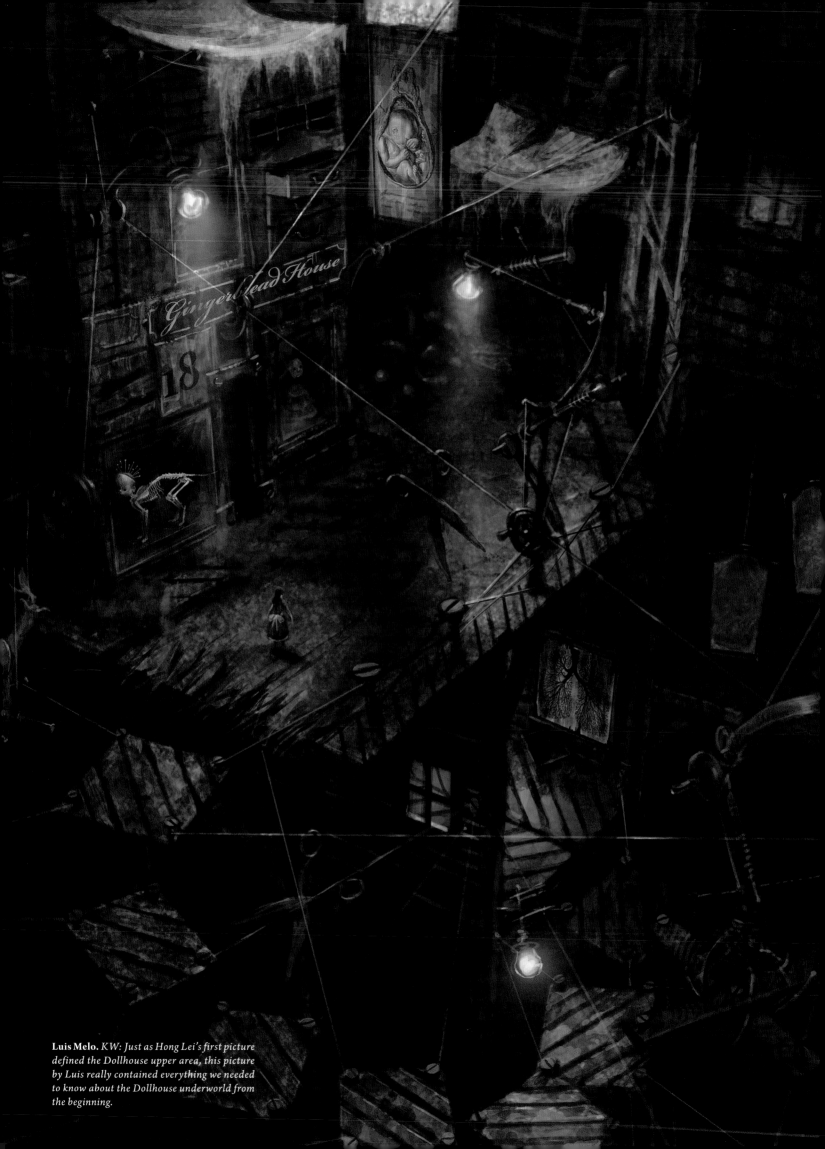

Gingerbread House

Luis Melo. *KW: Just as Hong Lei's first picture defined the Dollhouse upper area, this picture by Luis really contained everything we needed to know about the Dollhouse underworld from the beginning.*

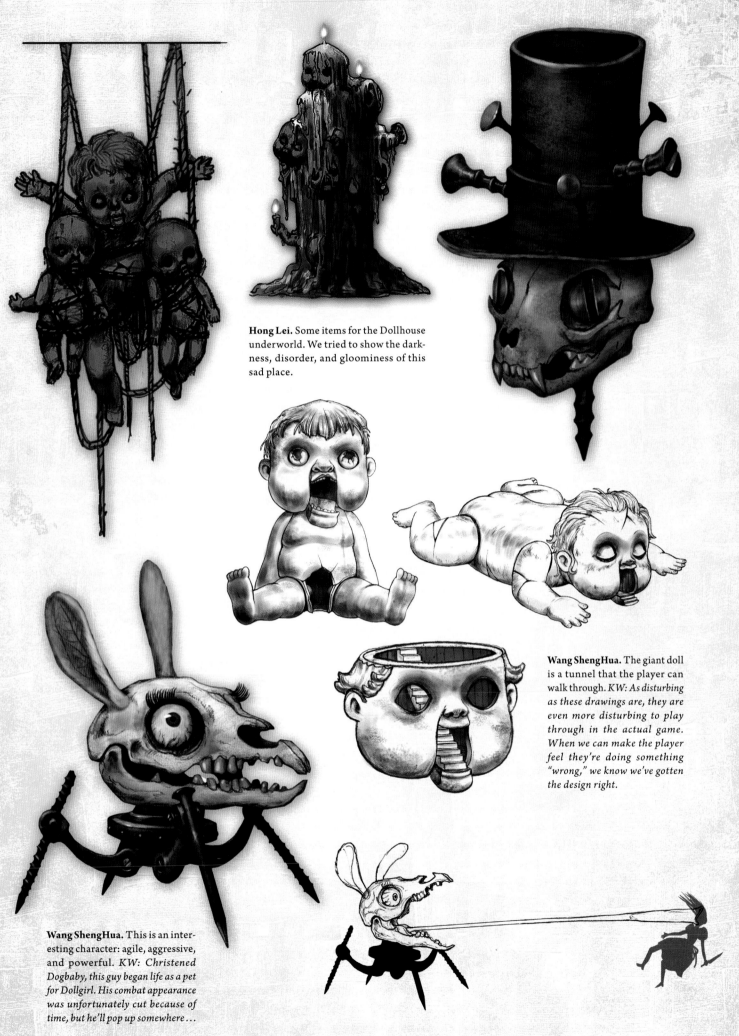

Hong Lei. Some items for the Dollhouse underworld. We tried to show the darkness, disorder, and gloominess of this sad place.

Wang ShengHua. The giant doll is a tunnel that the player can walk through. *KW: As disturbing as these drawings are, they are even more disturbing to play through in the actual game. When we can make the player feel they're doing something "wrong," we know we've gotten the design right.*

Wang ShengHua. This is an interesting character: agile, aggressive, and powerful. *KW: Christened Dogbaby, this guy began life as a pet for Dollgirl. His combat appearance was unfortunately cut because of time, but he'll pop up somewhere…*

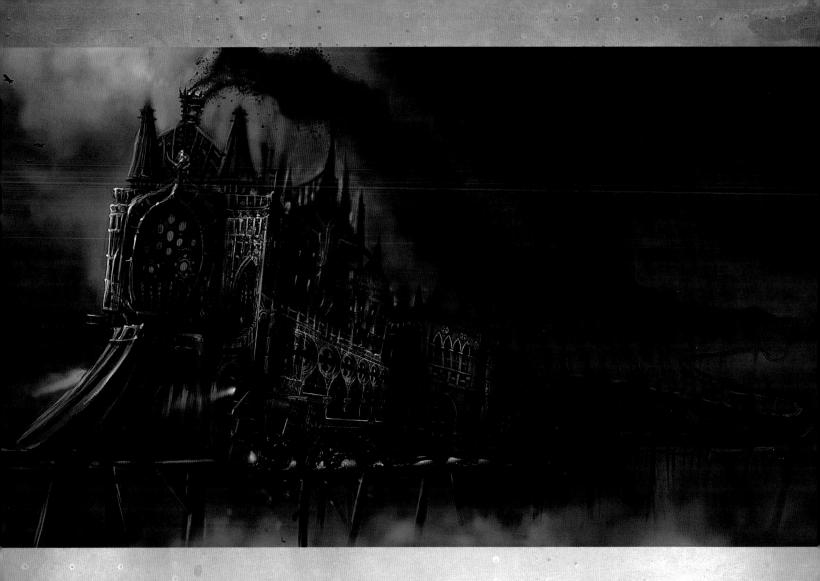

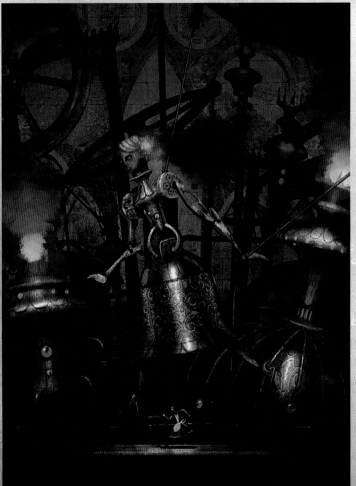

INFERNAL TRAIN

BEING THE SECOND episode in the game series, we wanted *Madness Returns* to borrow certain elements from *Through the Looking-Glass*, including the train line. In our game, the train has morphed into something quite different—a harbinger of doom, a representation of the end of Wonderland, and with it, Alice herself. It chases Alice through the world, haunting her.

The image above by Sun GuoLiang was done early on and remains the strongest representation of the train—a gothic monstrosity, with carriages grown to the size of cathedrals. It serves as the stage for the showdown with the Dollmaker. To the left is an early image of what the interior might possibly have looked like, when it was a much bigger level. We tried our best to separate the themes and motifs of the train from the Hatter's Domain.

TOP: Sun GuoLiang. This Infernal Train design was made when we had just started this project. It comes from Ken's description and the designers' requirements. This steam monster is made up of big buildings, really huge.

LEFT: Luis Melo.

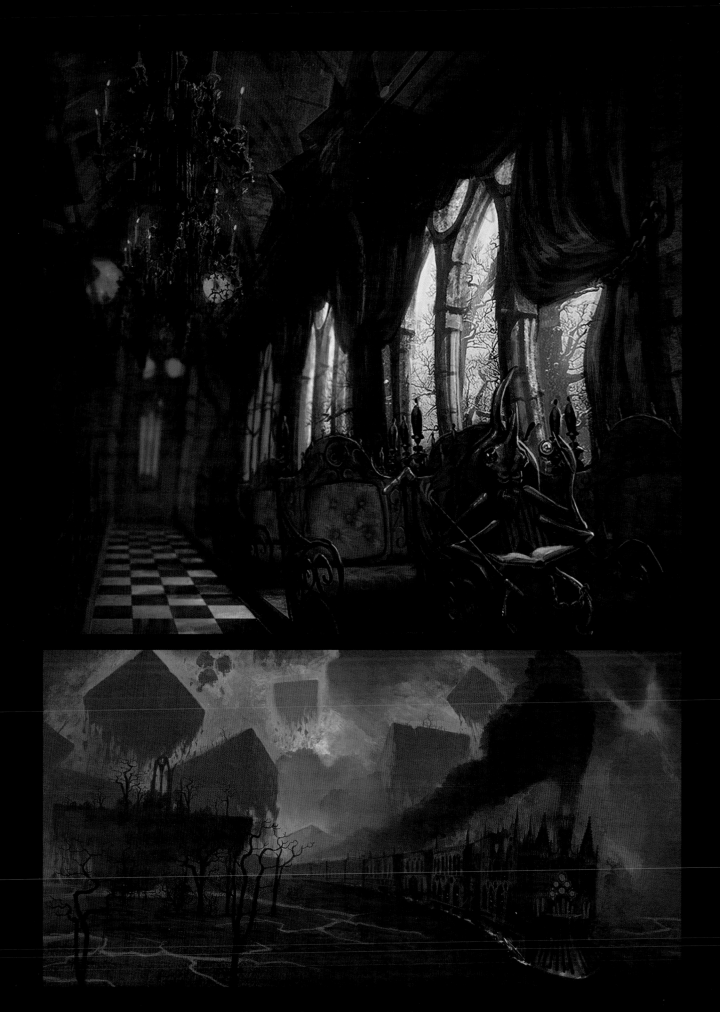

TOP: **Luis Melo.** *KW: This is quite close to the final design of the train interior, which appears much smaller and calmer compared to the exterior. The beetle guy didn't make it, though.* BOTTOM: **Luis Melo.**

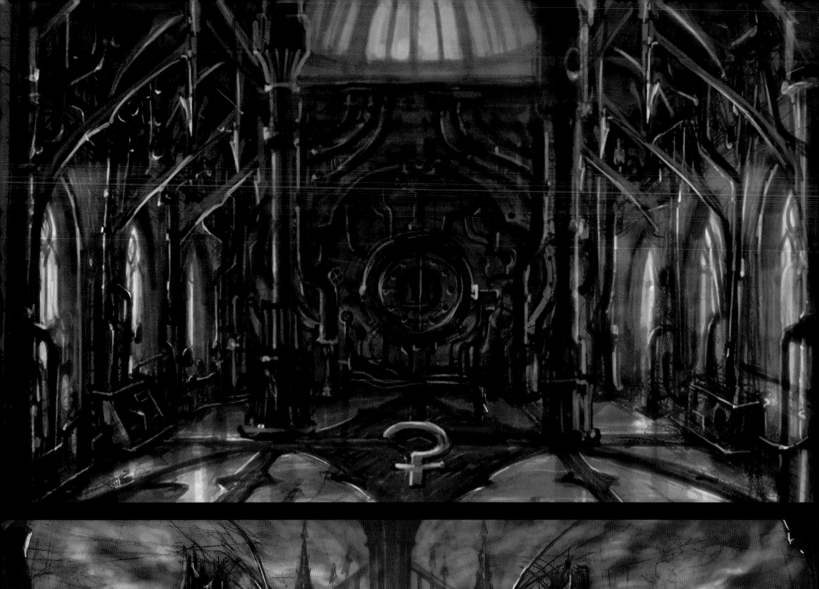

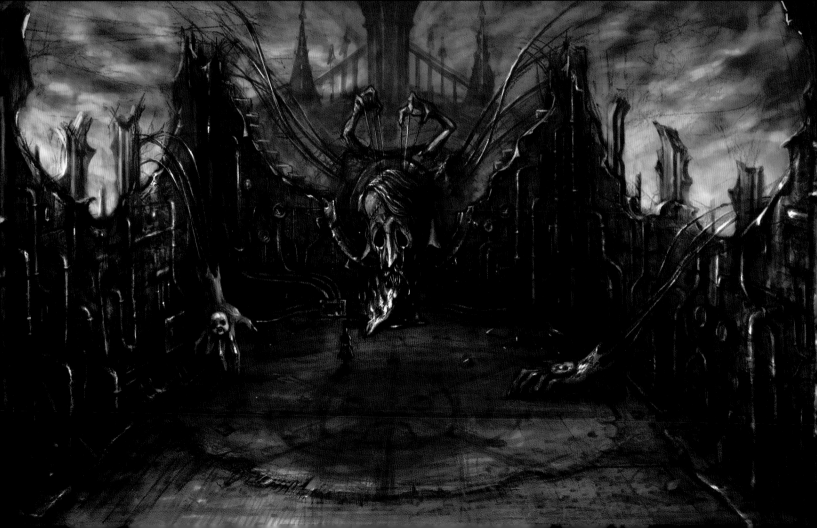

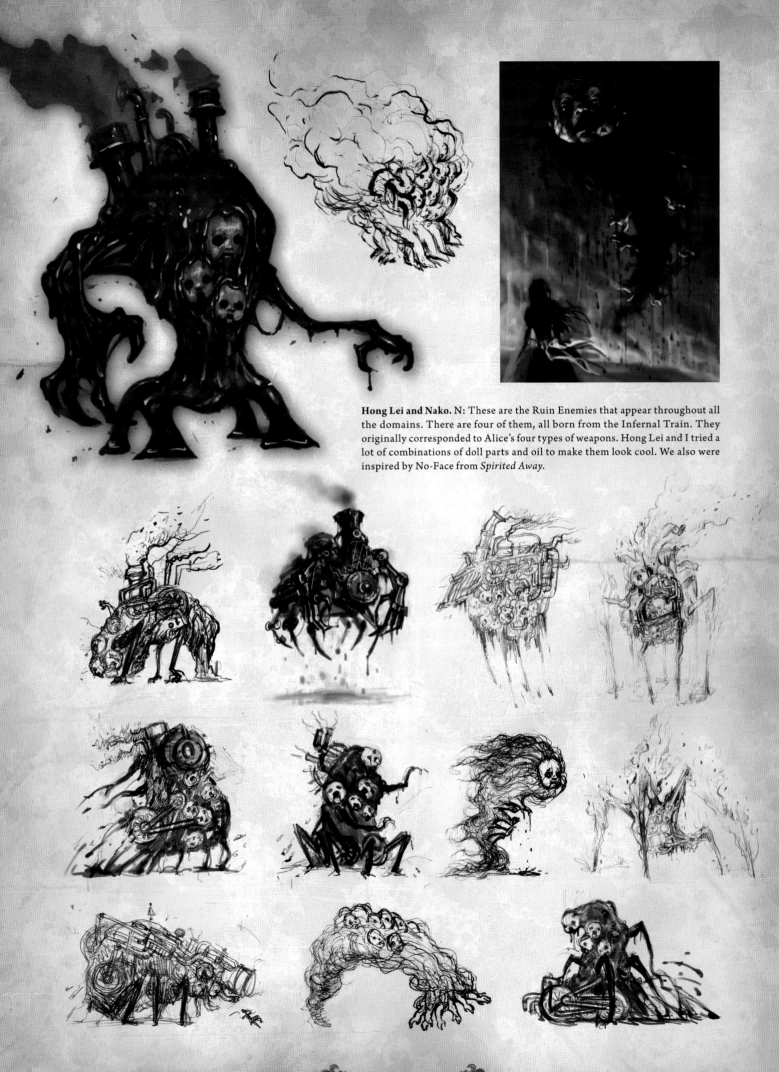

Hong Lei and Nako. N: These are the Ruin Enemies that appear throughout all the domains. There are four of them, all born from the Infernal Train. They originally corresponded to Alice's four types of weapons. Hong Lei and I tried a lot of combinations of doll parts and oil to make them look cool. We also were inspired by No-Face from *Spirited Away*.

Fellipe Martins and Renato Faccini.

CINEMATICS

WITH A PRECIOUS few months left to go on the project, we realized we weren't able to complete all of our 3-D cinematic scenes in time. Although we had some animation capacity available, cinematics work had always fallen upon our level designers, who were busy focusing on enhancing gameplay and creating compelling, solid environments. This left no time for tweaking movement splines, adding particle effects, or improving camera framing. What made things worse was that changes to troublesome gameplay or level geometry could make days' or weeks' worth of cinematic work obsolete, as they were often tied together.

We then made the decision to move many of our scenes into a special motion-graphics presentation, created by a small group of artists. This would allow us to manage this process separately, independent of the level design, and also to give these scenes a unique style.

We imported Fellipe Martins, an old friend and Spicy Horse collaborator from Brazil, to head up the illustration team who would create the assets for these scenes. However, we still lacked motion-graphics expertise, so we collaborated with Edward Goin of FLY films, a video- and film-production company in Shanghai. On a very tight schedule, they worked together with a small team of artists to create vivid, imaginative interpretations of the scenes that I think work much better than a straight 3-D presentation ever would have.

Fellipe:

It was a rewarding challenge. The initial idea was to bring the original Tenniel illustrations to life, as if he actually illustrated our version of the story. I had two solutions, neither of which was easy. Using mockups and a lot of nineteenth-century printing reference, I started to build a production process, which only became effective once we started to think in a production-line-factory mode. We didn't have a lot of time, but the team was fantastic, and each talented individual contributed their unique signature. It shows in the final product.

Fellipe Martins and Renato Faccini. *FM: The final Mock Turtle, the one who receives the dismissal letter, doesn't wear a hat, shoulder pads, or medals. You see, Mock Turtle wasn't an admiral yet. Hopefully we realized that soon enough.*

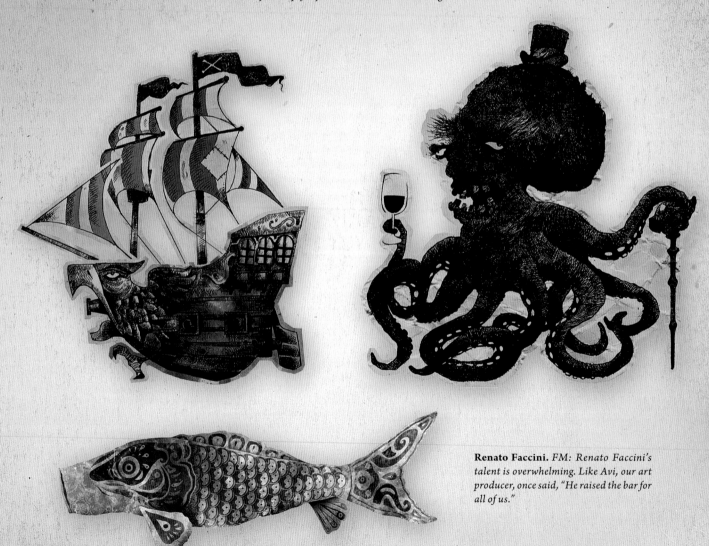

Renato Faccini. *FM: Renato Faccini's talent is overwhelming. Like Avi, our art producer, once said, "He raised the bar for all of us."*

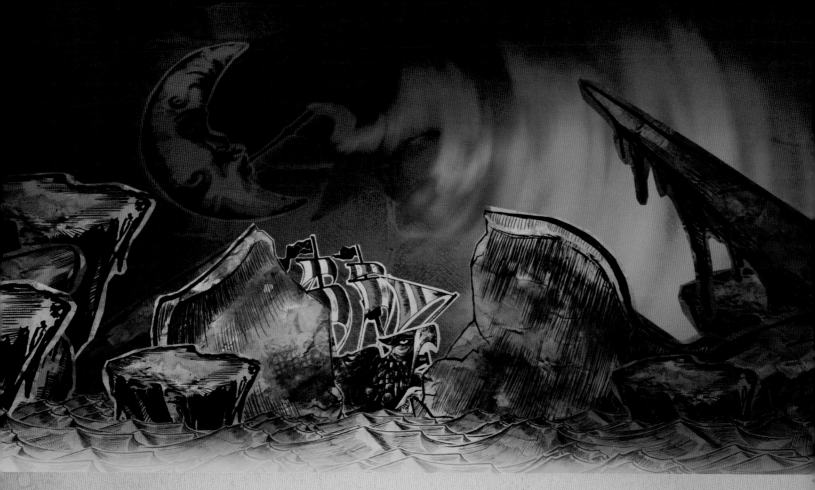

Edward Goin. *FM: Edward Goin, our animation director for 2-D cinematics, showed us some of his magic when he followed the mood and vibe of the Tundra exactly as Nako, the concept designer, imagined it.*

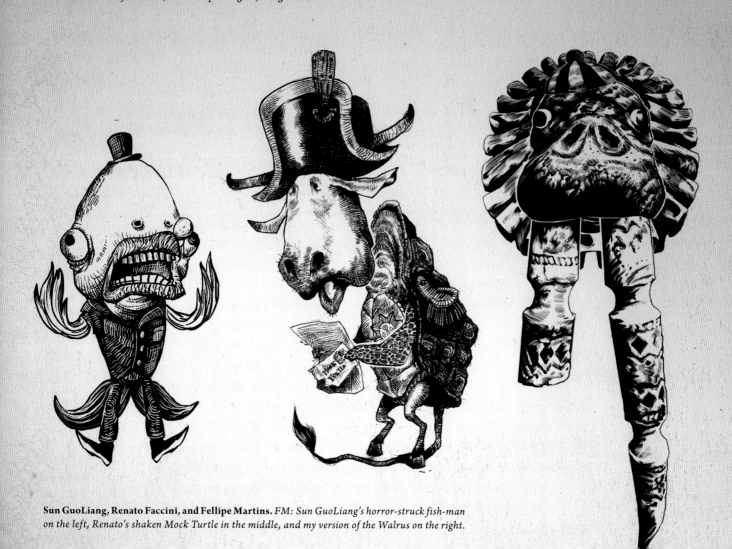

Sun GuoLiang, Renato Faccini, and Fellipe Martins. *FM: Sun GuoLiang's horror-struck fish-man on the left, Renato's shaken Mock Turtle in the middle, and my version of the Walrus on the right.*

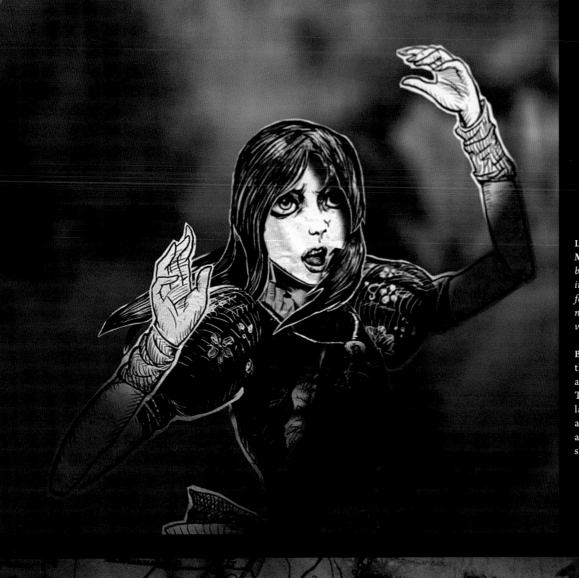

LEFT: Sun GuoLiang and Fellipe Martins. *FM: Some of the assets to be animated were packed with an incredible number of layers, ready for action. I remember counting more than seventy on a walking version of Bumby.*

BELOW: Fellipe Martins. One of the first mockups to be presented as an art guide for 2-D cinematics. This one represents all Wonderland sequences. Later on, Ed added his own signature with awesome, colorful lights and shadow casting.

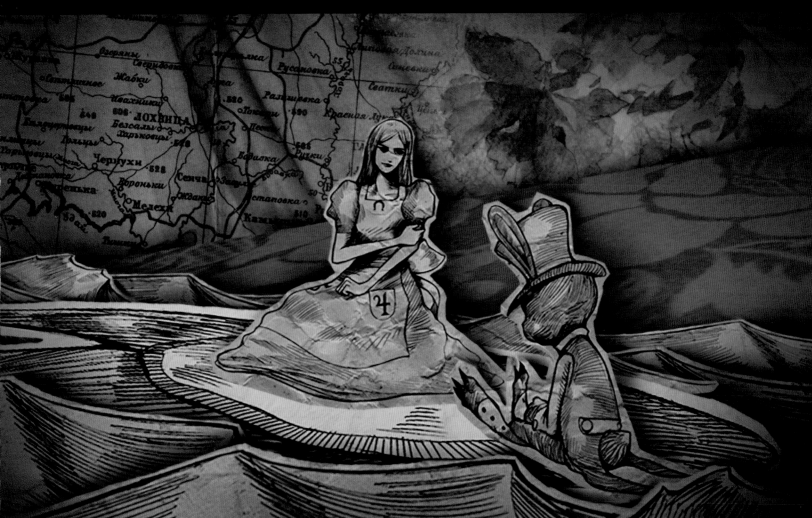

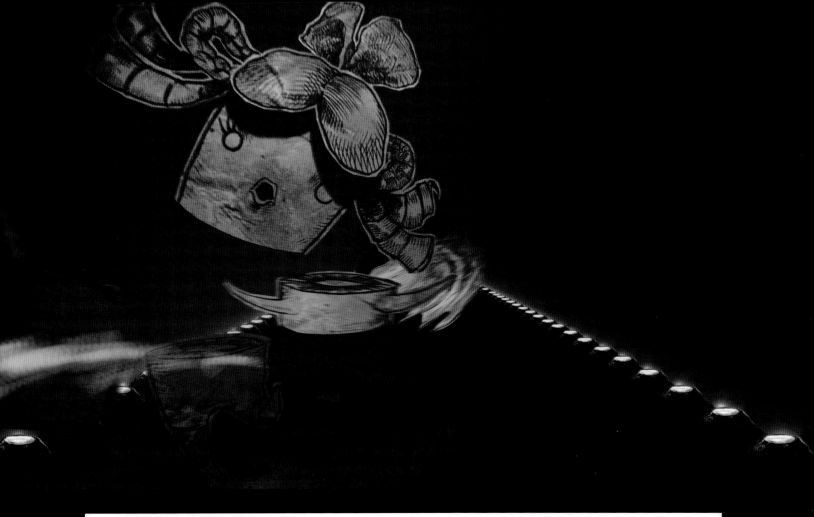

Chapter 6 - Queen Meeting
2D Cinematic

1

FADE IN
CU of Queen, looking angry. Track forward.

VO Queen: " Madness and destruction... "

Assets: CU Queen. 3/4/ angry.

2

We are entering London cinematics now. Liddell Manor. Exterior. Alice's window. Creepy shadows approaching the window as we track forward. Shadows look like queen's hands.
VO: " ...ask questions you know the answear... "

Assets: House wall plus window. Silhouettes for shadow casting.

3

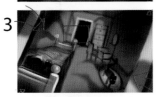

Alice's Bedroom. As we track forward, shadows are "consuming" the room, reaching for the door, while moonlight lits the scene. Her door is open.

VO: " It's not polite..."
Assets: Alice bed (schematics), cat pillow. cat sleeping. Furniture (wardrobe, mirror, chair). Door. 1 painting.

4

Alice POV. A creepy figure walks towards Lizzie's bedroom, just across the corridor. Opens Lizzie's door.
VO: "And that noise wasn't Lizzie talking in her sleep..."
Assets: Creepy shadowy Bumby. Articulated for walking animation.

5

... and enters the room. Creepy shadows approaching the door.

6

Creepy figure walks out. Shadows approaching the corridor, almosti touching the figure.
Alice VO: Oh no... poor Lizzie..."
CUT

7

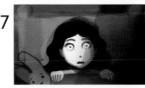

CU, Young Alice. Scared. Bunny by her side. Shadow covering here face. Bumby locks the door and approaches her.

Assets: Young Alice's scared face. Hands. Blanket.

8

As Bumby gets closer, we can see his shadow casting over Alice's face.

9

CU Bumby. His face partially covered in shadows. Glasses shining on darkness.

 VO: ". . . And there are no Centaurs in Oxford."

Assets: MIDSHOT Bumby. Covered in shadows.

Door closing on Alice's face.
VO: ". . . Or we are all doomed !"

FADE TO BLACK

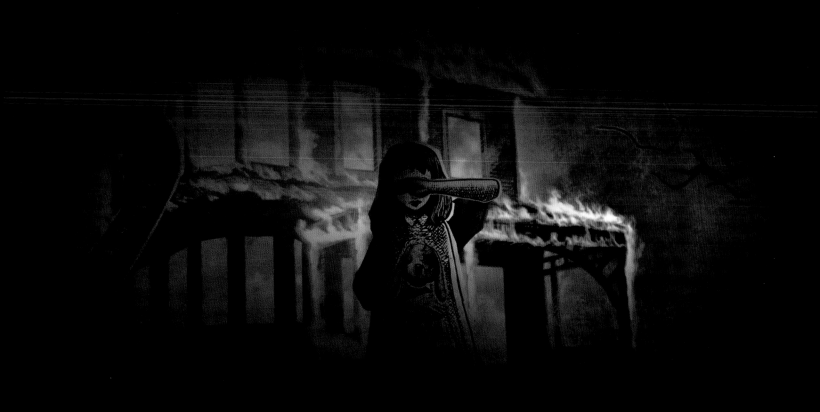

ABOVE: **Wu YueHan and Fellipe Martins.** *FM: For a while, we discussed the usage of animated assets instead of realistic fire effects on some scenes. Realistic fire was easier, faster, and showed good results. Real fire won.* BELOW: **Wu YueHan and Sun GuoLiang.**

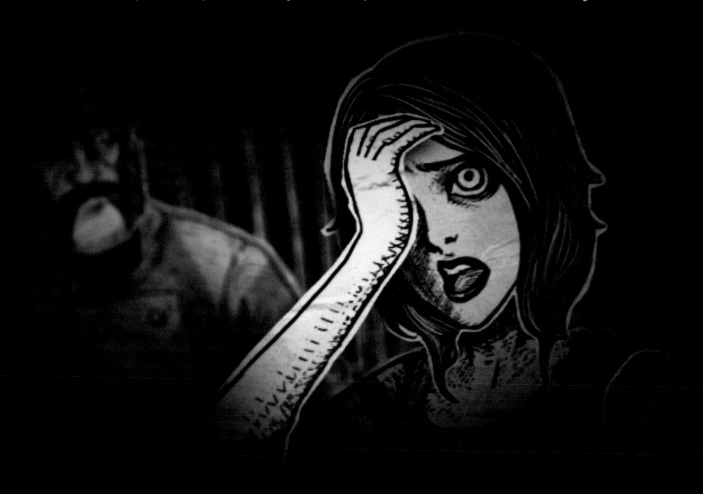

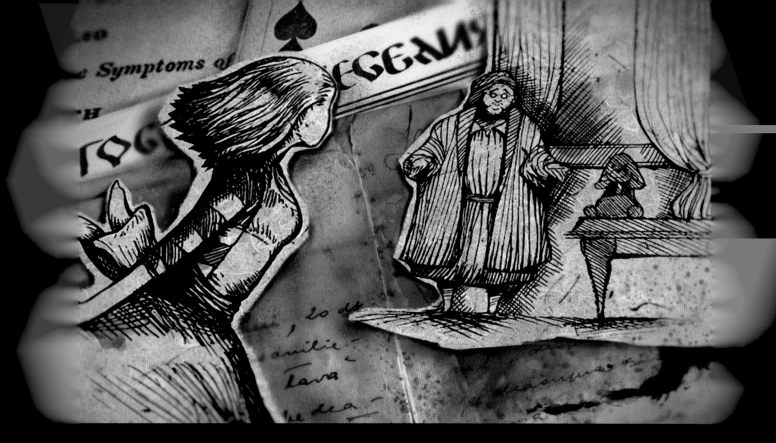

Fellipe Martins. Another old mockup, this one representing London sequences, dirty and desaturated. Also my favorite.

Chapter 4 - Guard Narrative
2D Cinematic - Gaol - Encounter with Jack, The Pimp

1

Mid shot, two guards holding Jack, he's looking back at them. He's angry, guards are idly looking at him. Zoom in.

VO: " Same night Jack Splatter--that waste of mother's love--was nabbed for gutting that heavy outside the Mermaid."
Assets: Back view - 2 guards and one angry Jack. He'll will be loking back. Try something expressive on the poses.

2

Wide shot of Alice, being dragged around by two guards. She's somewhat angry.

VO: " I was taking Alice down, and...We meet two coppers walking Jack to the cells."
Assets: Full front of 2 guards and 1 London Alice. Again, expressive pose. Gaol enviro: 1 lantern, 1 prison door, 1 bench (already have).

3

Mid shot of guards holding Jack. He's explaining himself, pledging not guilty. Foreground, cut in of Alice looking at him.
VO:" He's mouthing the usual "I never", "wrong bloke," nonsense."
Assets: Full frontal on 1 Jack (pledging) and 2 guards, holding him. mid shot London Alice, back view.

4

Suddenly he 's Alice. Points at her, freaks out.
VO:"When he sees Alice. "That's the bitch what done it" he yells".
Assets: Same Jack, alternative head (freaked out/angry) and pointing hand.

5

Alice's really angry, cursing Jack with al her might. Guards next to her, just watching.

VO: " She screams "you miserble cur"
Assets: Mid shot London Alice, angry and shaking her fist. 2 Mid shot guards, idle pose.

6

CU of Jack and guards. He's taking those curses, unable to do nothing. Guards are laughing, after all, he IS a leech.

VO: "you leech, you maggot"

Assets: Same bodies, alternative Jack head (outraged face). 2 guard heads (laughing).

7

Wide shot of outraged Jack and laughing guards. Back view Alice. She still spitting her curses.
VO:"...living off another's labor , etc."

8

Mid shot of Alice, passing out, still angry. She's about to go to Wonderland, so to speak.

VO: "I'm admiring her line of inquiry, but suddenly..."
Assets: Same mid shot shot London Alice, with alternative hand and (fainting) head. Alternative head for guard (laughing).

9

And she falls.

VO: " she hits her head or something and faints.."

10

She lies on the ground, cut-in of a guard's leg. Jack and guards on the background, looking at Alice. No one is laughing anymore.

VO: " Couldn't send her home could I?"
Assets: View from top of Alice's head, laying on the ground. 1 guard leg. Same Jack with 2 guards. (Optional heads, staring at Alice).

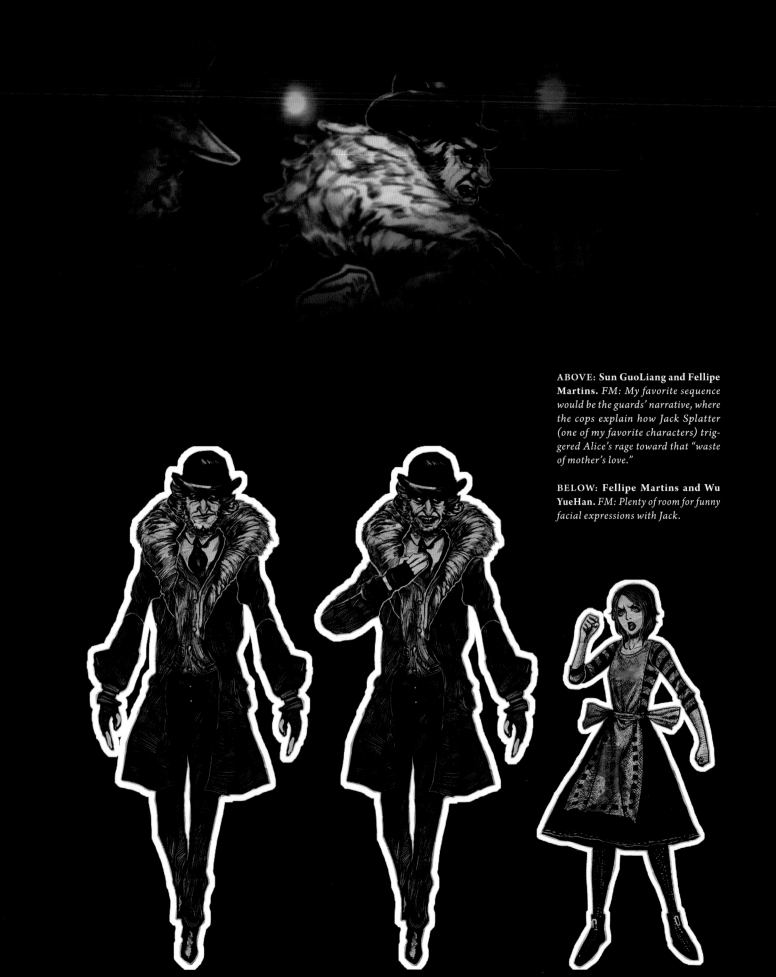

ABOVE: Sun GuoLiang and Fellipe Martins. *FM: My favorite sequence would be the guards' narrative, where the cops explain how Jack Splatter (one of my favorite characters) triggered Alice's rage toward that "waste of mother's love."*

BELOW: Fellipe Martins and Wu YueHan. *FM: Plenty of room for funny facial expressions with Jack.*

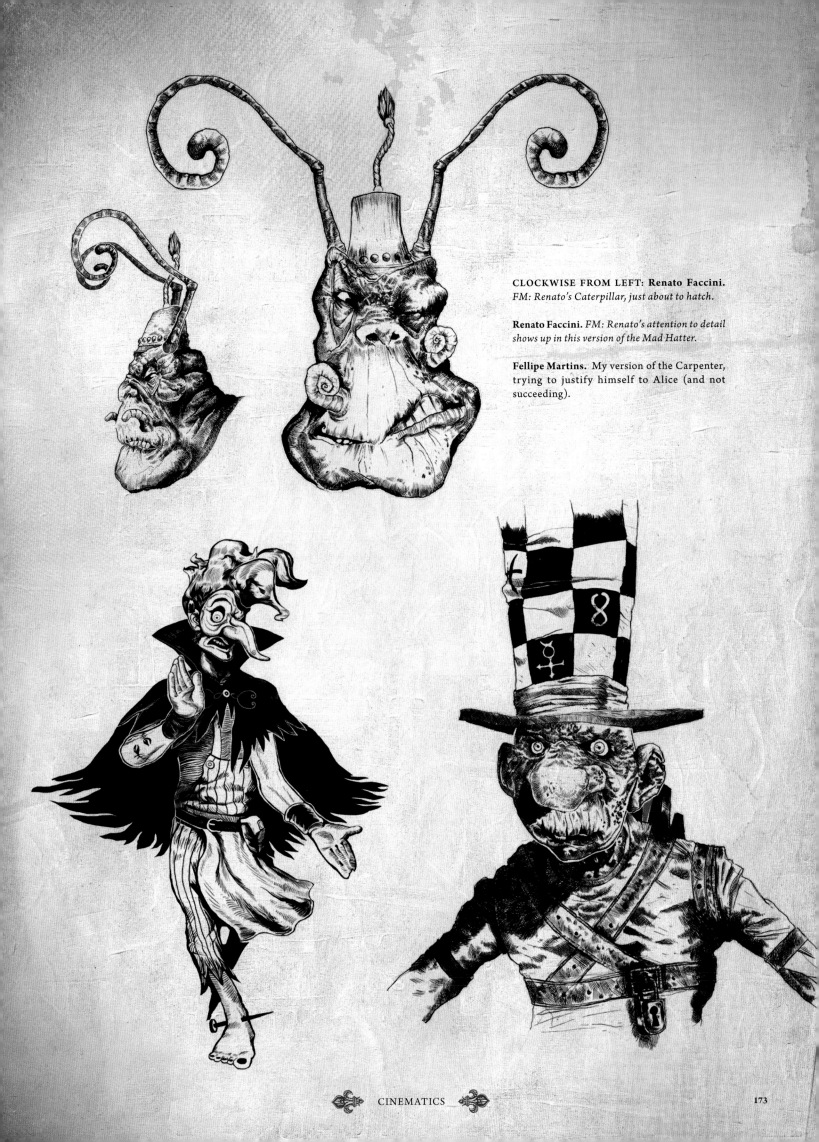

CLOCKWISE FROM LEFT: Renato Faccini.
FM: Renato's Caterpillar, just about to hatch.

Renato Faccini. *FM: Renato's attention to detail shows up in this version of the Mad Hatter.*

Fellipe Martins. My version of the Carpenter, trying to justify himself to Alice (and not succeeding).

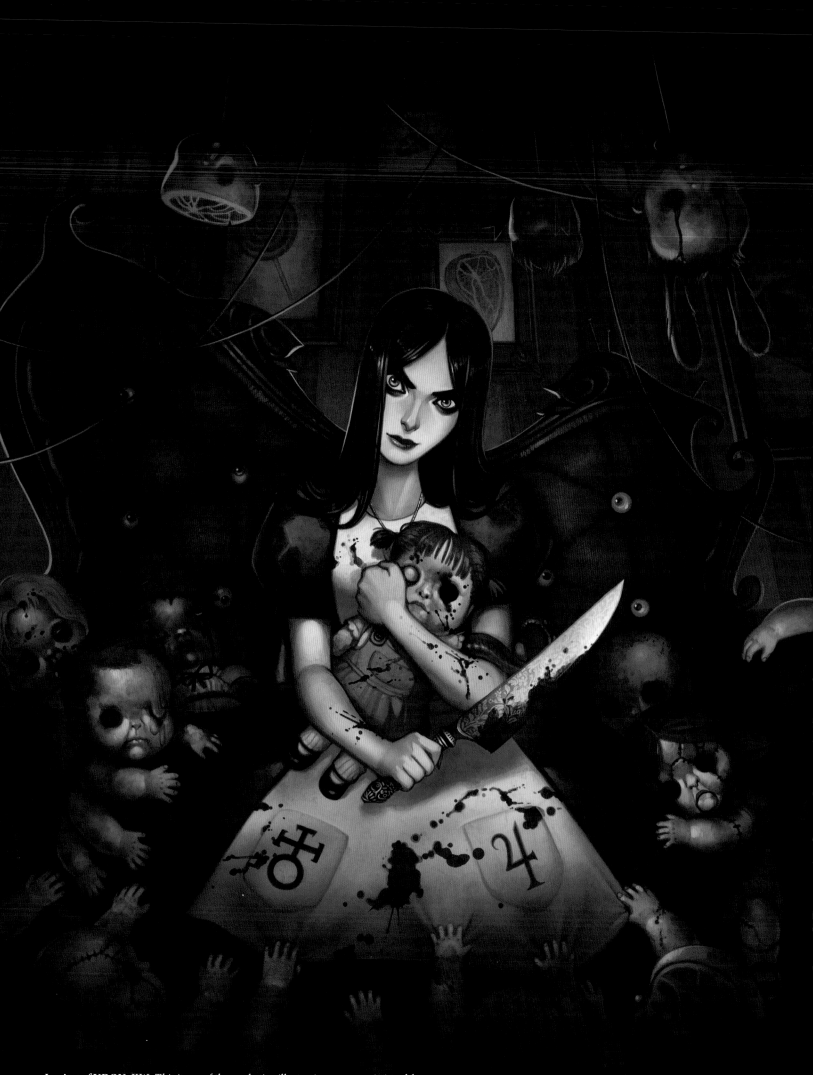

Joy Ang of UDON. *KW: This is one of the marketing illustrations we commissioned from Joy Ang. She really got the creepy-doll thing easily and injected her own ideas into the mix.*

ODDS AND ENDS

THIS INCREDIBLE journey is close to an end.

Concept design is where I started in the game industry. My first job was doing some sketches for a dark adaptation of *The Wizard of Oz* for American, after he saw some *Alice* fan art I had posted online. I never forgot that chance he gave me.

In the years since, I've had to learn the many disciplines of game art—from particle effects to facial morph targets, from normal maps to memory optimization. A capable video-game art director must have an understanding of, if not a capability with, a wide range of technical and artistic fields in order to lead their team. But I've always held the highest standards and reserved the highest scrutiny for the work of the concept artists under my charge.

The artists who worked on *Madness Returns* were not hand-picked for the job. We didn't collect a heavy-hitting team of the most die-hard *Alice* fans. They were not assembled for their love of twisted violence, their knowledge of gothic architecture, or their specialty in surreal landscapes.

They are the Chinese-Australian-Portuguese family that gathered in Shanghai to create *Grimm* and then pitched

packages for *BaiJiu Racer*, *Robo Libre*, and a host of other insane ideas you may never see. They deserve a lot of respect, then, for enduring the research, ego trips, false starts, drill sergeanting, and trials by fire that it took to research, sketch, detail, and finalize so much world-class art, only a portion of which is held within the pages of this book.

Looking back over all this art, I find myself incredibly proud of the way each artist rose to the challenge, developing skills they never knew they had, to spin out this fantastically rich, horribly devious world of imagination and nightmares. It's unfortunate that more of these designs did not make it into the final game. Some were cut because of time, others because of technical challenges, and some because they just didn't quite fit in the direction the game was moving at the time.

This book is therefore a wonderful testament to the incredible efforts of this talented team over the past two and a half years.

Ken Wong
Art Director
December 2010

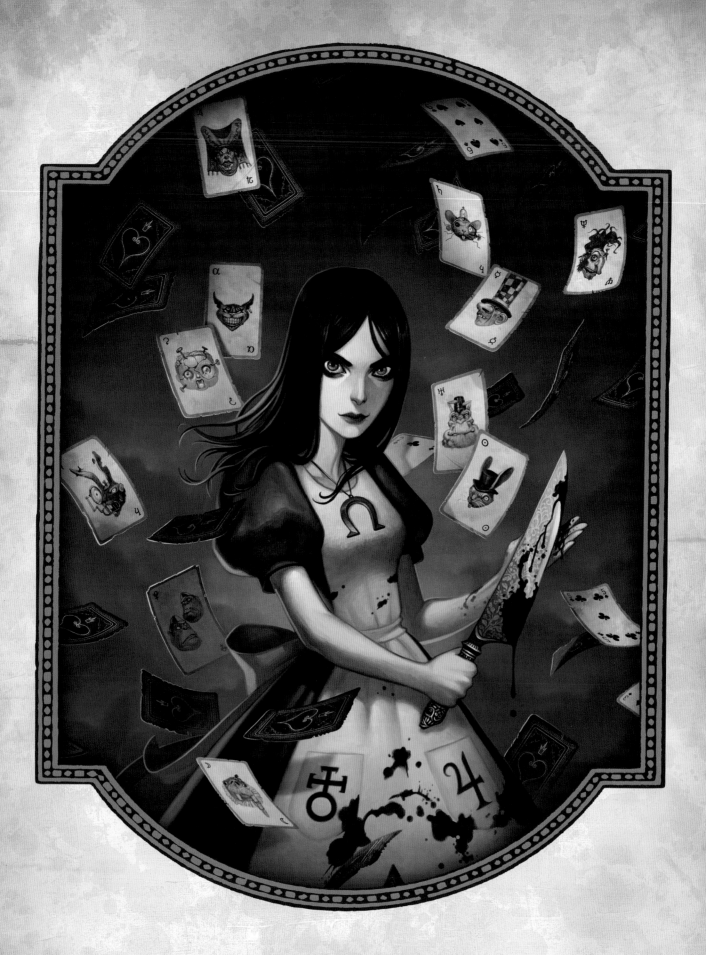

Joy Ang of UDON. *KW: Another of Joy's illustrations. This image prompted us to assign alchemical symbols to each of the characters. The card back Joy designed here was eventually used in the game, too.*

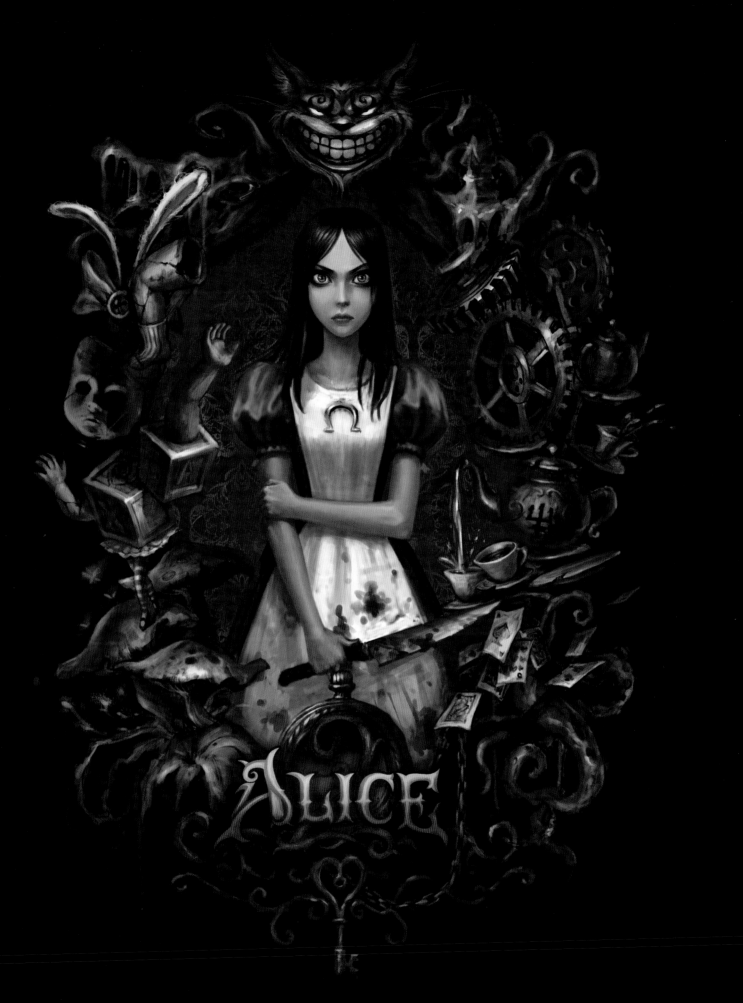

Nako, Sun GuoLiang, Hong Lei, and Ken Wong. *KW: This was an early attempt by our internal team to design a marketing image. Because it needed to be done really fast, various parts of this image were done by different artists, then combined. We each did color treatments, and then passed the selected color treatment between us for final adjustments.*

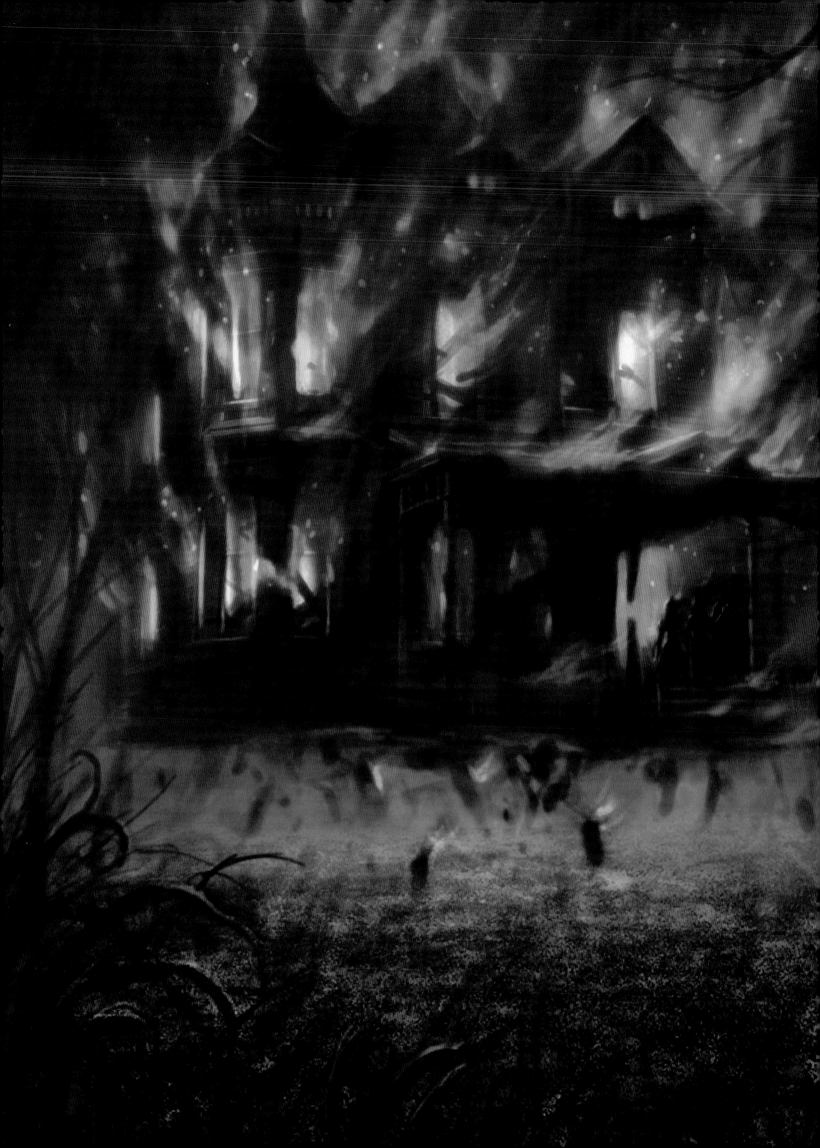

LEFT: **Nako.** Midnight in Hyde Park. Alice sees her house floating and on fire, and her family members are waving to her.

ABOVE: **Ken Wong, Nako, and Luis Melo.** *KW: These are various ideas for the game logo.*

HATTER'S DOMAIN COLOR SCRIPT

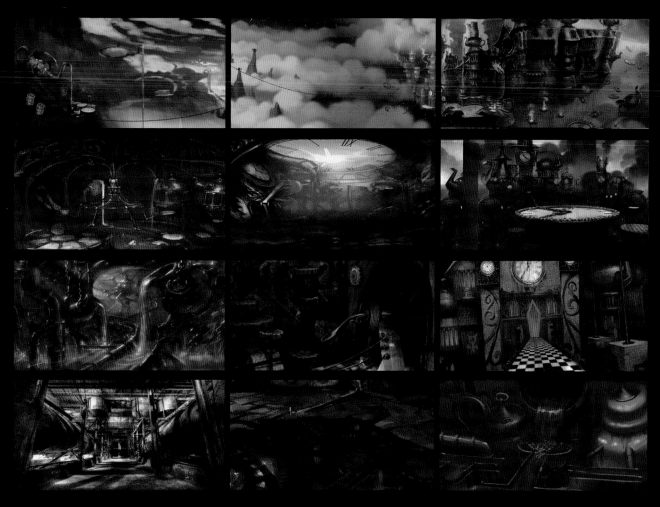

Spicy Horse design team. *KW: With such a variety of locations, it was important for us to identify areas by color scheme. The Hatter's Domain was always in danger of becoming a gray-and-brown mess of rusty metal. Here you can see us pushing turquoise, crimson, and blue gray in an effort to give each area its own color identity. These color scripts were also useful to get an overview of our sprawling domains.*

DELUDED DEPTHS COLOR SCRIPT

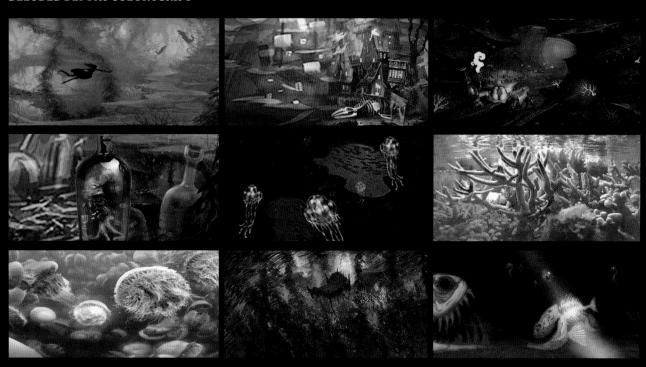

Spicy Horse design team. *KW: From the start, I didn't want the Deluded Depths to be dominated by blue. We also wanted to color and light our scenes more theatrically, with less concern for realism. This allowed us to use any colors we wanted, depending on the theme of each area.*

 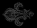

CHAPTER 3 LONDON COLOR SCRIPT

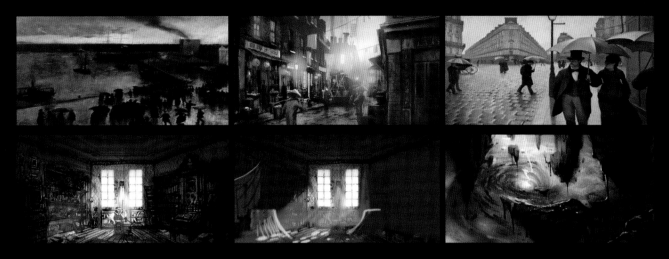

Spicy Horse design team. *KW: In contrast to most of Wonderland, London is gray and bleak. These keys depict the wan morning light, as Alice stumbles into a rich area of London to meet her old family lawyer. Here she hallucinates and ends up walking into the Vale of Doom.*

MYSTERIOUS EAST COLOR SCRIPT

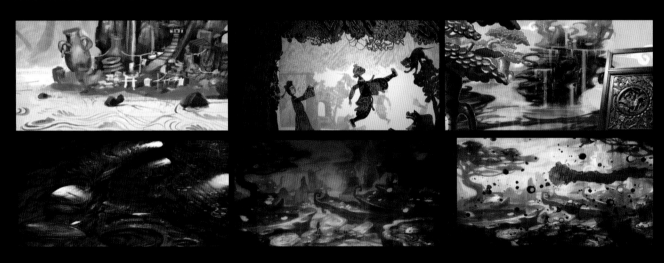

Spicy Horse design team. *KW: The colors of the miniature Oriental Domain were dictated largely by the materials it was constructed out of. Some of these areas are among the most beautiful and unique in the game.*

QUEENSLAND COLOR SCRIPT

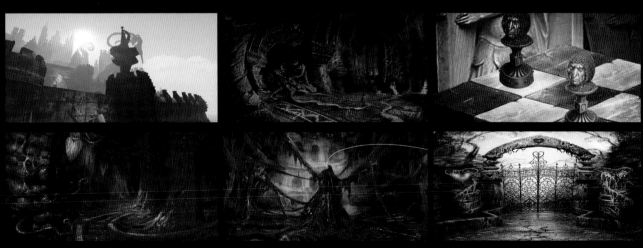

Spicy Horse design team. *KW: Queensland's color scheme is divided into dead, dry areas, which have been bleached and drained of color, and the wet, fleshy areas that throb blood red and bruised purple. Breaking these areas up are the cleaner chess rooms and the green-tinted maze.*

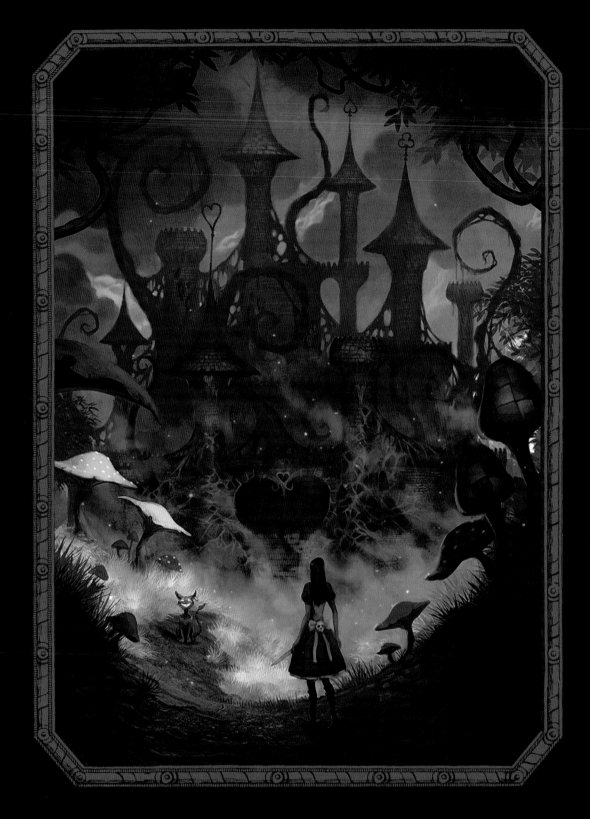

ABOVE: Luis Melo. BOTTOM LEFT: Nako. BOTTOM RIGHT: Ken Wong.

THE ART OF ALICE: MADNESS RETURNS

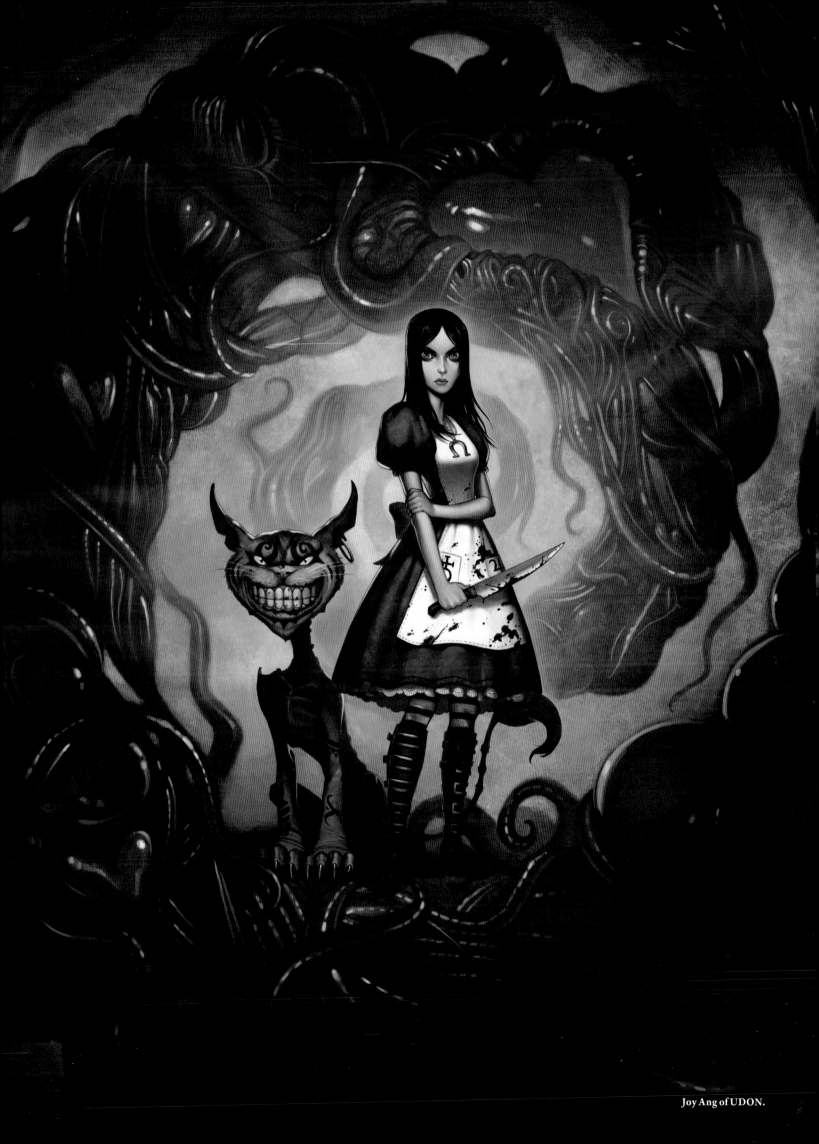